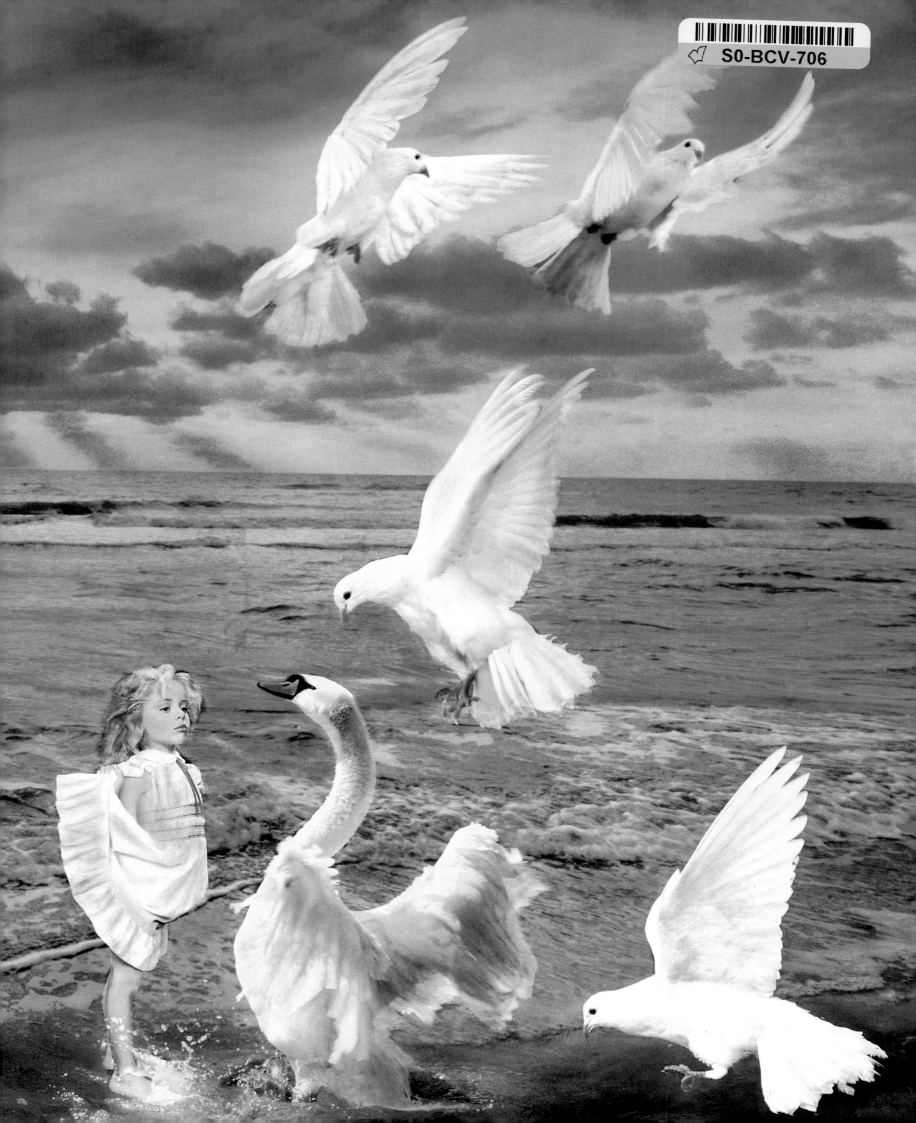

I dedicate this book to all children with the hope that also the less fortunate can find sunshine in this world full of shadows.

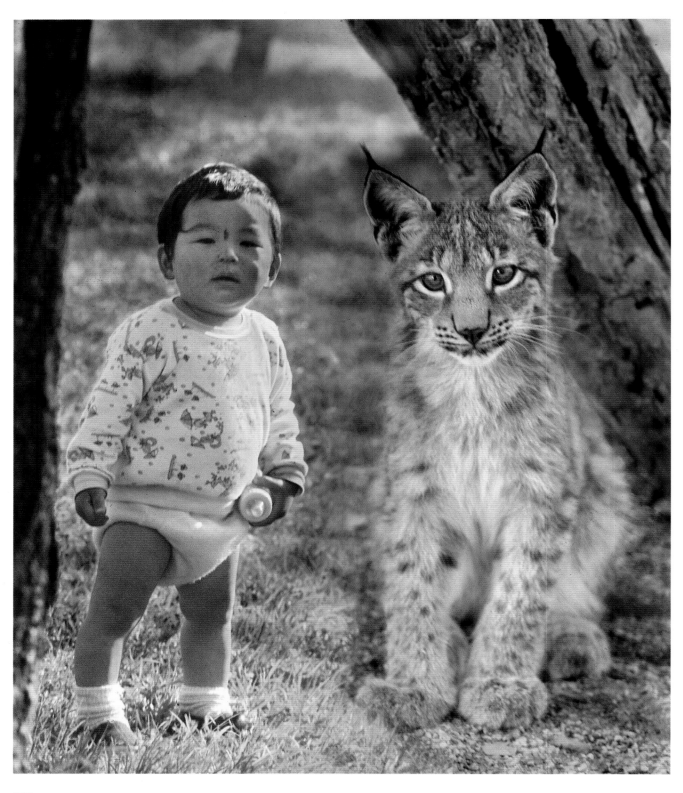

The strongest strength is an innocent heart.
Ralph Waldo Emerson

THE WONDER OF INNOCENCE

GINA LOLLOBRIGIDA

HARRY N. ABRAMS, INC., PUBLISHERS

Library of Congress Cataloging-in-Publication Data
Lollobrigida, Gina
 The Wonder of Innocence / Gina Lollobrigida.
 p. cm.
 Includes index.
 ISBN 0–8109–3573–2
 1. Photography of children. 2. Children—Pictorial works.
 3. Children and animals—Pictorial works. 4. Lollobrigida, Gina.
 I. Title.
TR681.C5L65 1994
779' .25 — dc20 94 –1412

Designed by Gina Lollobrigida
Printed and bound by Giorgio Mondadori, Milan, Italy

Published in 1994 by Harry N. Abrams, Incorporated, New York
A Times Mirror Company

**This book was prepared with the support and cooperation of
PROFESSIONAL IMAGING, EASTMAN KODAK COMPANY**

CONTENTS

168 fantastic photographs by

GINA LOLLOBRIGIDA

FOREWORD

6

A Wish from **MOTHER TERESA OF CALCUTTA**

INTRODUCTION

11

INNOCENCE AND POETRY *by Gina Lollobrigida*

ESSAYS

53

A CHILD LIVES IN EVERY RESEARCHER
"The child is father of the man" *by Carlo Rubbia*

54

PERHAPS IF WE COULD BECOME CHILDREN AGAIN...
In Search of the (Lost) Innocence of Nature *by Fulco Pratesi*

139

THE OFFENDED INNOCENCE
The True Causes of So Many Childhood Dramas *by Ernesto Caffo*

187

Illustrated Index

A WISH
from
MOTHER TERESA OF CALCUTTA

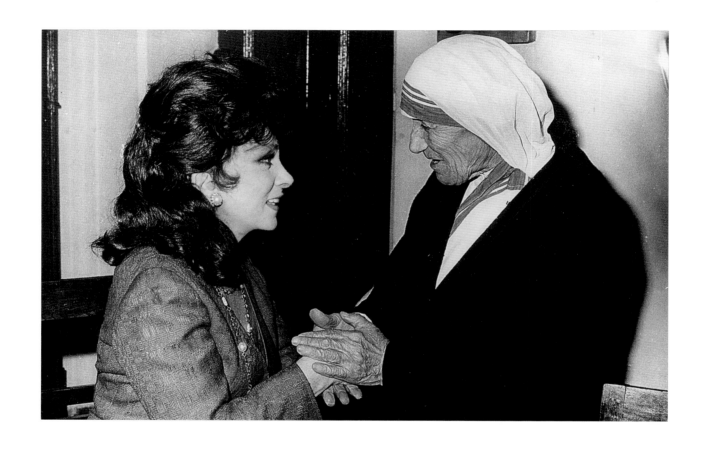

Dear Gina,
Love others as God loves you.
God Bless you
Me Teresa mc
12-3-91

Jesus had great love for children
we read in the gospel where
He says, Let the little children
come to Me, because every
child born and unborn is
created for greater things
to love and to be loved.

so let us love the child
the most beautiful creation
of God.
 Pray with your children
in your family and you
will love each other as God
loves each one of you.
 God bless you
 M. Teresa mc

Calcutta, India, March 30, 1990

Innocence
in Eden

Imagination is
the beginning
of creation.
You imagine what
you desire;
You will
what you imagine;
And at last you
create what you
will.

George Bernard Shaw

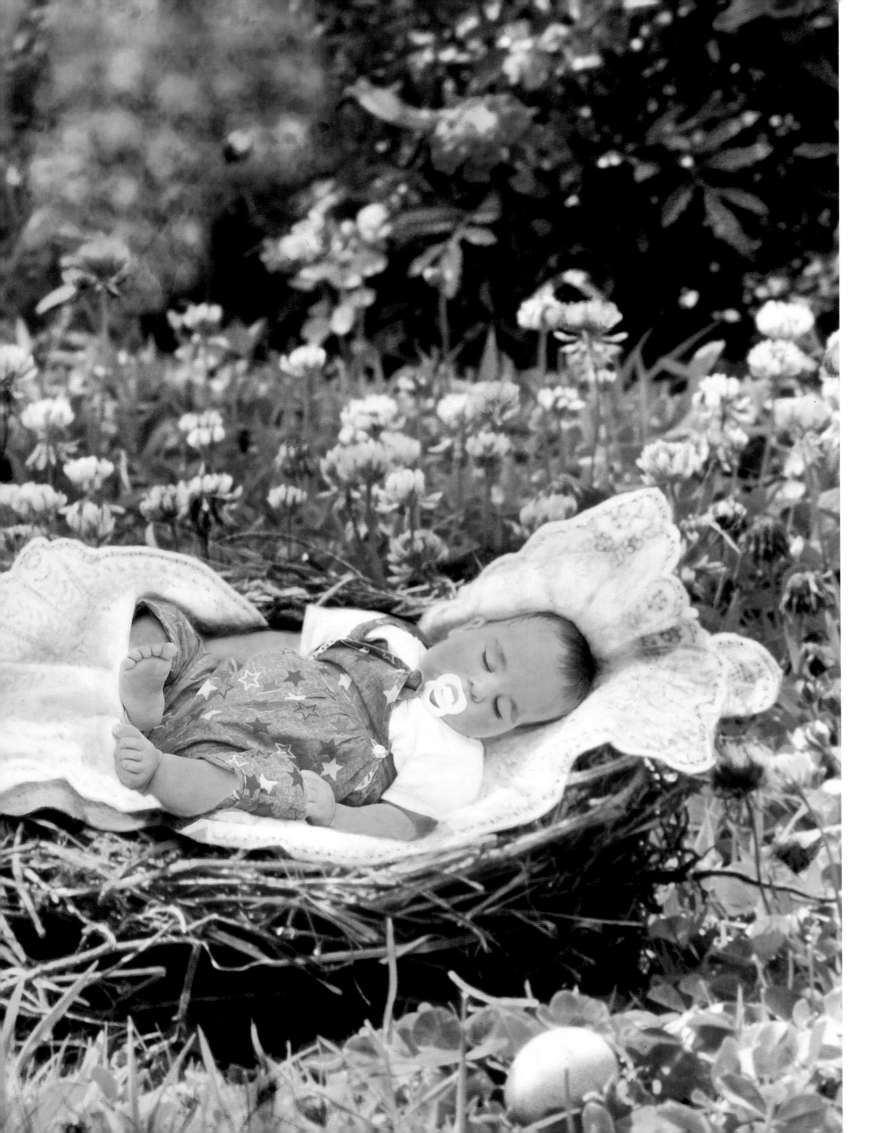

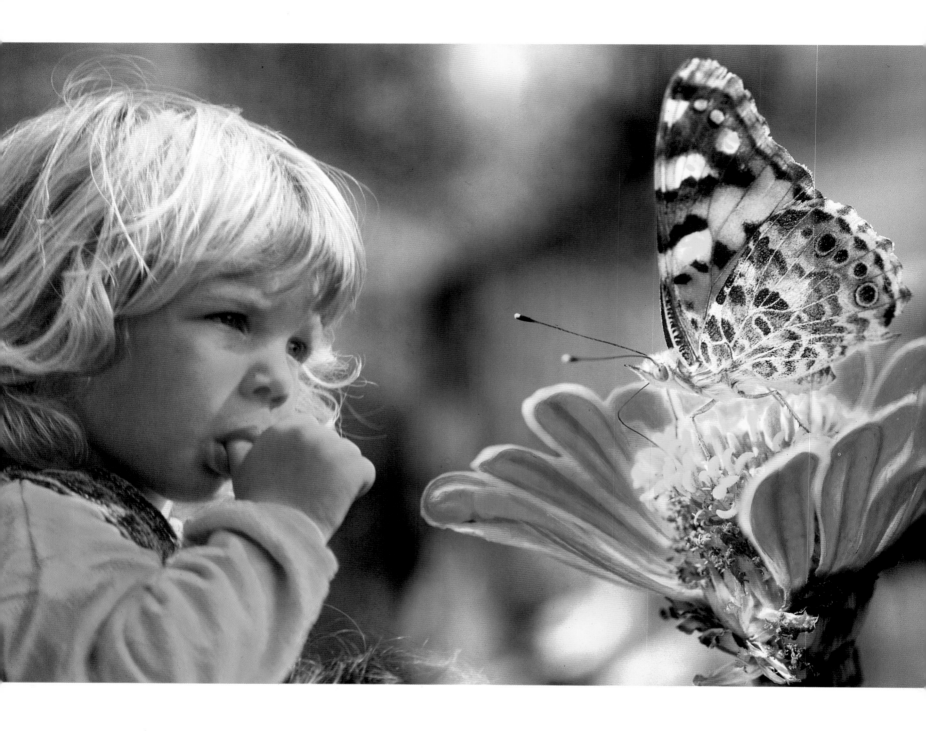

I'd be a butterfly born in a bower, where
roses and lilies and violets meet.

Thomas Haynes Bayly

INNOCENCE AND POETRY

The desire to jump into this enchanting and hazardous photographic adventure grew inside me, little by little, because of my love for children, their fairy tales and animal stories, and from a desire to portray a different reality. I was fascinated by the technical challenge that these pictures represented. I wanted to let my imagination fly and I wanted to use my camera to describe, to create, to paint my flights of fancy.

This passion for imagery, sketching, painting, and sculpting I have carried with me since my adolescence when I was a student at the Accademia di Belle Arti in Rome. The world of cinema came to fetch me from there, and it has been of great importance to me. However, movie-making needs the collaboration of many people who must all be in tune with one another, while painting, sculpting, and taking photographs make me feel self-sufficient. Once more—as had happened with the movies—something that started almost as a hobby has become not only a profession but a real passion, my secret hideout, something that gives me a great emotion.

I worked for more than ten years on this project. They have been years of uninterrupted enthusiasm, always threatened by new and bigger technical problems. At first these pictures of children and animals, taken in many different places all over the world, often in extremely difficult conditions, were just for myself. Later, looking at these shots of the last twenty years, observing the expressions of children, vivid and innocent, I felt a growing desire to transform them, to superimpose them, to create a new relationship between them, in an unexpected way: to create new images, different from the day-to-day reality, something surreal, fantastic.

I was staring at them, but I was seeing them as if they were transparent, other images: my infant dreams, inner images that had never been explained, never put into words. I was, in my mind, putting together scenes that childhood innocence makes possible because it is not limited or burdened by such notions as logic, the sense of dimensions, size, or fears. I was beginning to feel again the freedom of imagination. I was trying to live again all those wonderful emotions of my childhood at the park or at the zoo when I was surprised at how big or how small animals could be, when I hoped to be able to play games with a panda or fly higher than any butterfly, when I wanted to share my ice cream with a monkey, when a bluebottle fly could frighten me much more than a lion. I evoked simple but important feelings of my past and inside myself grew the desire to transform memories and images of my childhood into a photographic reality with a patient mosaic work.

This book has entailed years of research, study, and experimentation. I worked long days and more often long nights in my private photographic laboratory which is part of my home, indeed of my life. I worked alone, using an enlarger and my tricks and secrets. I never had any electronic equipment, only determination and steadfastness. I think it was all worth it!

I was happy living those moments of intense joy elaborating images created by fantasy and memories. A reality that repeats itself each day, every minute: how life keeps on starting all over from the beginning. Everyday life begins again and brings with it innocence that—like water—wipes away what others have left written on the sand.

Thousands of new hearts open up to our sensitivity, to our ability to smile, to educate, to love. Little by little they will fill with the notions we will be able to impart them. What will they be like, as the years go by? Looking around we can see those who have been formed by what other people have (or have not) been able to offer them. It is often not a very pleasant situation. But that is why life is beautiful. There is a worthy project available to which we can dedicate ourselves to build a better future for them—indeed one and all—with enthusiasm, with love, much love.

Children with their big wide-open eyes question us. Their looks should help us to forsake selfishness that undoubtedly leaves our hearts quite bare. A getaway from the routine of day-to-day reality that will awake our joy of innocence.

Marvel and Mystery

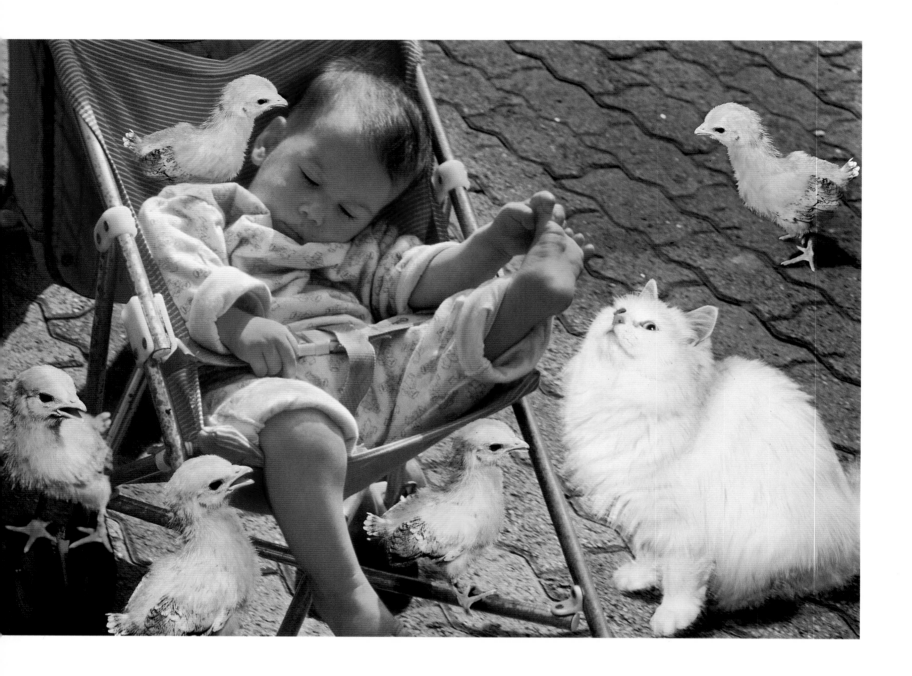

Between the dark and the daylight,
When the light is beginning to lower,
Comes a pause in the day's occupations,
That is known as the Children's Hour.

Henry Wadsworth Longfellow

How dear to this heart are
the scenes of my childhood,
When fond recollection
recalls them to view.

Samuel Woodworth

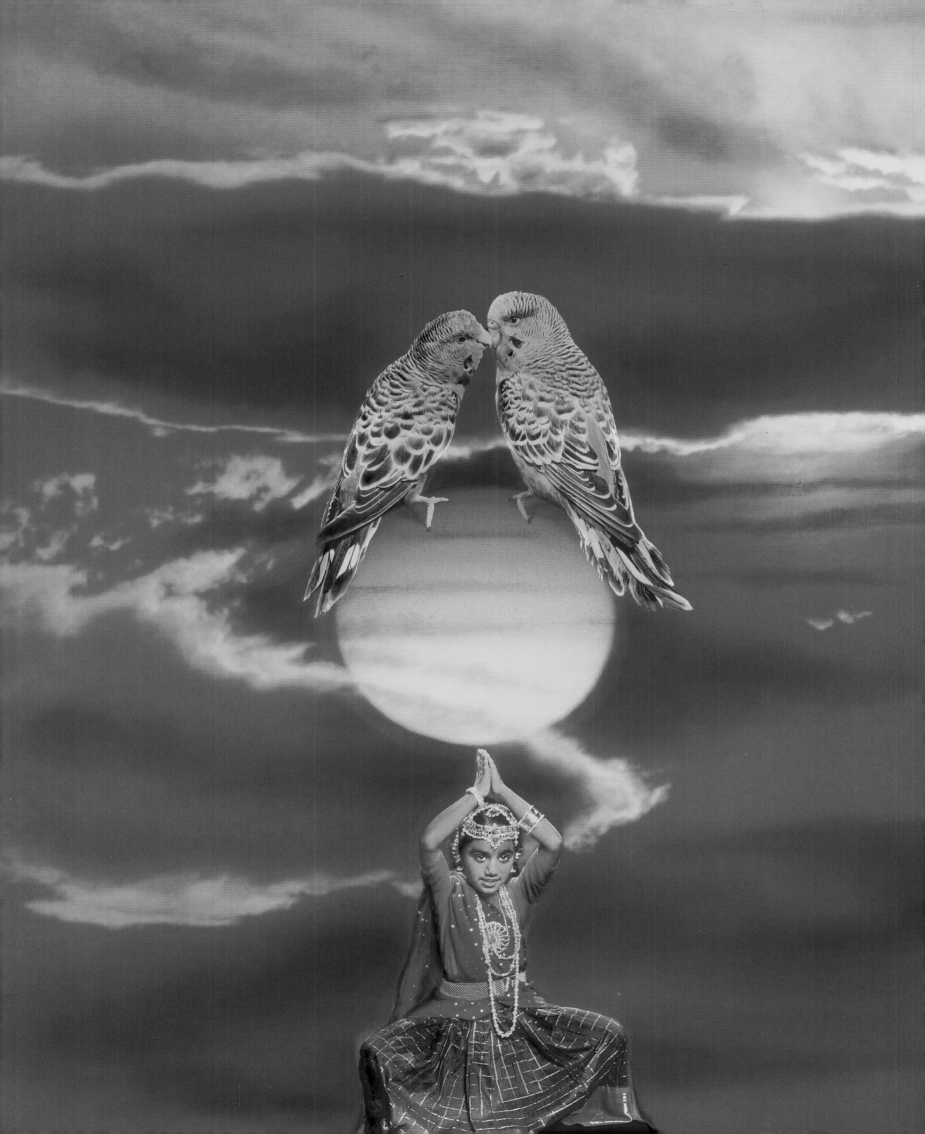

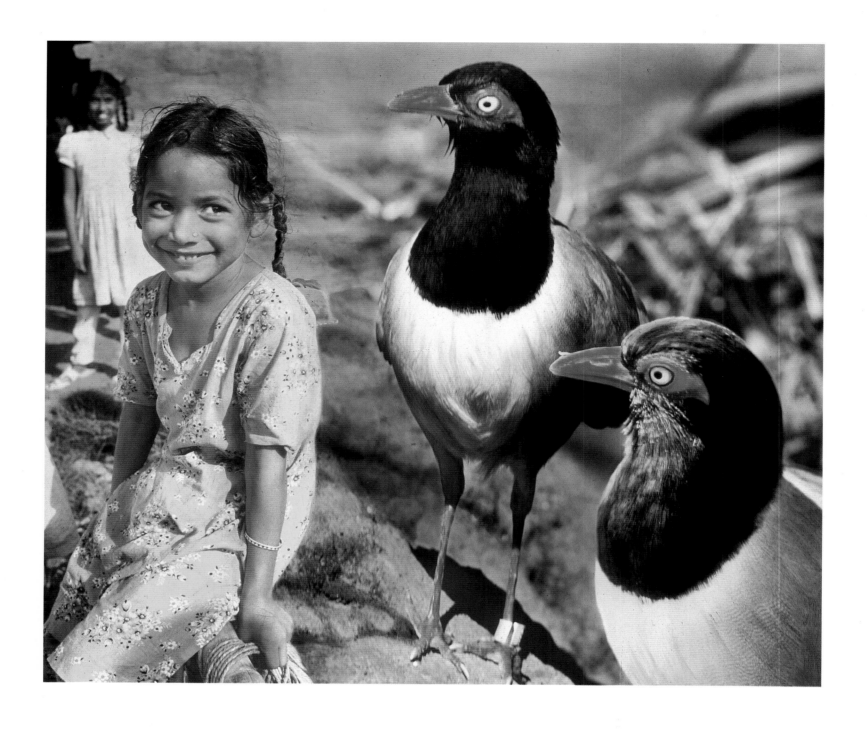

God gives us relatives; thank God we can choose our friends.

Alfred Addison Mizner

Life is a dream and dreams are dreams.

Pedro Calderon de la Barca

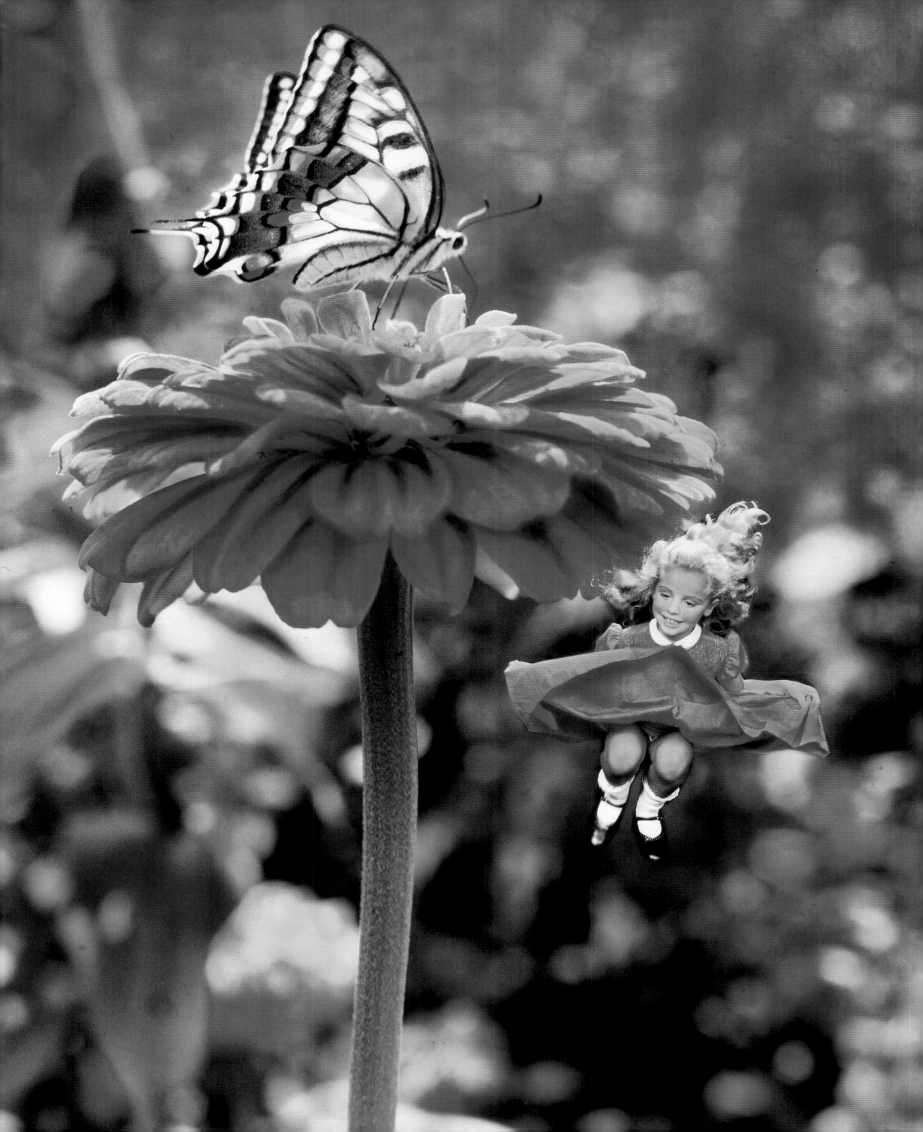

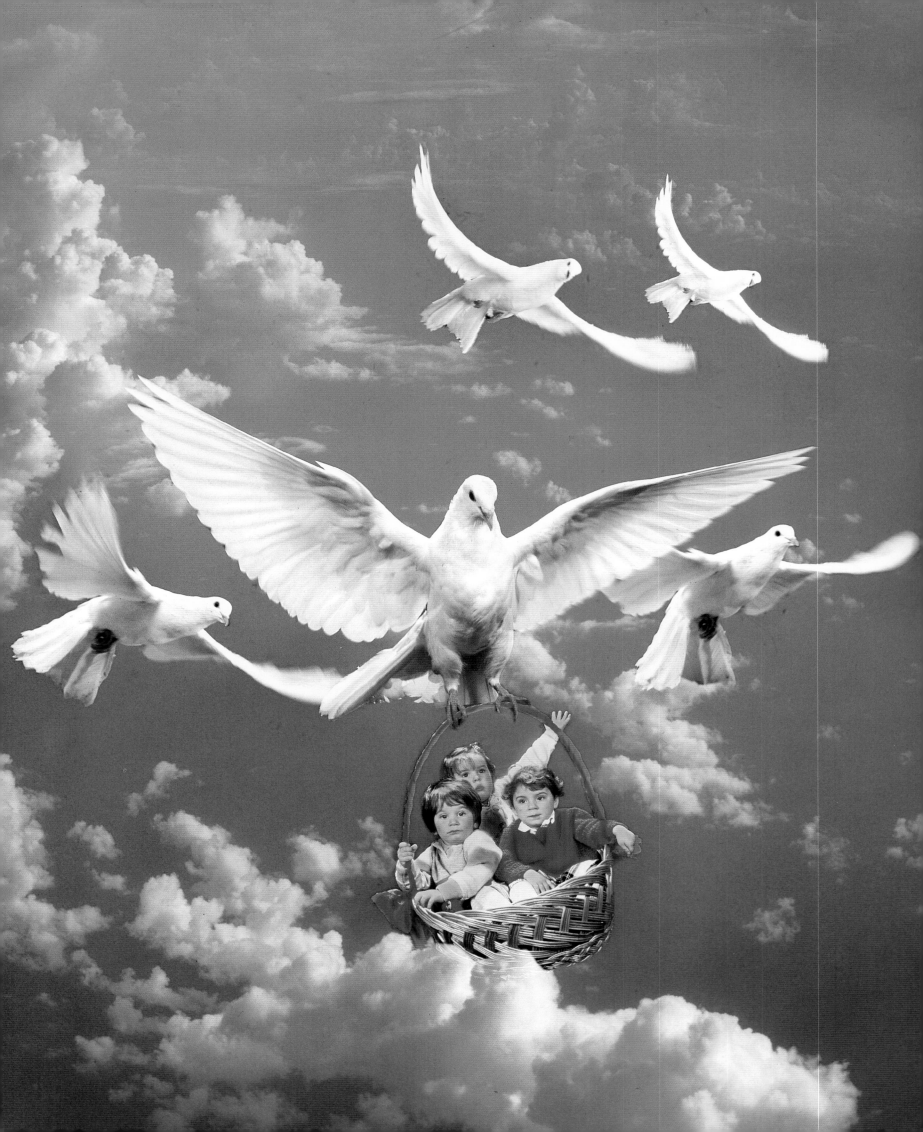

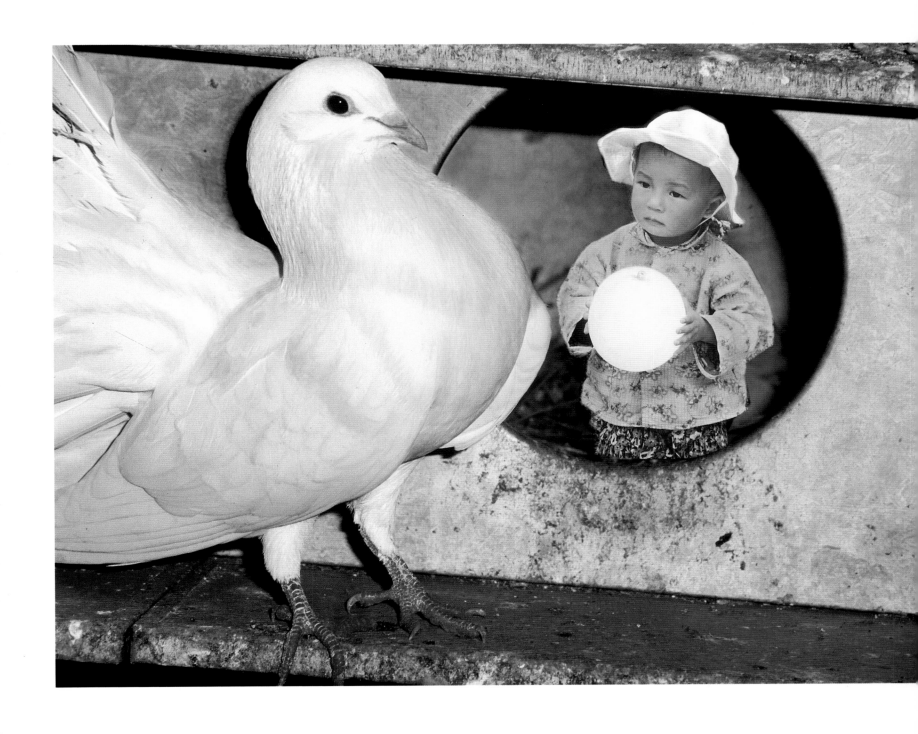

We are such little men
when the stars come out.

Hermann Hagedorn

Even a perfect egg must break for new life
to be born.

Edward Gloegger

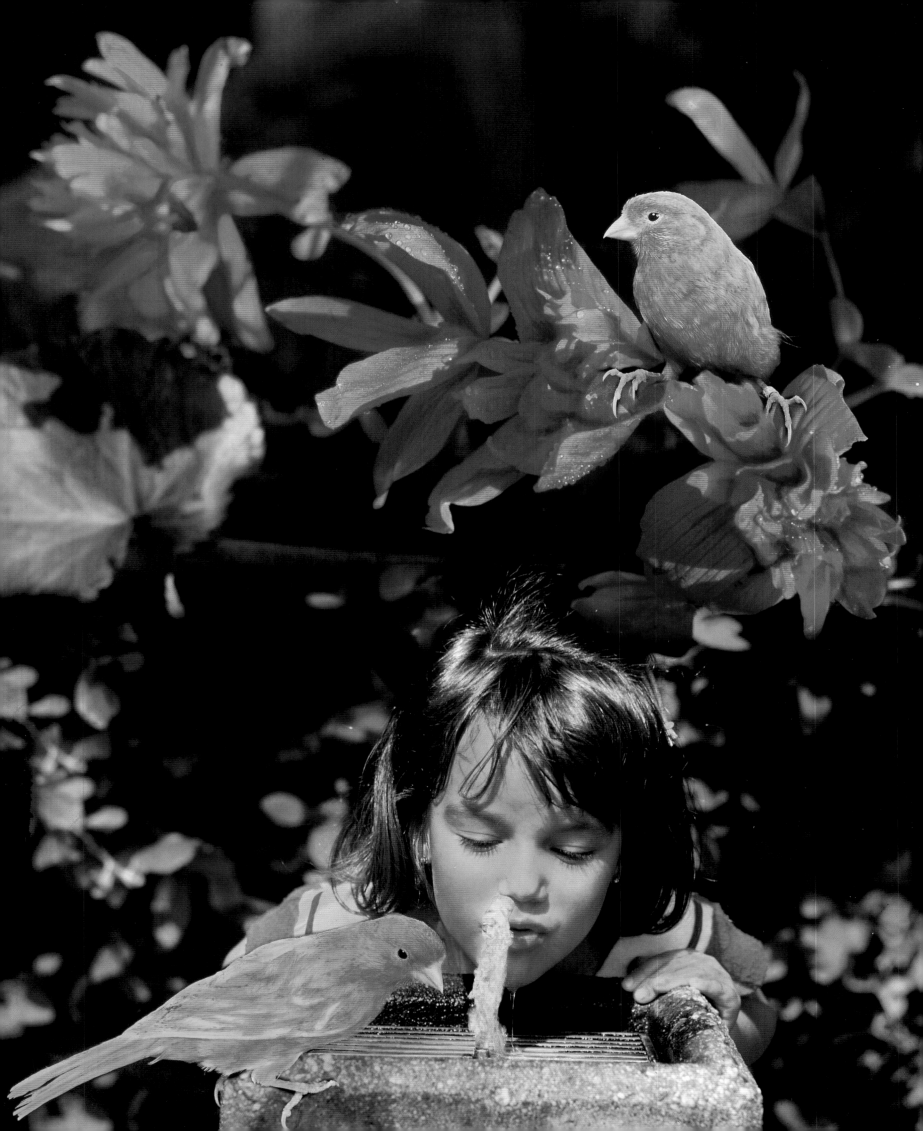

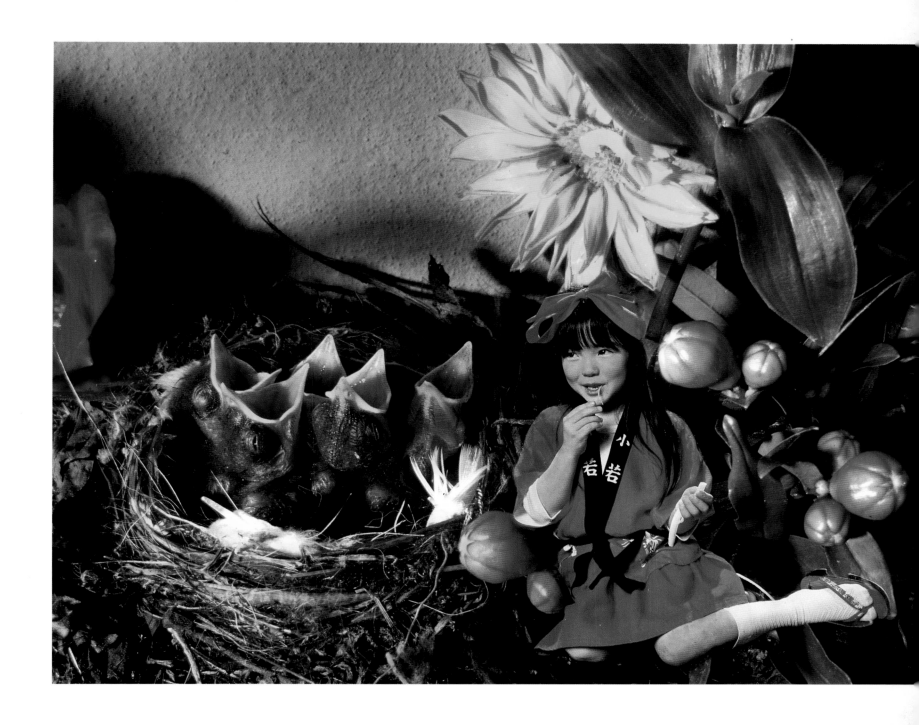

And a bird in the solitude singing,
Which speaks to my spirit of *thee*.

Lord Byron

Use what talents you possess:
the woods would be very silent
if no birds sang there
except those that sang best.

Henry Van Dyke

Games and Dreams

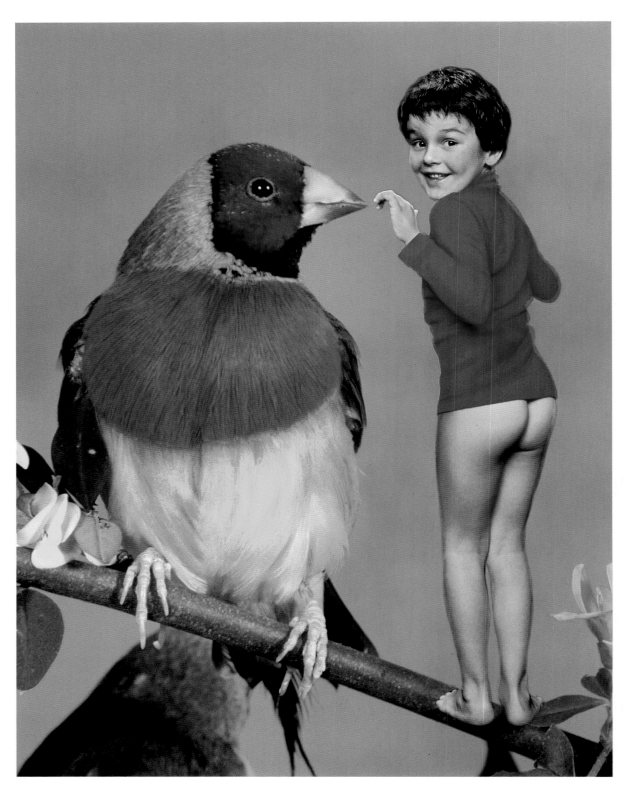

There's a Friend for little children
Above the bright sky,
A Friend Who never changes,
Whose Love will never die.

Albert Midlane

High heels were invented
by a woman who had been
kissed on the forehead.

Christopher Morley

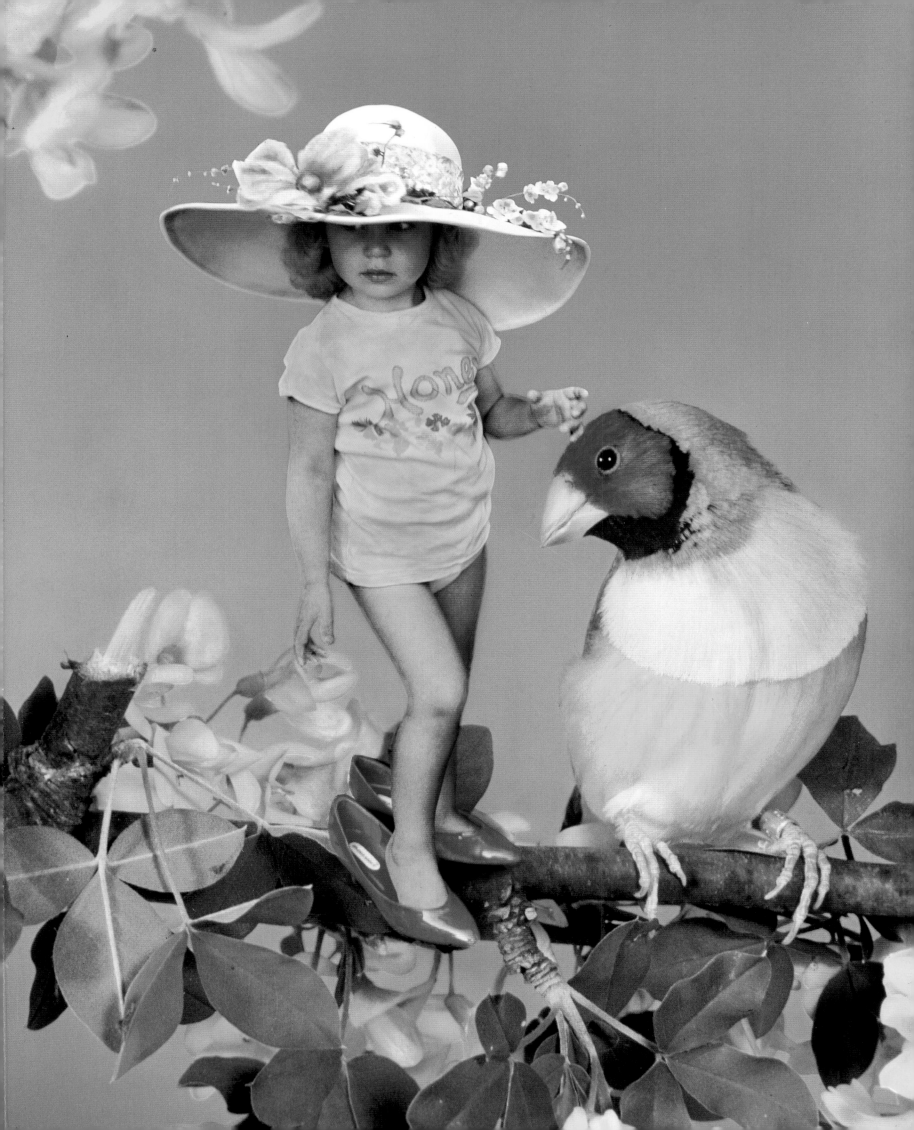

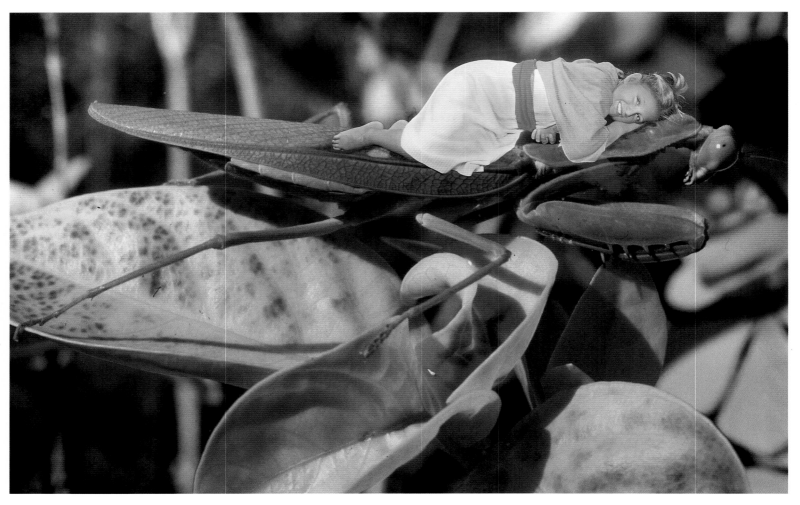

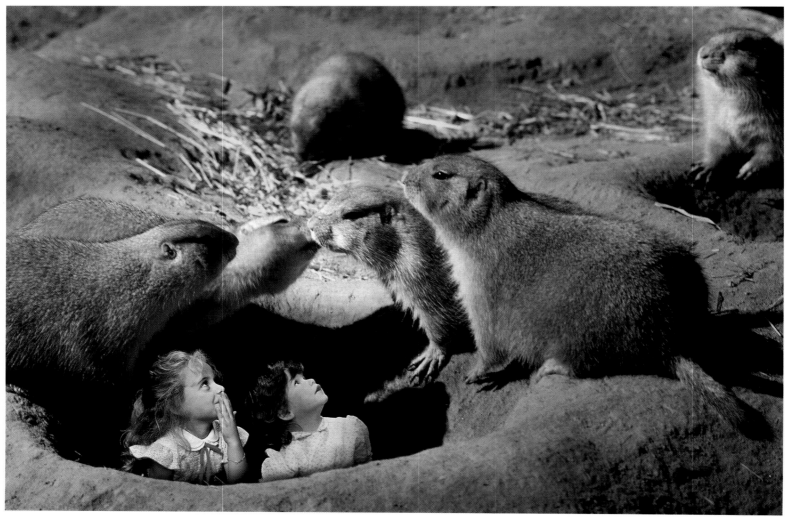

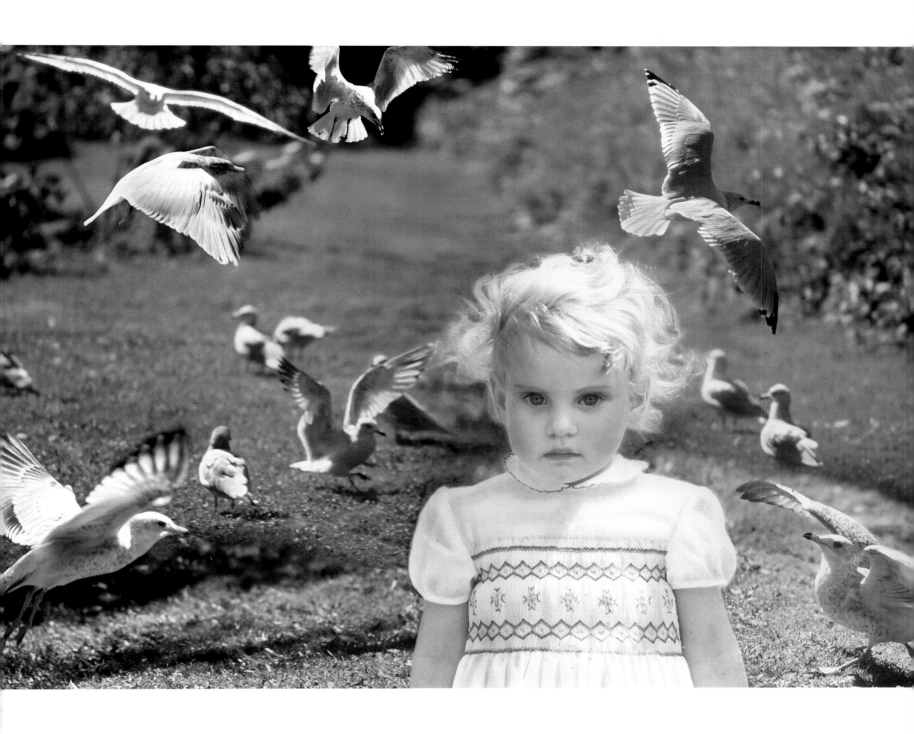

Serenity and freedom are the greatest blessings.
Ludwig van Beethoven

If you can give your son only one gift, let it be enthusiasm.
Bruce Barton

Spread love everywhere, and you will find joy.
Indian chant

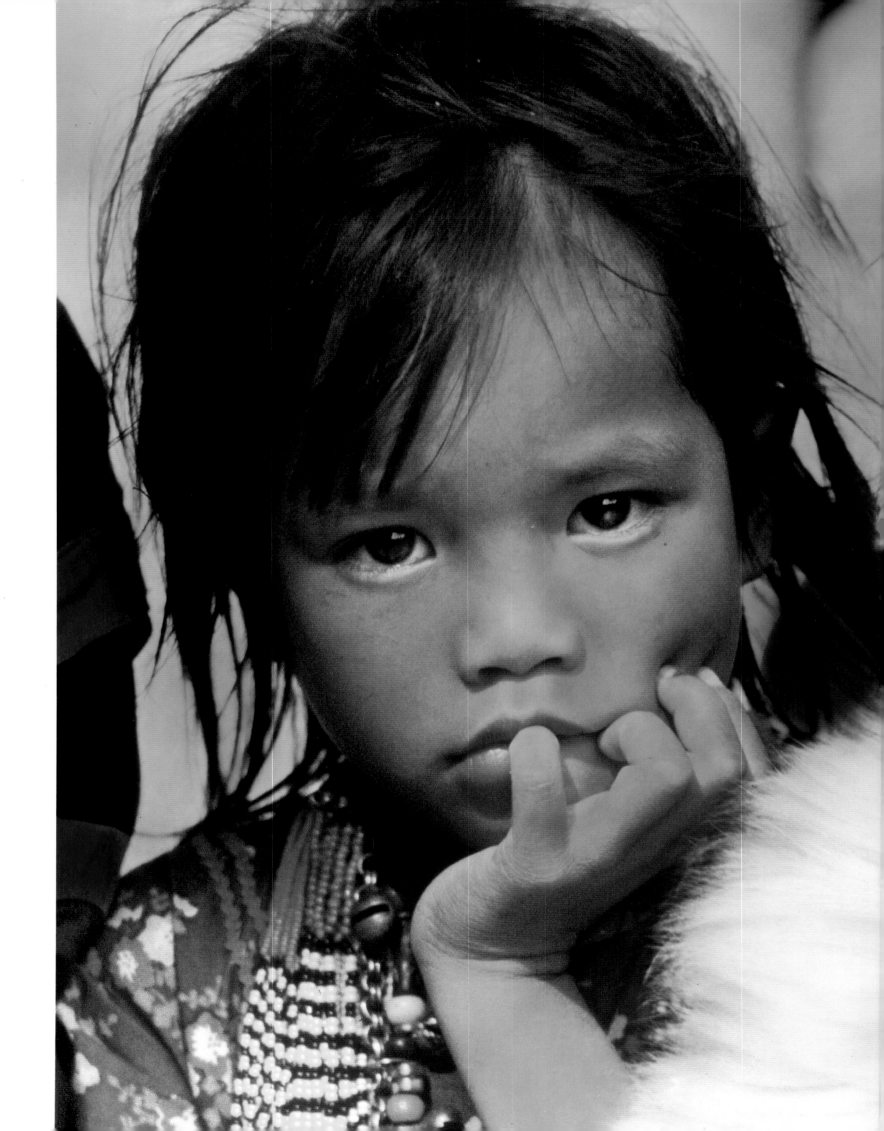

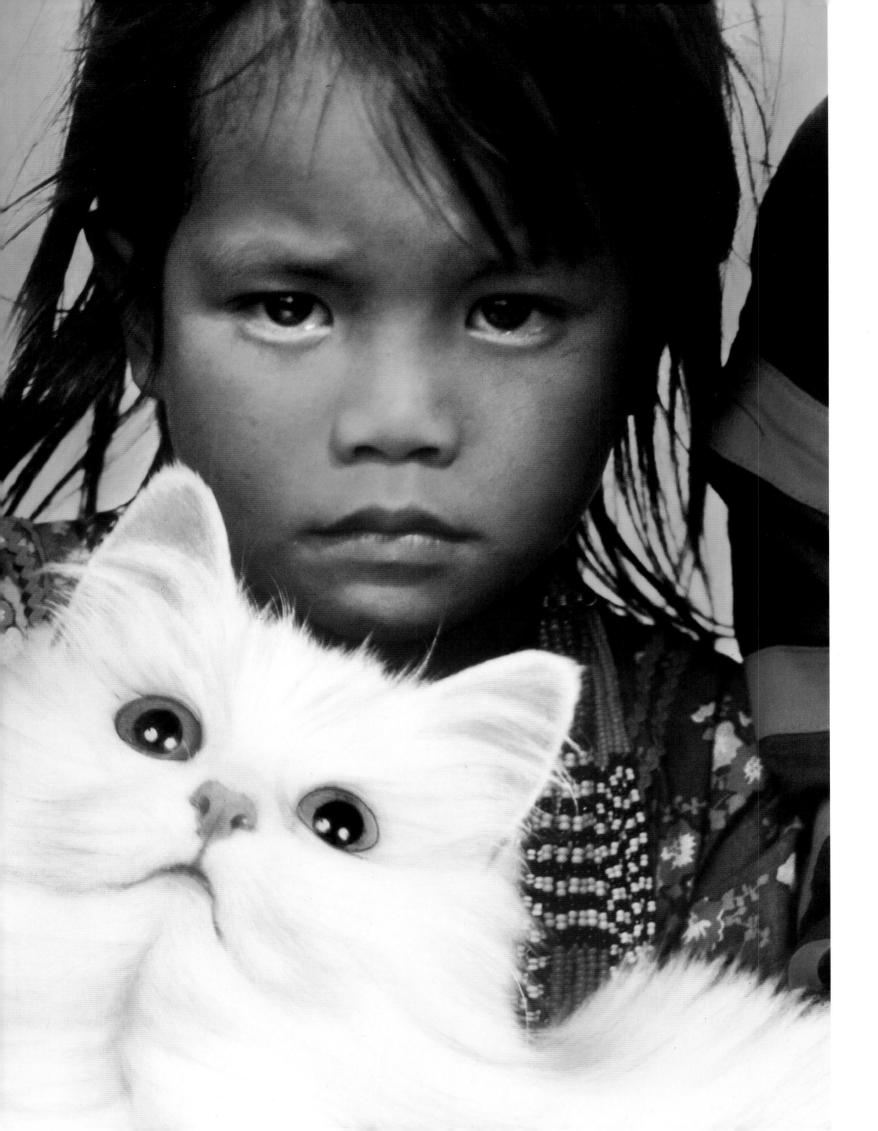

Children: Tears and Joy

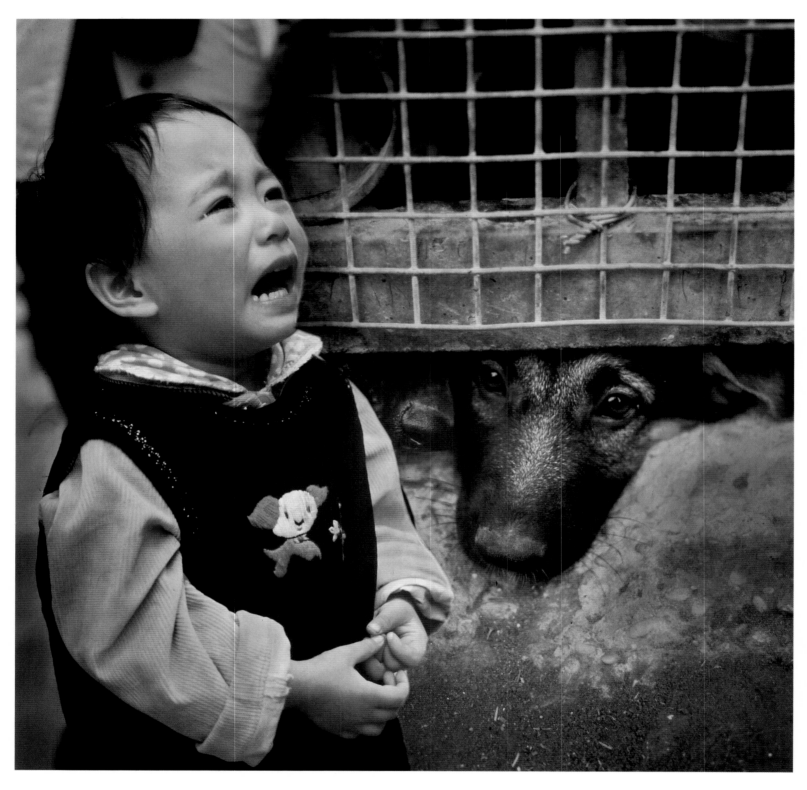

◁ Her eyes are homes of silent prayer.
Alfred Lord Tennyson

Tears are the words of the soul.
Filippo Pananti

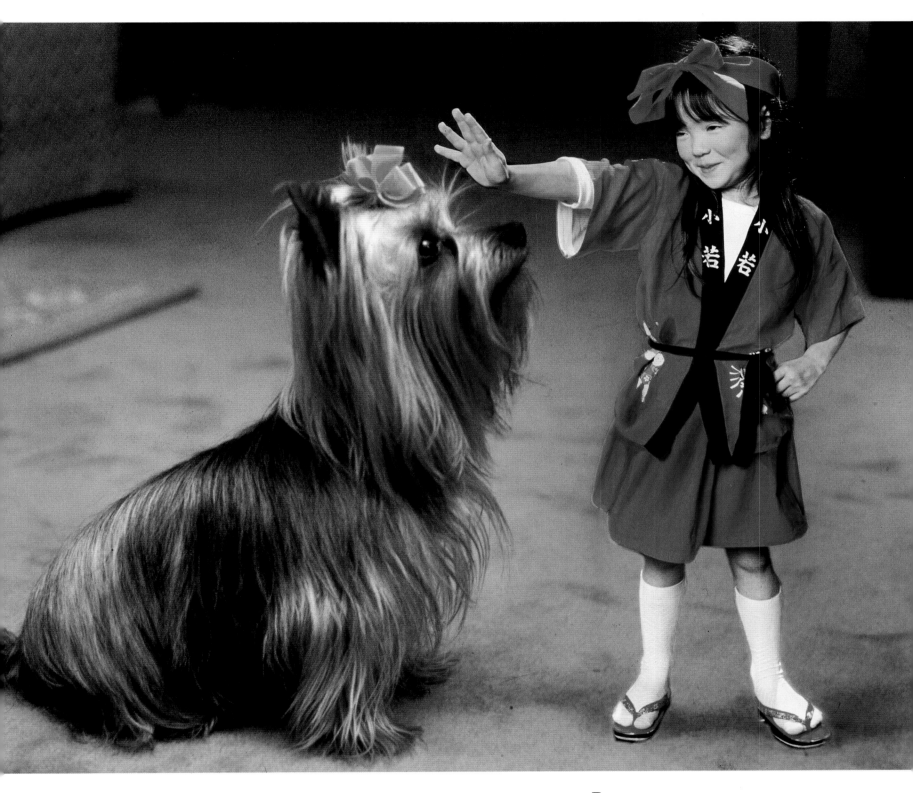

Joy shared, joy doubled;
sorrow shared, sorrow halved.

Proverb

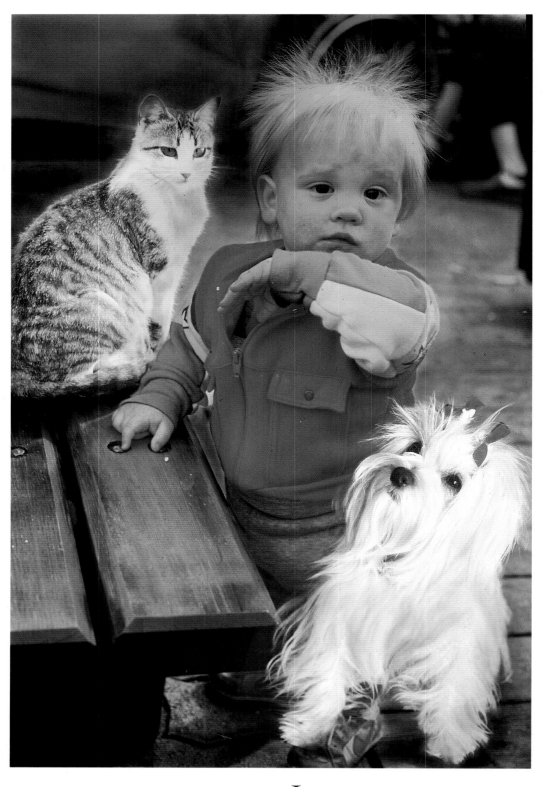

In order to maintain a well-balanced perspective, the person who has a dog to worship him should also have a cat to ignore him.

"Peterborough Examiner"

If you pick up a starving dog and make him prosperous, he will not bite you. That is the principal difference between a dog and a man.

Mark Twain

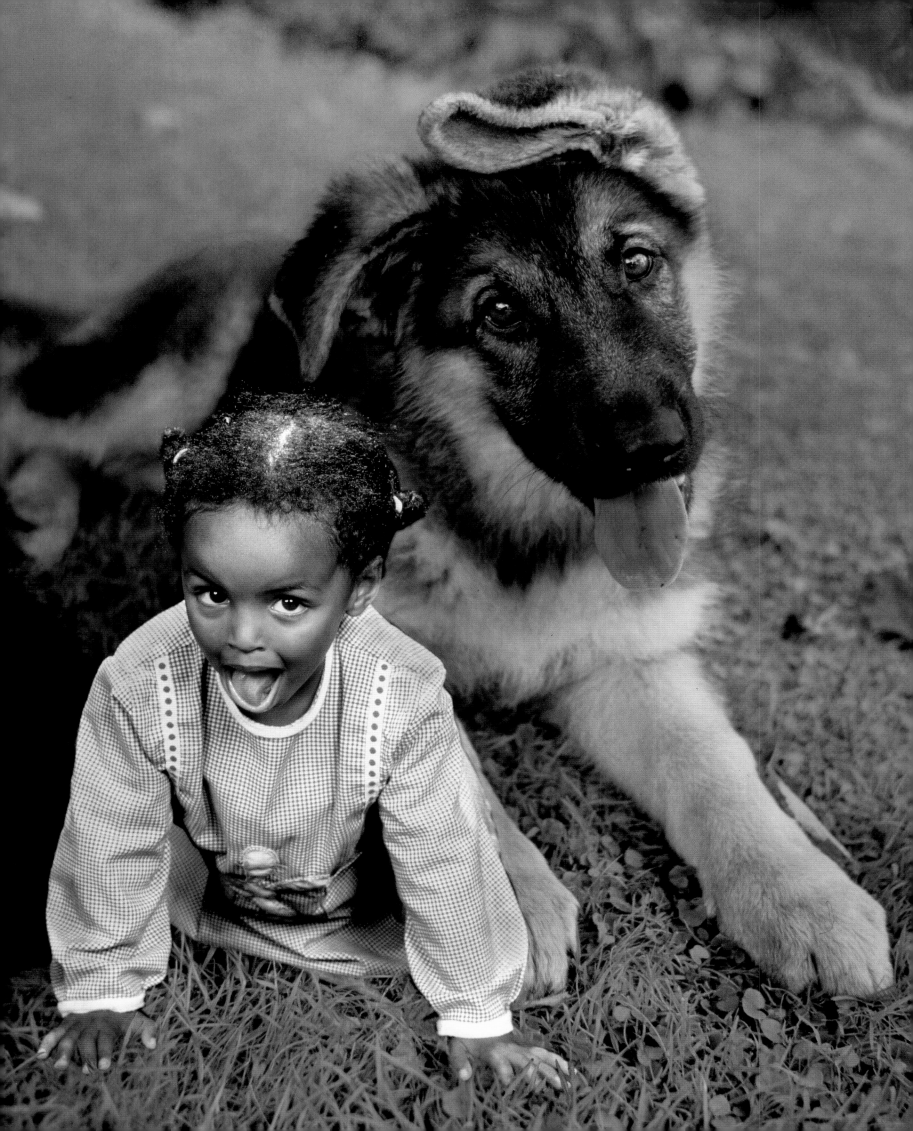

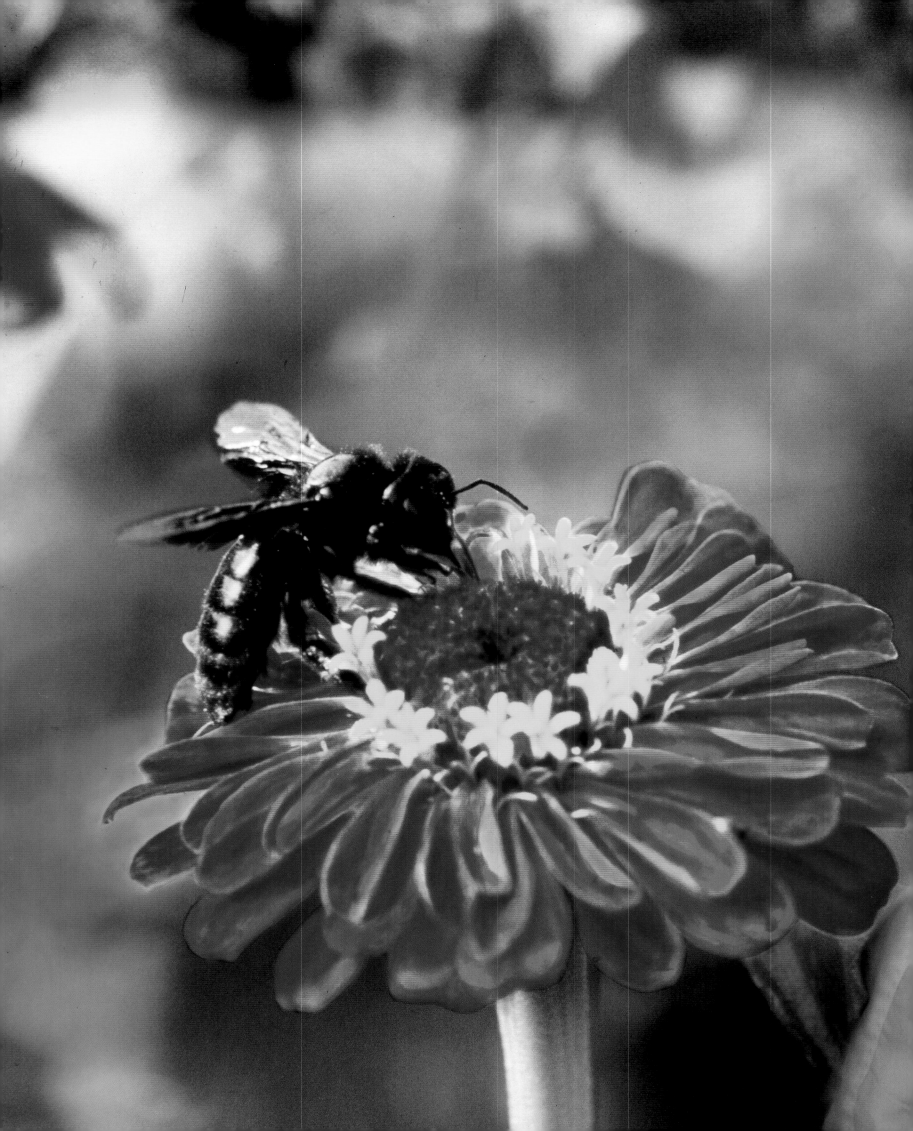

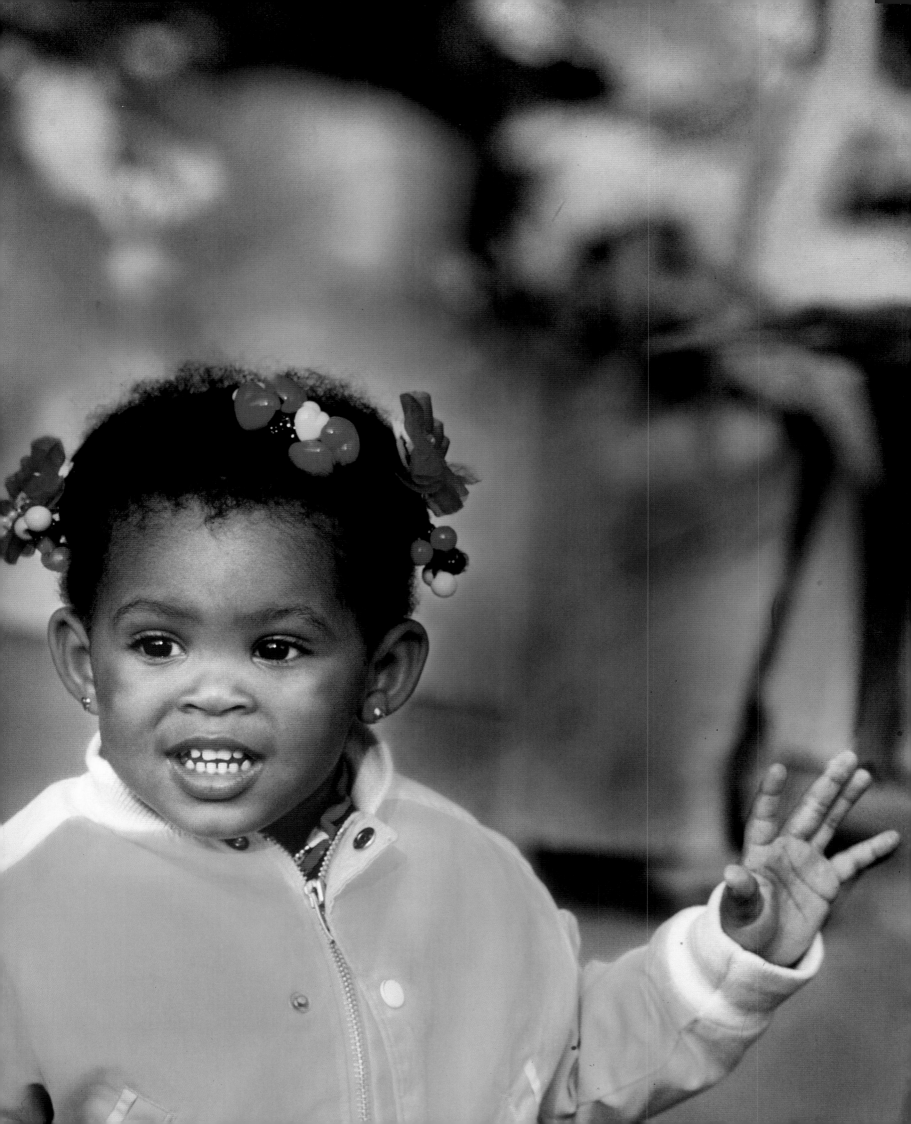

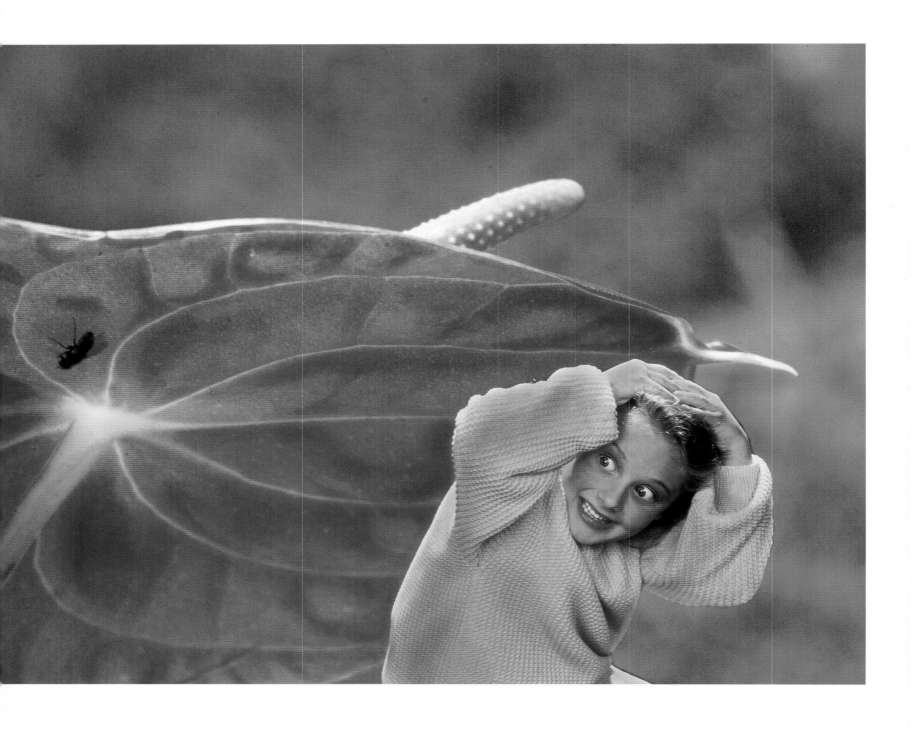

The only thing we have to fear is fear itself.
Franklin D. Roosevelt

◁ Unknown things scare more than known things.
Giacomo Leopardi

You cannot stop birds of sorrow from flying over your head, but you can prevent them from building nests in your hair.

Chinese proverb

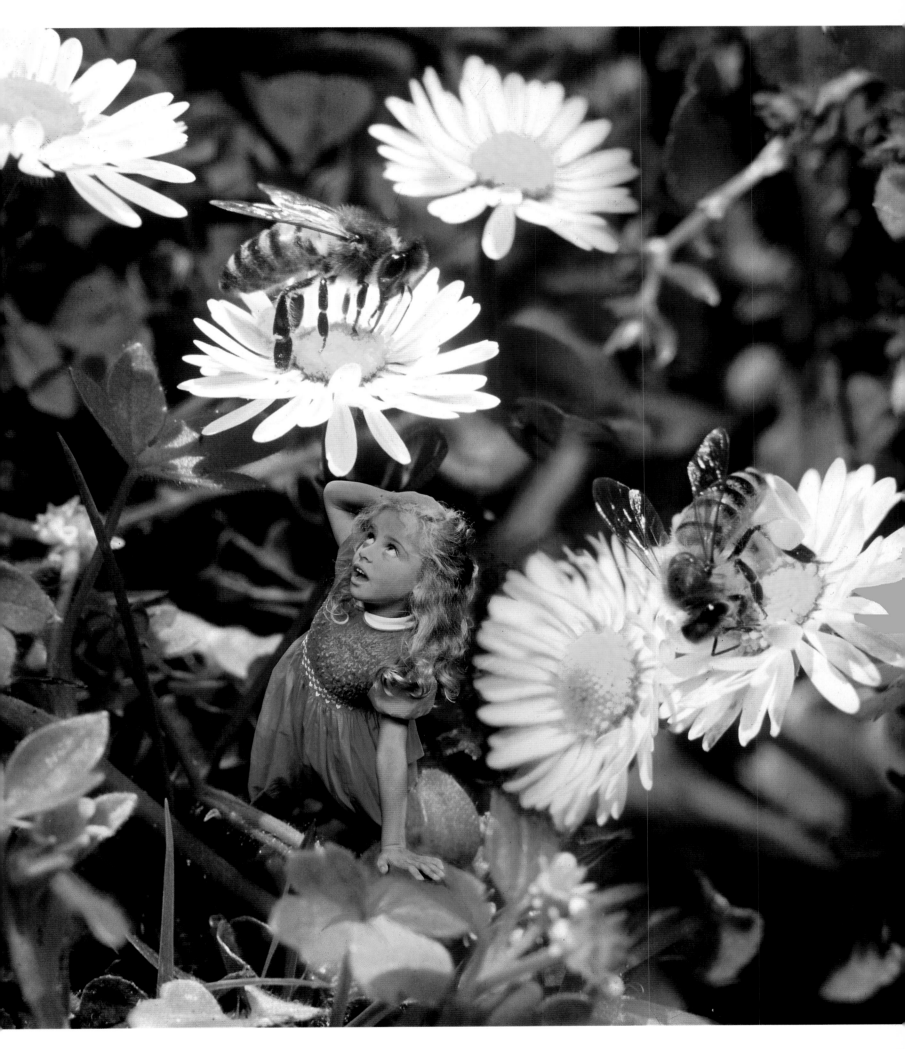

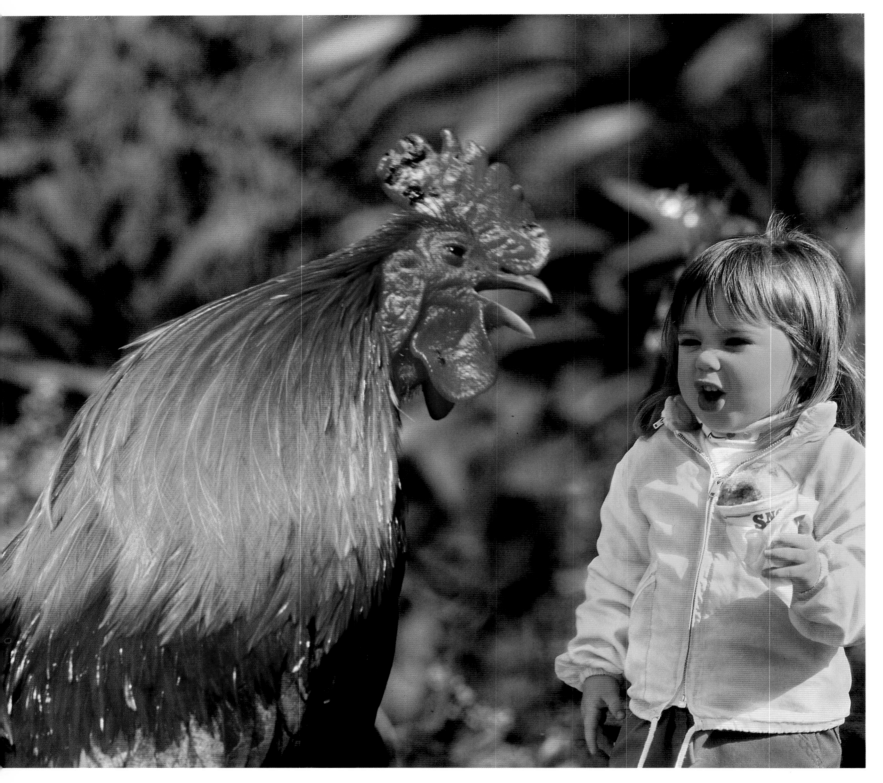

He was like a cock who thought the sun
had risen to hear him crow.

George Eliot

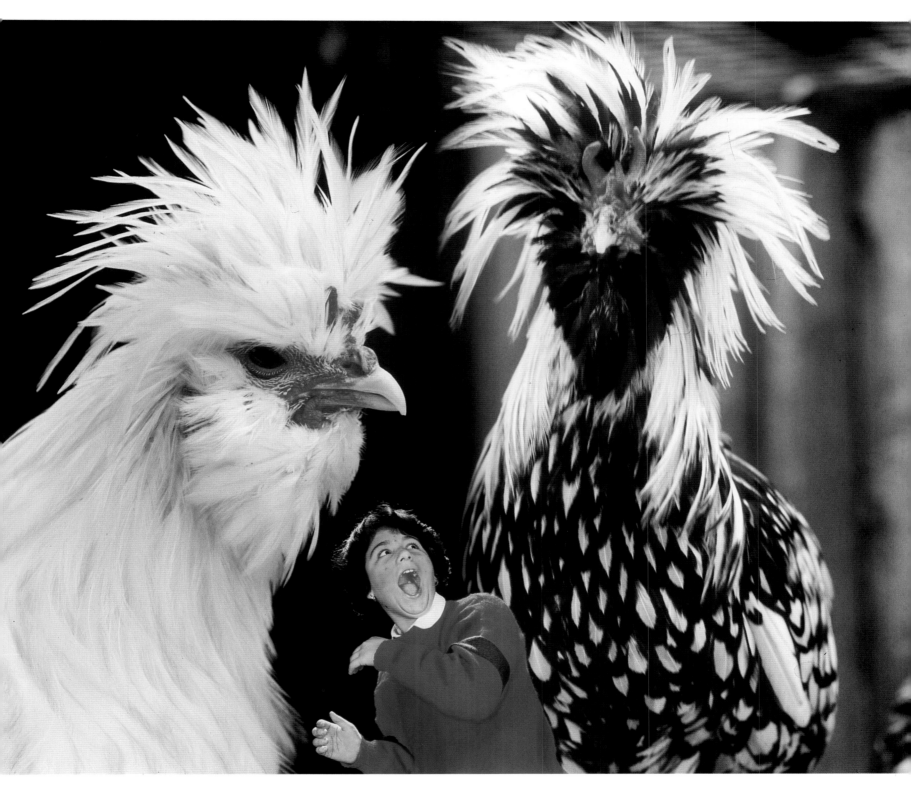

Wondrous the gods,
more wondrous are the men.
More wondrous, wondrous still,
the cock and the hen.

William Blake

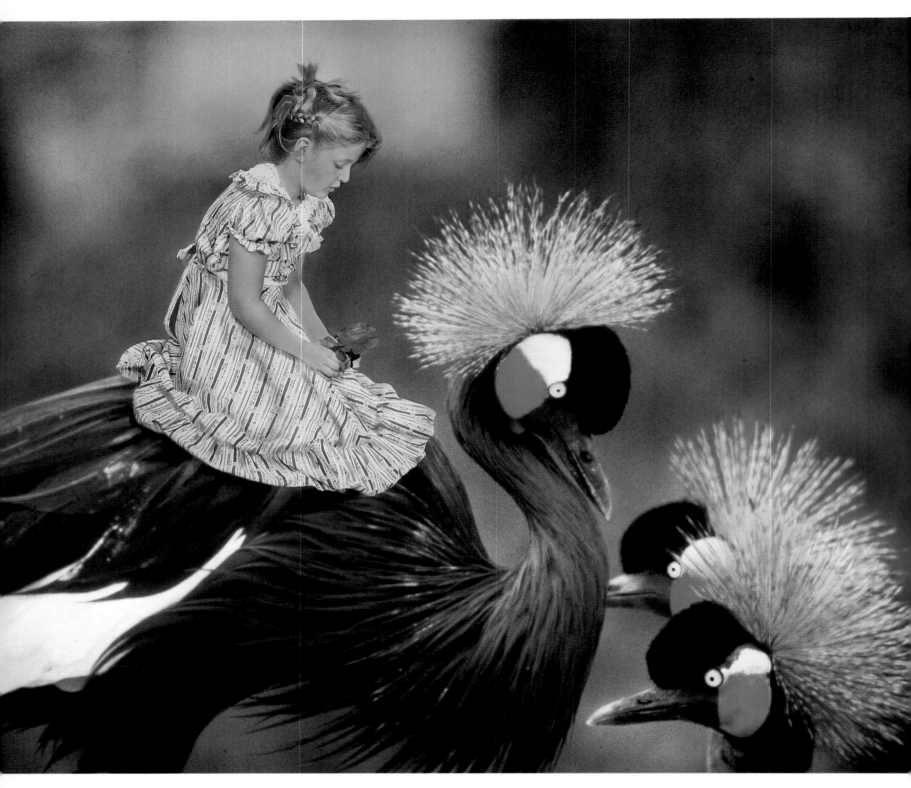

Kindness is the flower of humanity.
Lin Yutang

Happiness is a perfume you cannot pour on others without getting a few drops on yourself.
Ralph Waldo Emerson

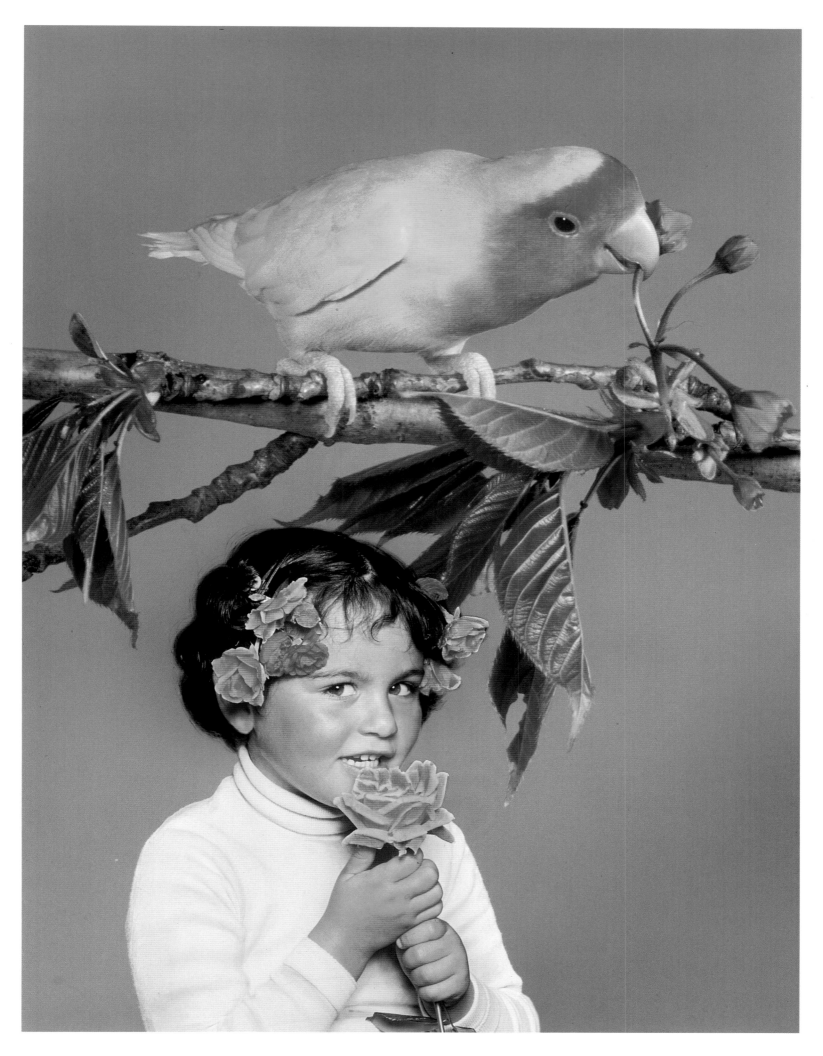

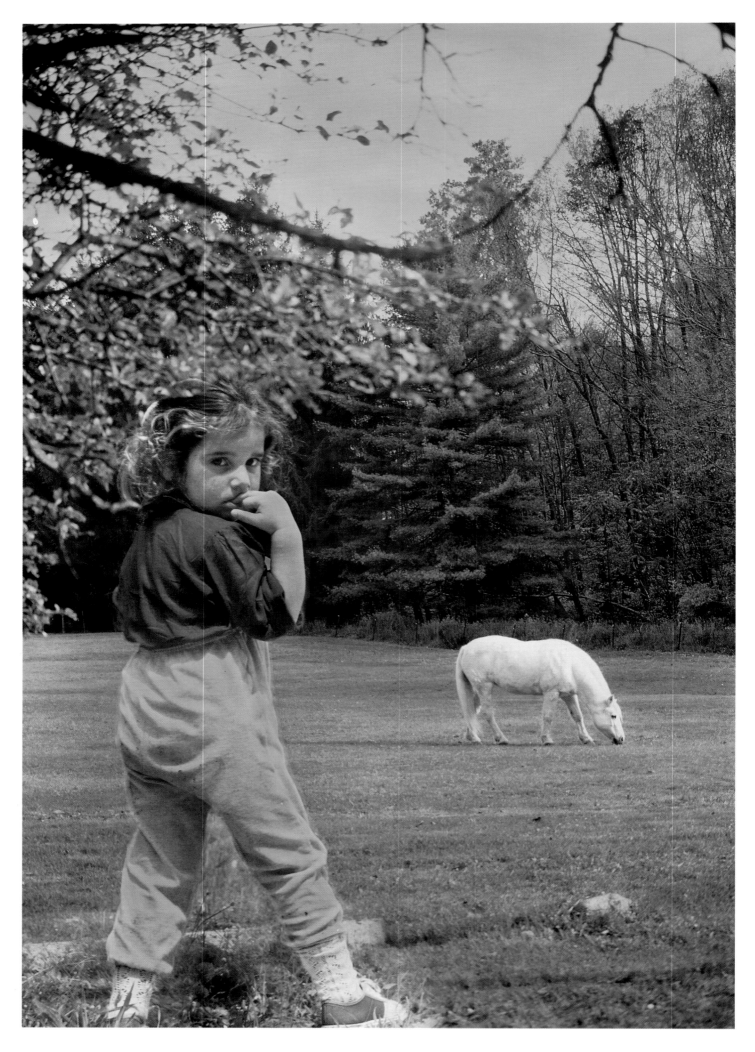

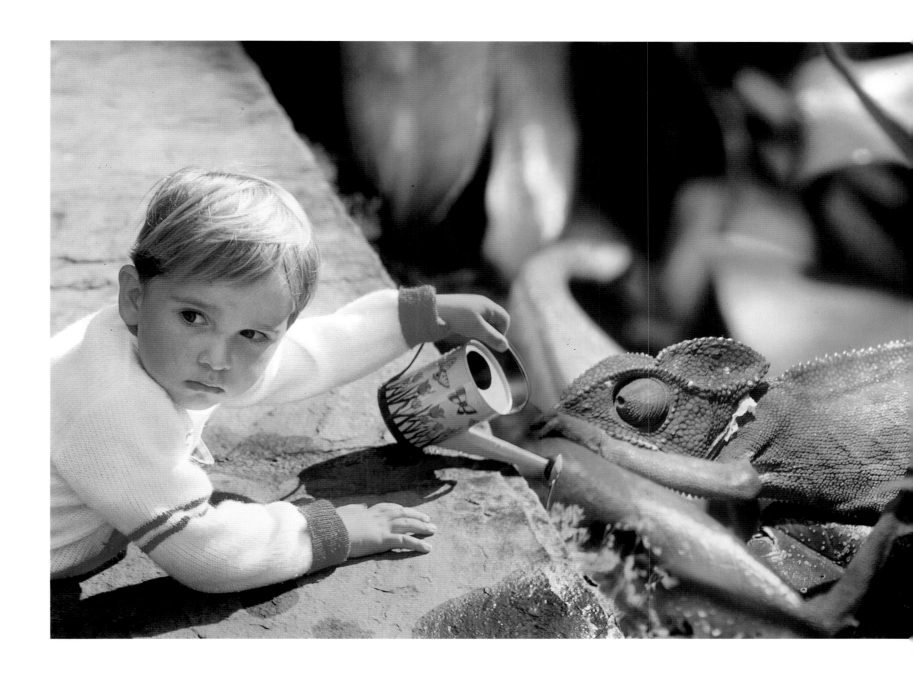

I love not man the less, but nature more.

Lord Byron

Work slips from lazy hands.

Filippo Pananti

A small boy is a pain in the neck when he is ▷
around, and a pain in the heart when he is not.

Anonymous

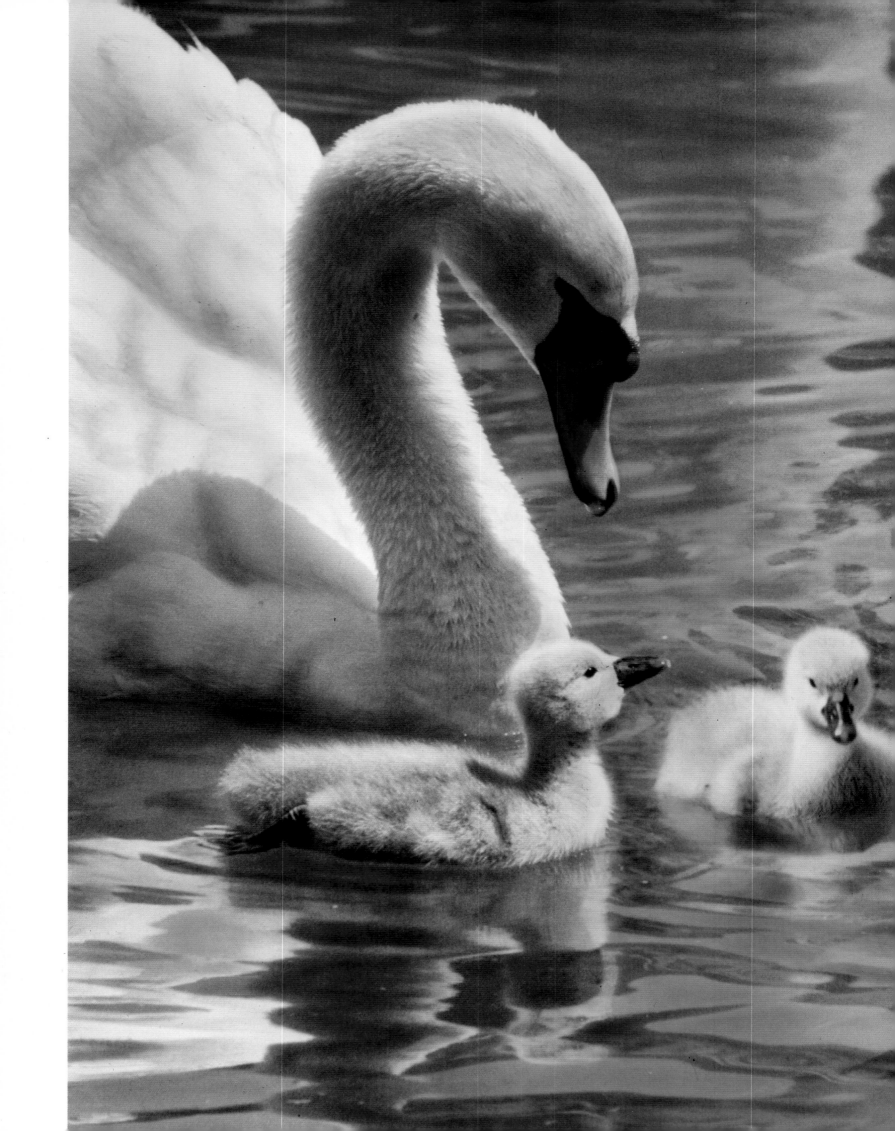

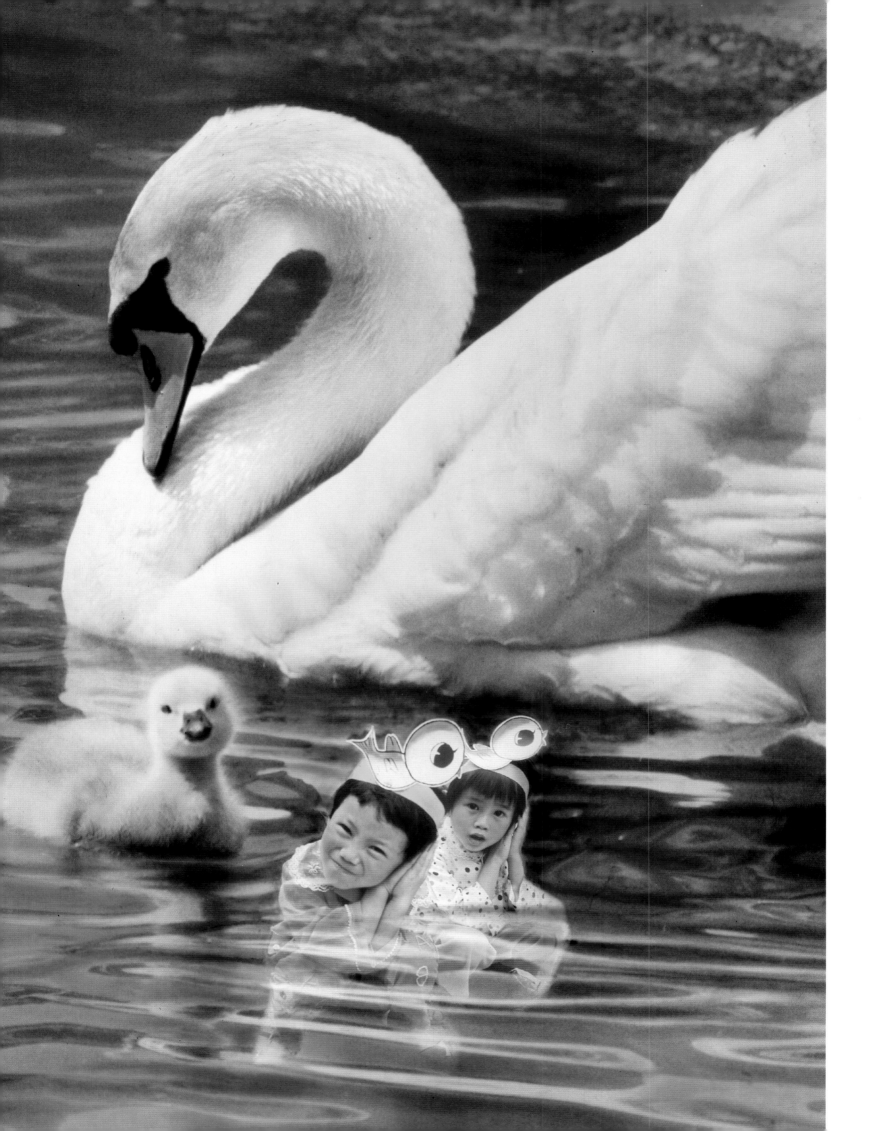

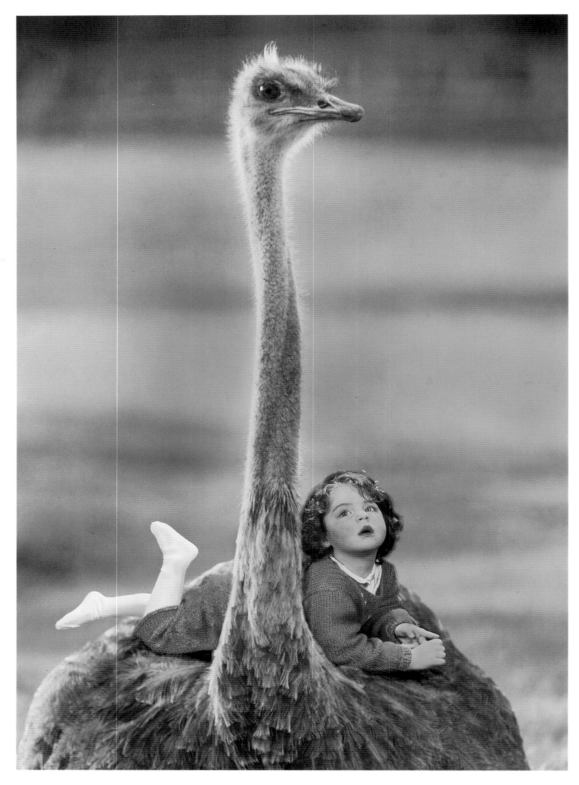

There is no excellent beauty that hath not some strangeness in the proportion.

Francis Bacon

Men are like leaves on the water; when they stop, they sink.

Lorenzo Pignotti

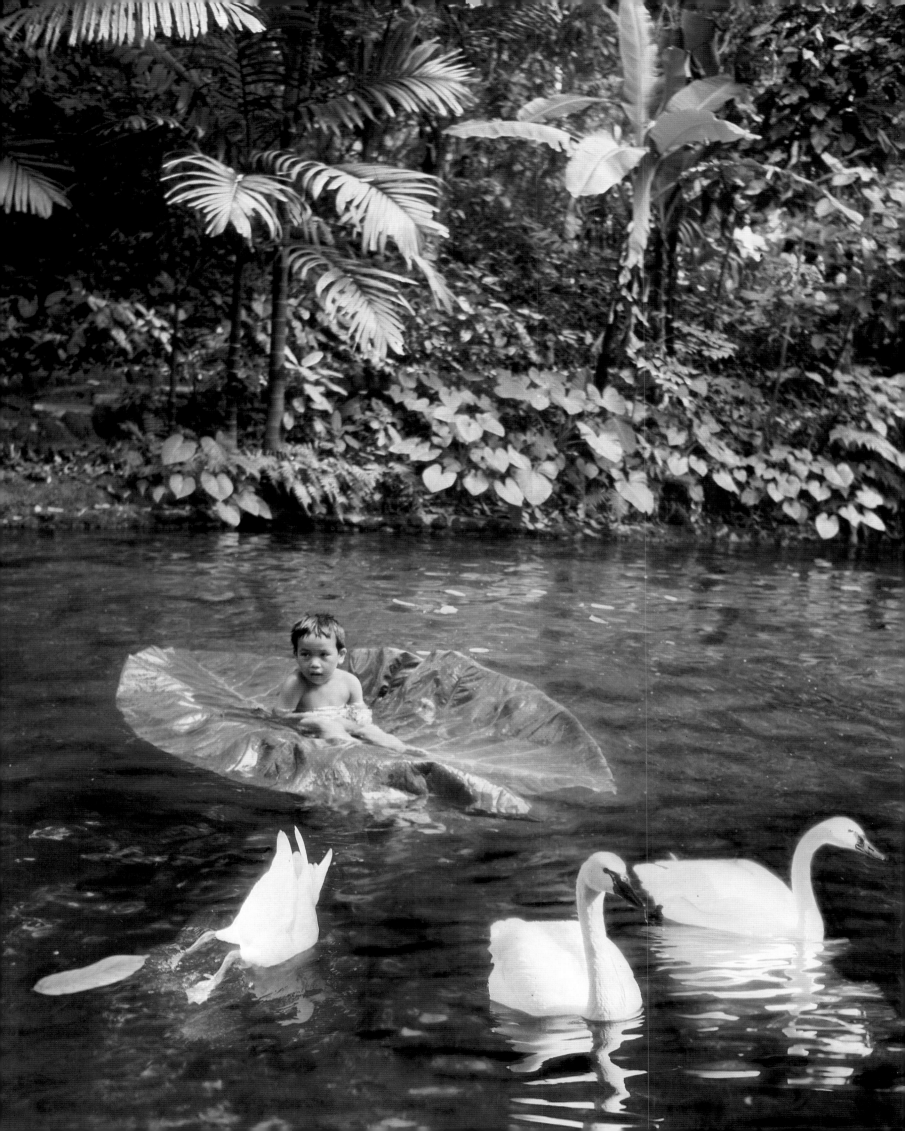

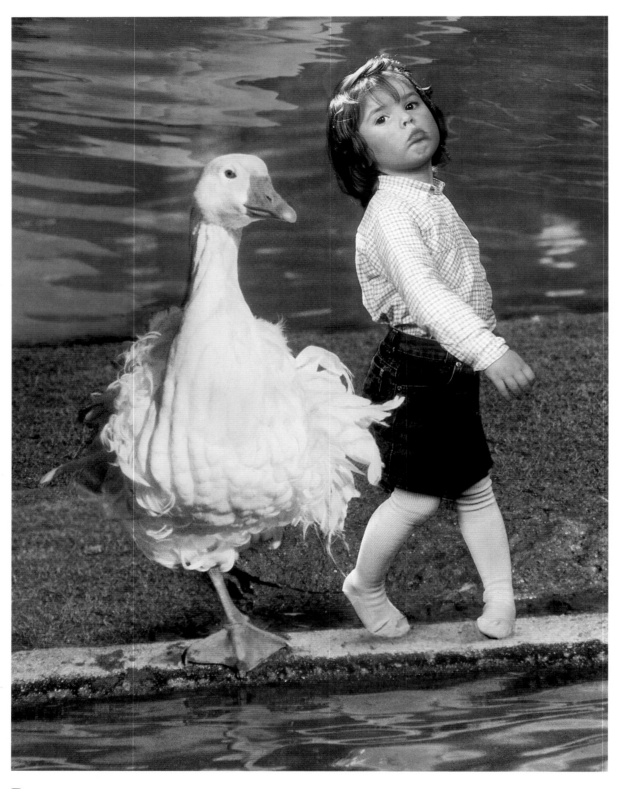

It doesn't matter what people think of me,
what matters is what I think about people.

Queen Victoria

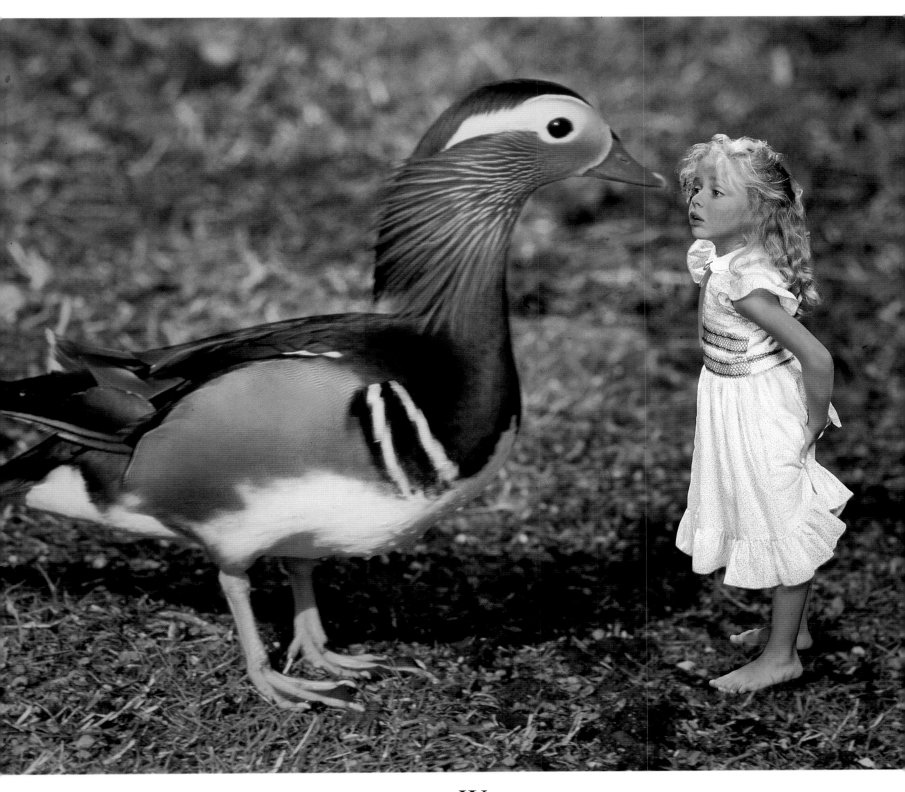

W omen are wiser than men
because they know less and understand more.

James Stephens

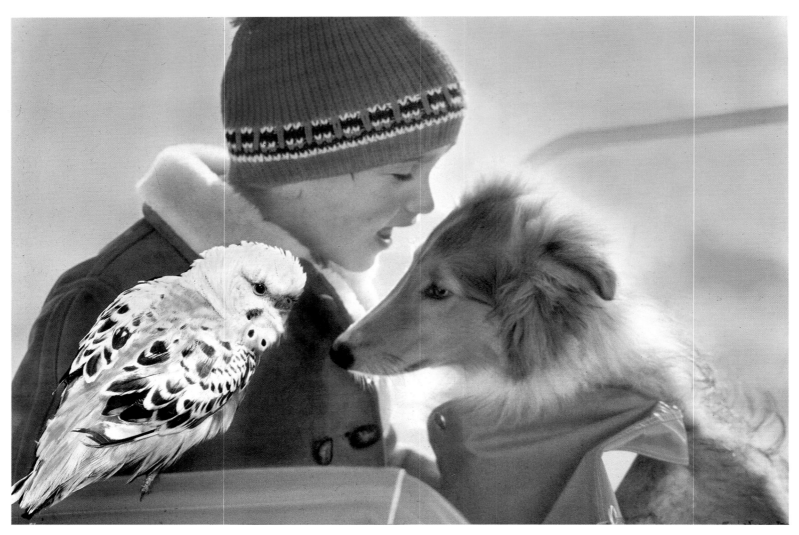
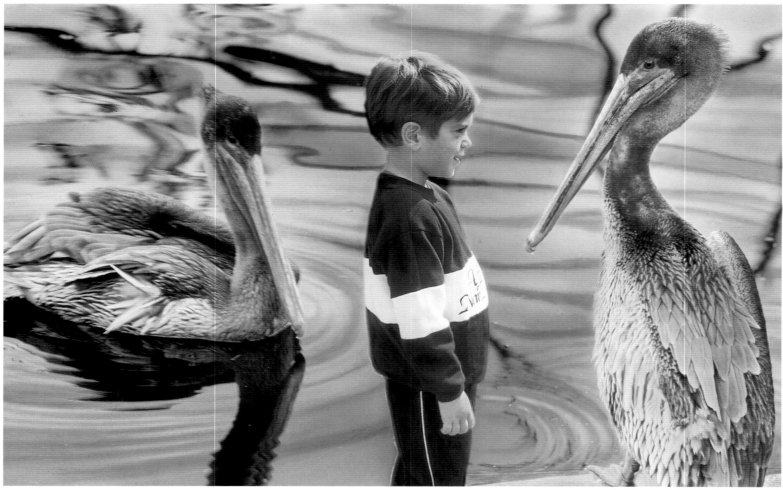

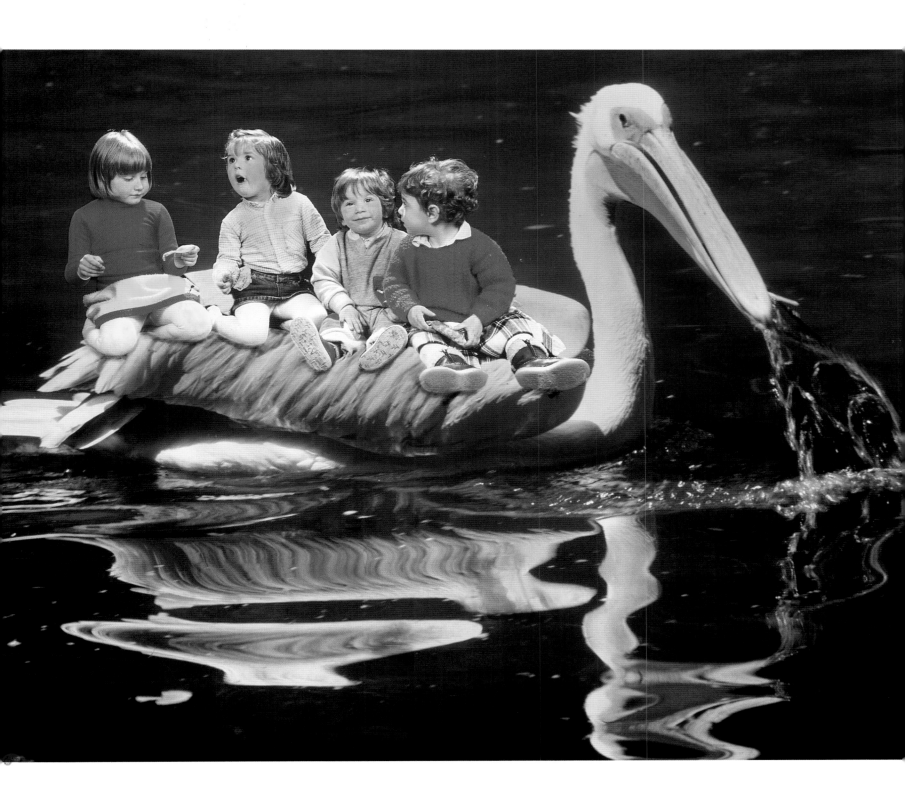

To have a brilliant conversation at the party,
it is not necessary to say very interesting things;
it is enough to know many useless things.

Jules Renard

To be good in conversation, learn how to listen
to people.

Christopher Morley

Conversation is like a boat —if everybody
crowds on the same side, it sinks.
It needs balance to keep afloat.

Marjorie S. Pither

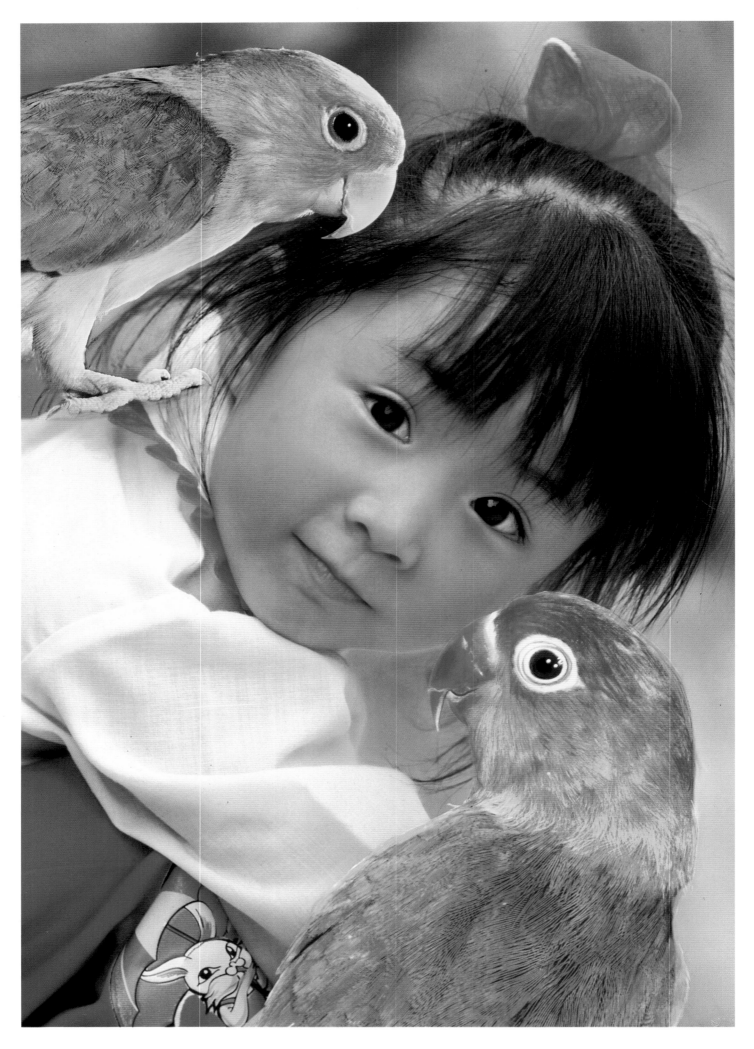

Between Dream and Reality

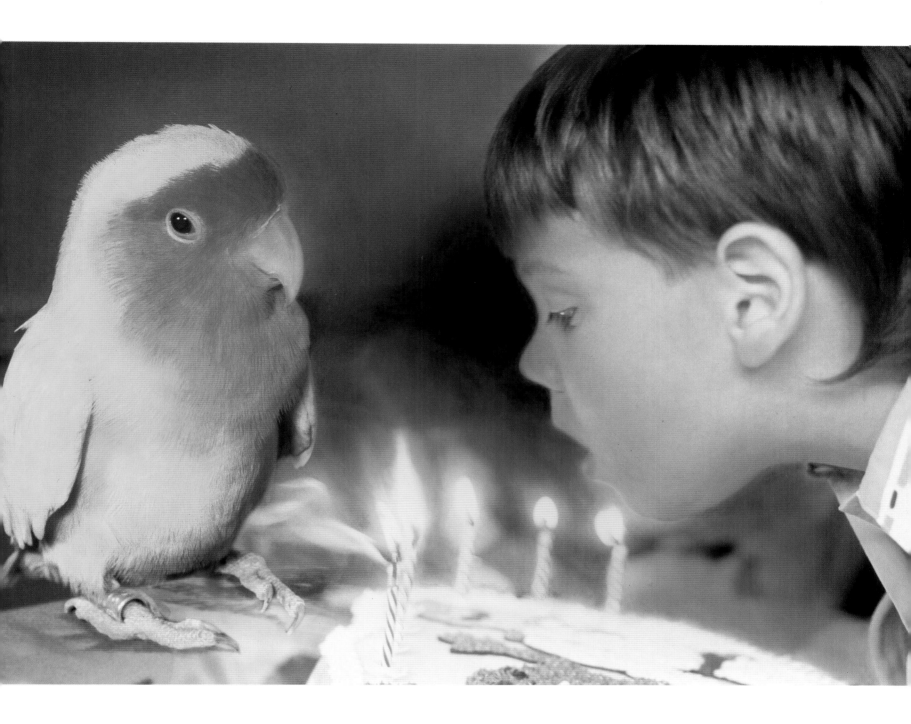

I think all this talk about age is foolish. Every time I'm one year older, everyone else is too.

Gloria Swanson

As the light of a small candle reaches far away, so a good deed shines in an evil world.

Lev Nikolaevich Tolstoy

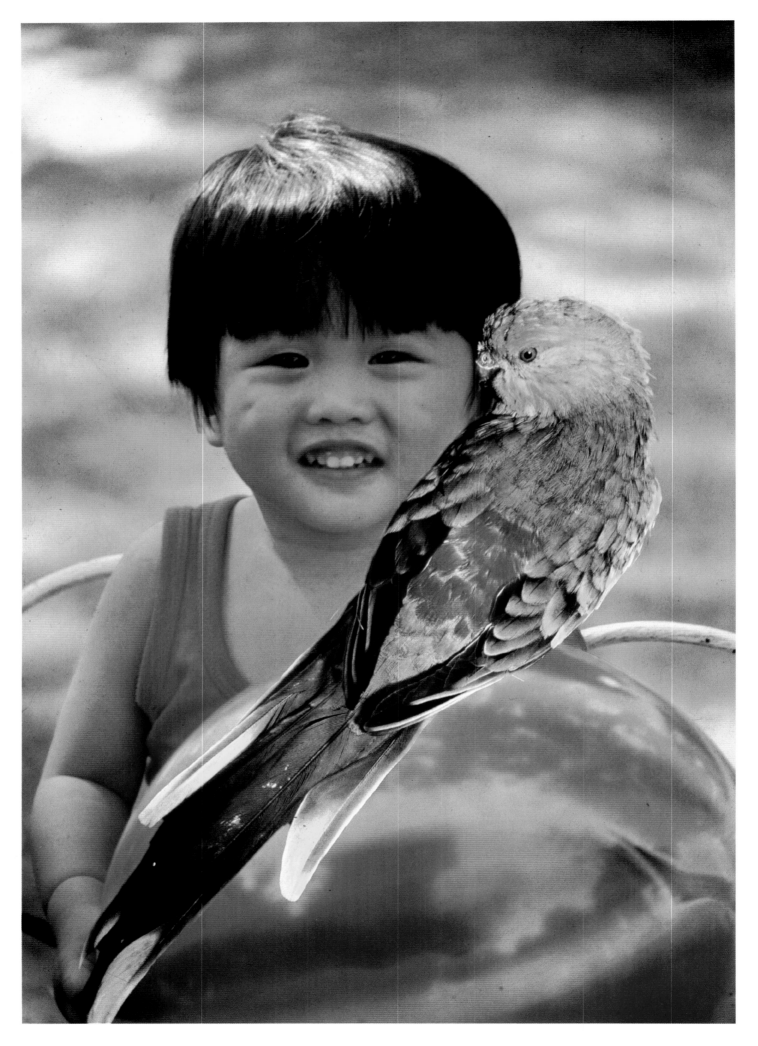

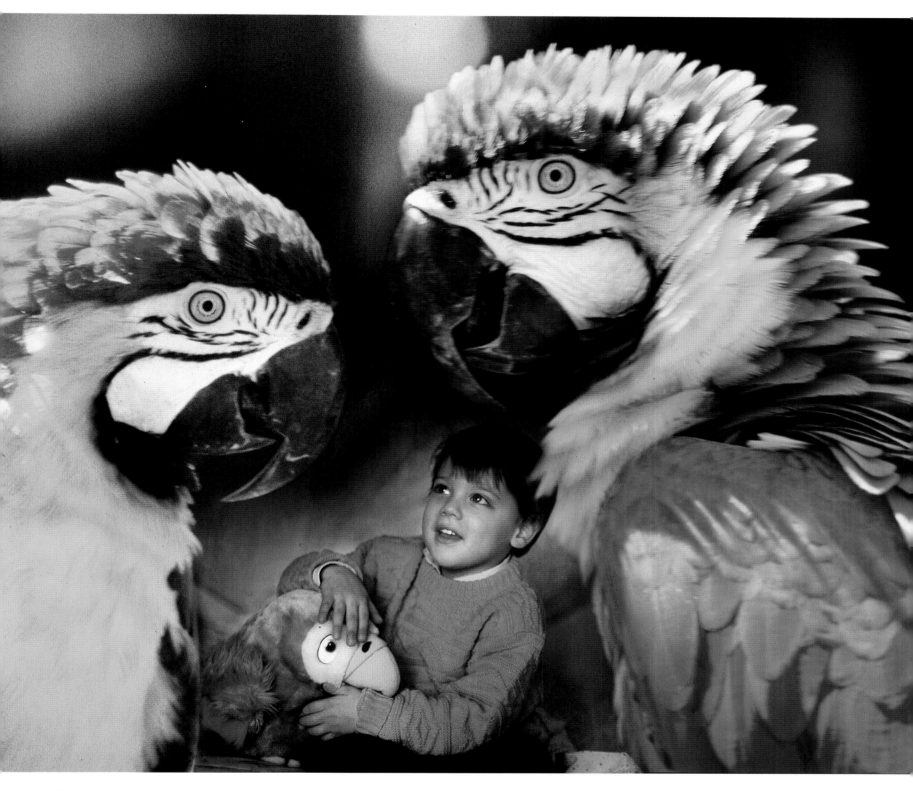

Sweet bird! Thy bow'r is ever green,
Thy sky is ever clear,
Thou hast no sorrow in thy song,
No winter in thy year!

John Logan

Often silence speaks, but you must not make it too noisy.

Charles de Gaulle

Anything one man can imagine, ▷ other men can make real.

Jules Verne

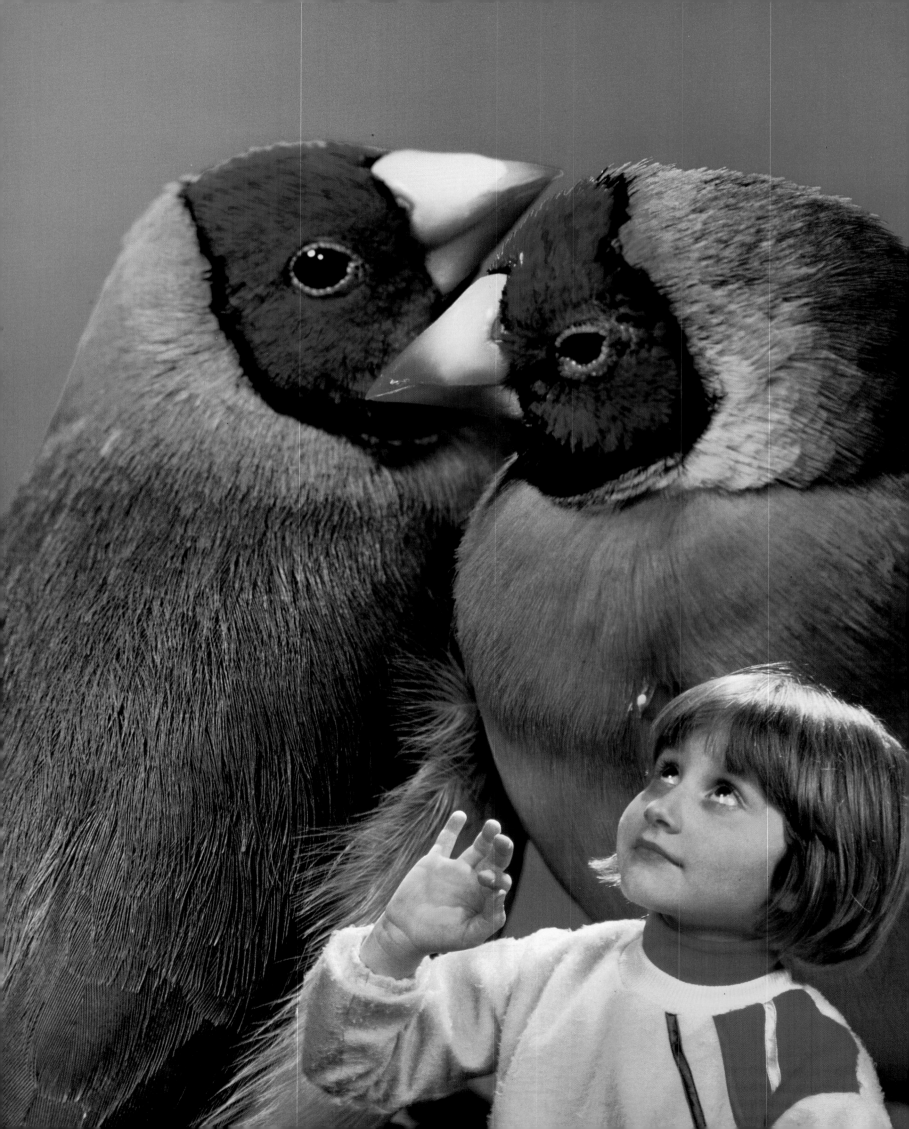

A CHILD LIVES IN EVERY RESEARCHER

"The child is father of the man"

CARLO RUBBIA

Modern society has placed great faith in scientific research. Around the world thousands of scientists are working to try to achieve a clear understanding of the conditions we live in and the universe that surrounds us. This is an enormous investment in one of the most profound human instincts: curiosity. Although we call ourselves *homo sapiens*, it was not wisdom that brought man down from his tree or indeed put man's footprint on the surface of the moon — it was curiosity. Wisdom is certainly necessary for the balance of our civilization, but it is not the quality that drives us forward. Progress is made not by wisdom but by curiosity.

How many times has each of us given a toy to a child as a present and then been disappointed or even angry to find that minutes later the toy has been broken? Frequently the child's curiosity is stimulated to the point that he or she does not hesitate to break the toy to find out how it works. Knowing what lies inside the toy is more important than playing with it. This is curiosity in its purest form. The risk of losing something is taken in the desire to answer a question posed by one of our most basic human drives. Fascination and the need to understand are seen most clearly in children, and these same instincts motivate scientific advance.

Biographies of famous scientists mention time and again childhood experiences that revealed their innate curiosity. Einstein told a magnificent story of his father showing him a pocket compass when he was ill in bed at the age of five. Lying in the darkened room the child was fascinated by the fact the iron needle always pointed in the same direction, whichever way the case was turned. He realized that for this to happen, the needle must be acted upon by something that existed in space; yet space had always been considered empty. How could this work? More recently the Italian physicist Bruno Rossi talks of his wonder when as a small boy he crossed the lagoon in Venice on an exceptionally clear day and could see the Alps rising behind the city, so close that they could almost be touched. He remembered his need to understand this phenomenon for the rest of his life. I myself can remember clearly the excitement of tinkering with pieces of old radios as a young boy in the attempt to understand how radios worked and perhaps could even be improved.

A child's fascination and eagerness to understand must, to my mind, remain lodged in every successful adult scientist. The well-known American writer James Gleick put this eloquently: "If I do this, what will happen? is both the motto of a child at play and the defining refrain of the physical scientist. Every child is an observer, analyst, and taxonomist, building a mental life through a sequence of intellectual revolutions, constructing theories and promptly shedding them when they no longer fit. The unfamiliar and the strange — these are the domain of all children and scientists."

There is of course more to scientific research than curiosity alone. Francis Bacon in the seventeenth century stressed pragmatically that the function of science was to improve the conditions of human life. According to Bacon the object was to establish "dominion over natural things" so one could act "to relieve and benefit the condition of men." In our own era science has dramatically altered our way of life both positively and negatively. Satellites beam information from one side of the world to the other; many diseases that killed thousands have been eradicated; people now travel faster and more frequently than ever before, all thanks to scientific research. However, science does not always produce benevolent results. Our new technologies have given birth to the monster of worldwide pollution, and prewar physics research led directly to the risks of thermonuclear war. Man must now prove his wisdom by finding methods to control these threats. However, to define the role of science simply as the creation of new technologies is to underestimate greatly the thrill of discovery. Scientists rarely set out to discover new technologies; their aims are normally more romantic, more childish: to understand something which no one has ever understood before. New technologies are frequently spin-offs from the central fundamental research.

Who are the great explorers of our age? Five hundred years ago Columbus could set off with three small ships and by sailing due westward for long enough encounter a whole "new world." Even at the beginning of our century expeditions could be launched to parts of the globe that were unknown to western civilization. Today, however, virtually every square mile of our planet is known to us, and the process of finding something entirely new has become much more complex. It is the scientists who have become the explorers and adventurers of our time. The privilege of working at the extreme edge of human understanding and the thrill of discovery has now passed on to research scientists. The computer terminal has now replaced the covered wagon, but the motivation remains precisely the same. Curiosity and the need to understand, which has its most spontaneous expression in the behaviour of the young, are what drive humanity forward. This childlike instinct is rooted in the core of all great researchers.

PERHAPS IF WE COULD BECOME CHILDREN AGAIN...

In Search of the (Lost) Innocence of Nature

FULCO PRATESI

"And the cow and the bear shall feed; their young ones shall lie down together." This biblical image (Isaiah 11, 7) might seem nothing more than a utopia. Not to me, however, since I have personally witnessed such a scene. It happened many years ago when I was on a high mountain in the Abruzzo National Park. About a thousand feet below me, there was a small valley where cows were grazing. Suddenly two brown bears came out of a wood of beech trees that was located a little farther down the mountain. Without hesitating, they crossed the sloping meadow on their way toward several large cherry bushes and began to strip them. The cows, who were at a distance of only a few yards from the two massive dark intruders, continued to graze. And, for a period of at least half an hour, the bears and the cows serenely shared the same living space — unaware of their role as precursors of the blissful state that has been promised to mankind.

All my life I have had a profound sense of admiration for the total and boundless perfection of nature. I consider the ecological relationship that exists between plants and animals, the sun and the rain, the earth and the wind such a stupendous mechanism that, in the billions of years that separate us from the "birth" of our Earth, it can only have been arranged by a supreme Being who must be directing the complicated and efficient process of evolution and natural selection. Treasures like the eye of the dragonfly or the corolla of a wild orchid, the brain of a mosquito or the feather of a peacock cannot be the products of a set of random events, even if they occurred over a period of infinite time.

While the perfection of nature astounds us, despite all that man does to alter it, its innocence moves us. As the dictionary explains, "innocent is one who does not know evil, due to not having experienced it, and is without malice." And what greater innocence than that which nature holds up to us? Innocent, without guilt or maliciousness, is the lioness who kills a zebra in order to feed her young ones (as recited in psalm 104, 21: "The young lions roar after their prey, and seek their meat from God"); innocent is the wave that undermines the rock at its base and causes it to crash into the sea; innocent is the volcano that buries forests and habitats under lava flows. All that happens in the infinite universe of nature is in and of itself innocent and pure.

Innocence disappears when man, no longer custodian and curator but tyrant and wastrel, enters into these admirable mechanisms with all the force of his technology and his egoistic greed.

Let us look through our mental microscope at a portion of this primeval nature, intact and perfectly finished, as it is presented to us in the first Book of Genesis. Here its components, soil and air, water and sun, plants and animals, exist in that balanced and constant interrelationship that botanists call the "state of climax." This condition can be found today in the dense and intact tropical forest that circles the planet along the equator or in the immense Siberian taiga around the Arctic Circle. Here we find a vast green mantle, precious and obscure, where insects and birds, men and trees, mammals and mushrooms, fish and rivers exist in perfect harmony such as Adam and Eve must have known in the garden called Eden. In short, the realm of perfect innocence.

But suddenly, as if through a minuscule wound, the intense green fleece of the virgin forest is cut by a thin, straight, reddish mark — civilized man has arrived. And now the infection begins to spread. The first instances of deforestation send spirals of smoke up into the sky and pave the way for new outrage. Oil wells, open-air mines, fields yielding scant harvests, and pastures set aside for paltry herds replace the perfect equilibrium that existed in the olden days. The cities advance, devouring pristine nature, corrupting the inhabitants that are native to them, burying a magical and composite fabric under the squalor of our suburbs — a squalor that is not just physical.

Like the horrendous deity Moloch who required appalling sacrifices, consumerism, the worst scourge of our so-called civilization, devours and corrupts the green innocence of old. Although it occurred in a different context, the ancient Israelites had already been rebuked for this sin when the Lord spoke through the words of the prophet Jeremiah, "And I brought you into a plentiful country, to eat the fruit thereof and the goodness thereof; but when ye entered, ye defiled my land, and made mine heritage an abomination" (Jeremiah 2, 7).

Today, the degradation continues. The superb biological diversity that has produced, as the result of millions of years of natural selection, an infinite number of animal and plant species (many of which have not yet been discovered by science) is ceasing; our wildlife is disappearing at the rate of four thousand to six thousand species per year. And these are flowers and butterflies, birds and ferns, mammals and fish, which no one will ever be able to create. If the Roman Colosseum or another ancient ruin should happen to collapse, it would be possible to reconstruct it, if worse comes to worse, thanks to existing drawings and our technical knowledge. But the day when the Indian rhinoceros, a remnant population of pachyderms with

fewer than a thousand individuals, should disappear, not even the most advanced technology would be able to give us back this marvel of creation.

Our planet is creaking and moaning as if squeezed in the grip of pincers. One of the jaws consists of the unrestrainable greed of the people belonging to those cultures that, already arrived at a high level of well-being, regurgitate the poisons and the refuse of a throw-away society into the biosphere and squander the resources that were accumulated over many geologic eras. The other jaw is the uncontrolled population increase in the poorest nations, which are transforming the natural ecosystems at an unsustainable rate by degrading and destroying them. Year after year, the quantity of gases that are responsible for the greenhouse effect increases and the protective ozone layer decreases. The tropical forests are the irreplaceable depositories of biologic diversity. But they are disappearing at the rate of more than 34 million acres per year.

If we divide the approximately 58 million square miles of the earth's land area by the approximately six billion inhabitants of the earth, we end up with an area of just over six acres (the equivalent of five small playgrounds) per person, or more than 100 persons per square mile. And this is if we calculate everything, truly *everything*, including glaciers and deserts, forests and cultivated terrain, cities and industrial areas.

In Search of Our Lost Innocence

Would it be possible to somehow climb back up the downward slope and return to our Earth its ancient innocence? Of course it would be possible. And, on paper, it should not even be very difficult. It would suffice (merely) to redirect people's thinking and expectations by convincing them that consumerism and degradation constitute a dead-end street and that the possession of material goods does not bring happiness. What is needed is a different way of life, one based more on "being" than on "having"— a way of life similar to the one that has been pointed out to us for thousands of years by the greatest thinkers, from Buddha to Gandhi, from Socrates to Seneca, from Saint Francis to Jesus Christ.

"In today's society, we will not find a solution to the ecological problem," Pope John Paul II said on December 8, 1989, "unless we seriously reconsider our way of life. Austerity, moderation, self-discipline and a sense of sacrifice should enlighten our everyday life, so as to make sure that it will not become necessary for all of us to suffer the negative consequences of the carelessness of a few of us."

To obtain these results, it would suffice (merely) to apply to a "re-civilizing" of mankind those same propaganda techniques that push us to ever greater consumption and waste; or, those less efficient but still effective ones that have inspired so many of us to give our wedding rings "to our country" fifty years ago or to send our sons to die in the thicket of the jungle or the sands of the desert. And all this, for motives that were neither very noble nor very deeply felt.

When it comes to killing and destroying, people are ready to do anything, even today. But, to save this marvelous and irreplaceable planet, few of us are willing to give up our car, our boat, our second or third house, or our extremely high consumption of energy and resources.

Perhaps if we could become children again....

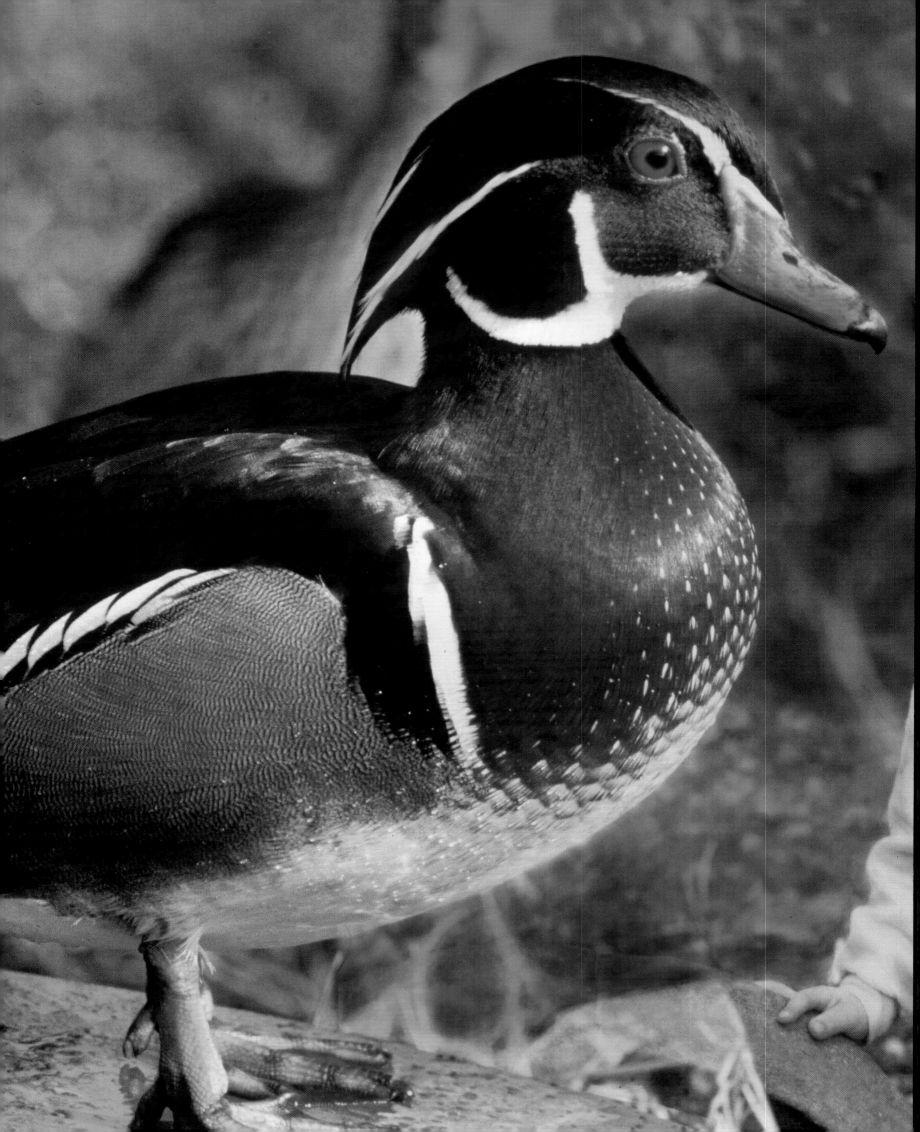

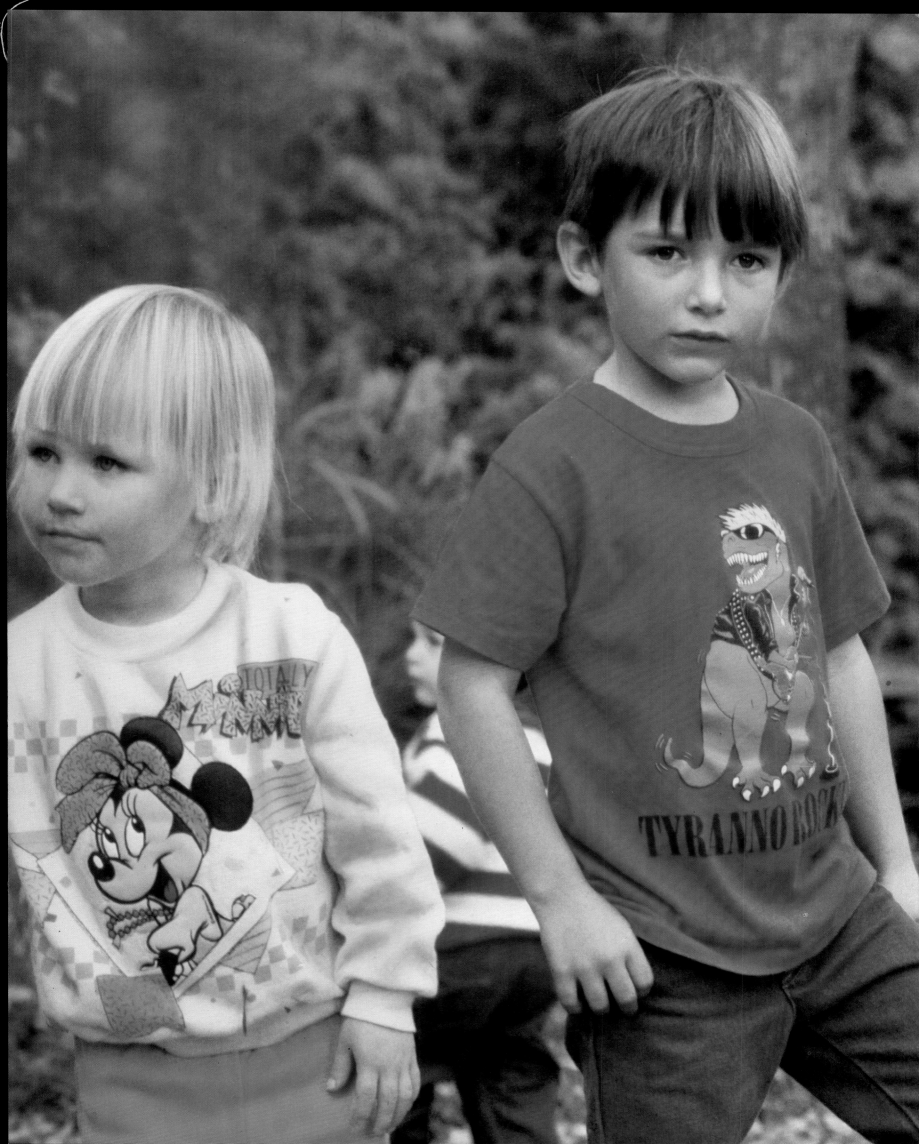

On the Wings of Fantasy

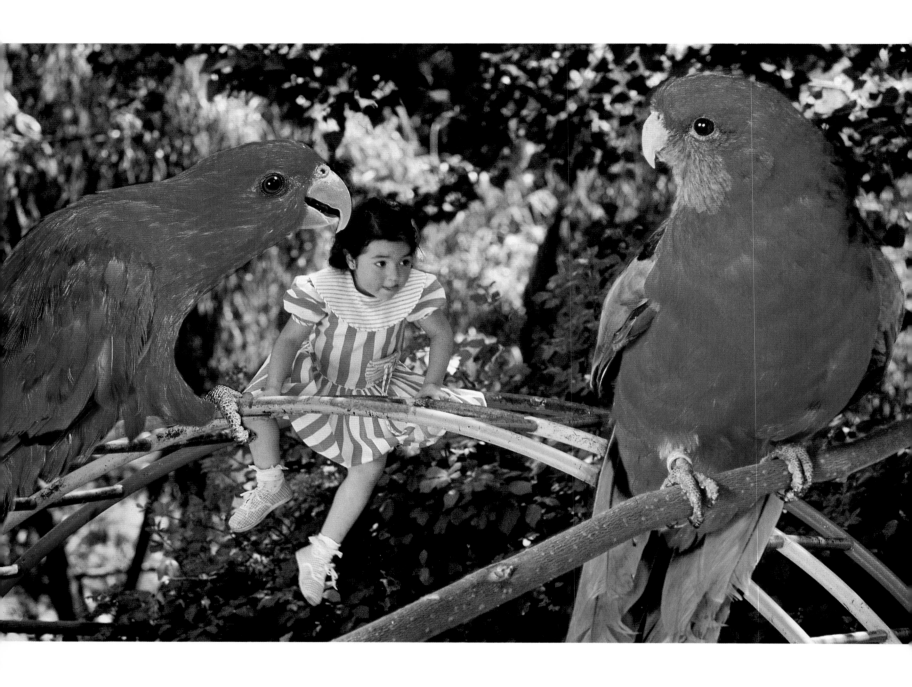

Who never wins can rarely lose, who never climbs as rarely falls.

John Greenleaf Whittier

◁ The young look for happiness in the unexpected, the old in their habits.

Paul Courty

Experience is the ripe fruit of useful memories.

Filippo Pananti

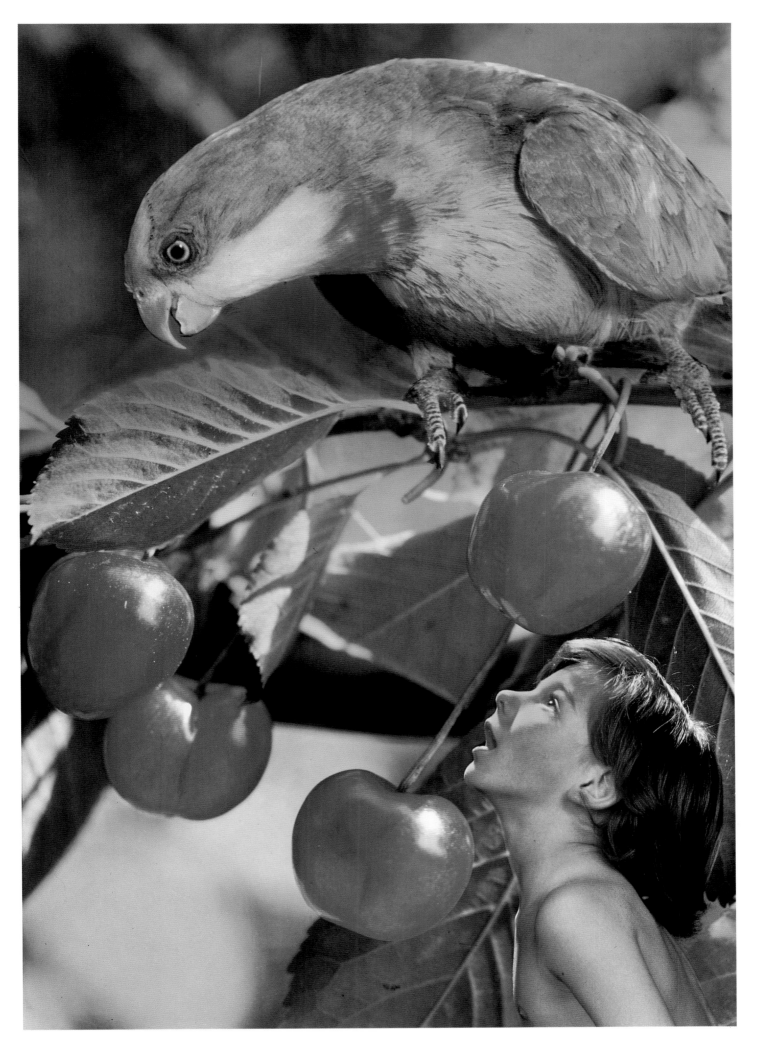

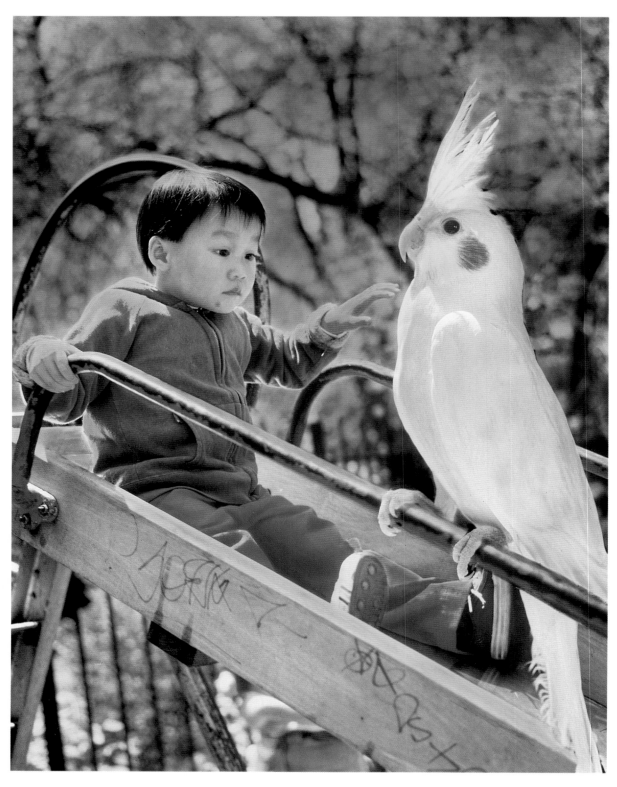

Living is beautiful,
because living is beginning,
always beginning,
at every moment.

Cesare Pavese

A lie is like an avalanche
increasing while rolling.

John Locke

60

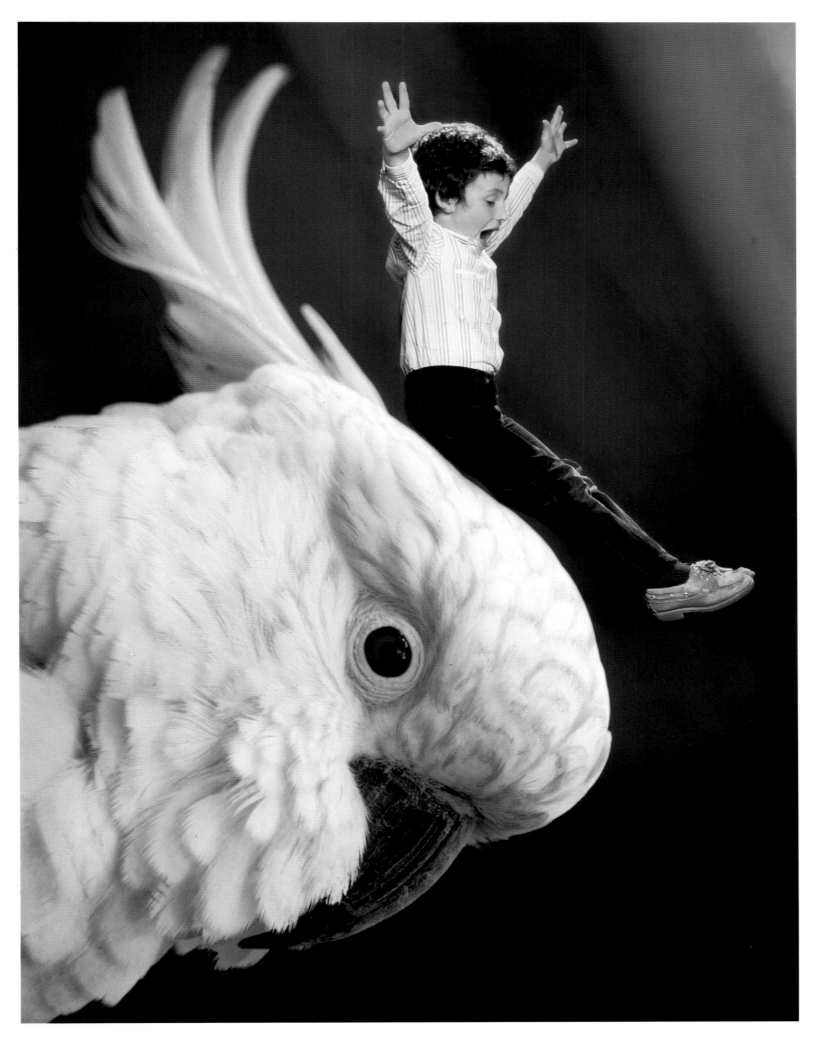

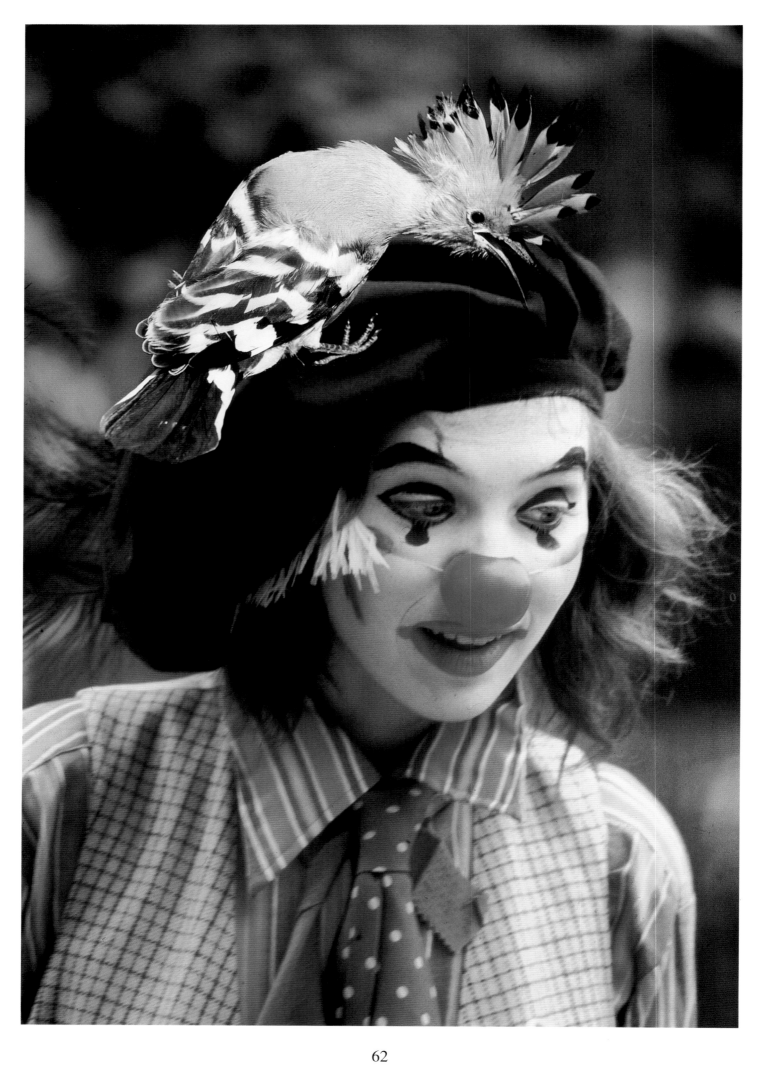

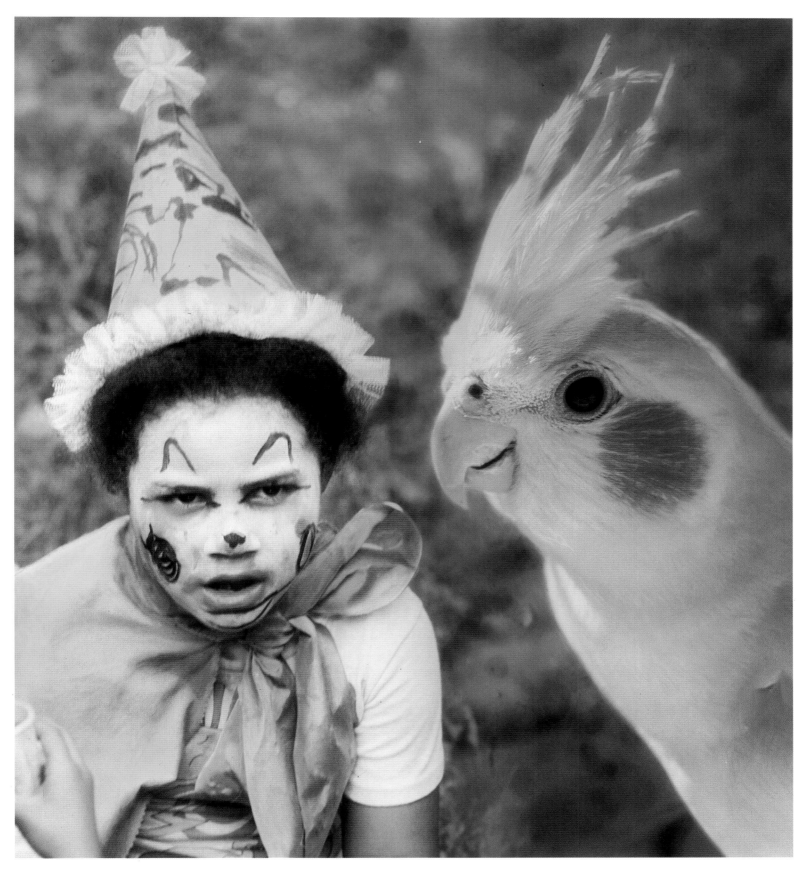

Life is a jest;
And all things show it.
I thought so once;
But now I know it.

John Gay

A celebrity is someone who works hard to become well known and then wear dark glasses to avoid being recognised.

"Happy Variety" (London)

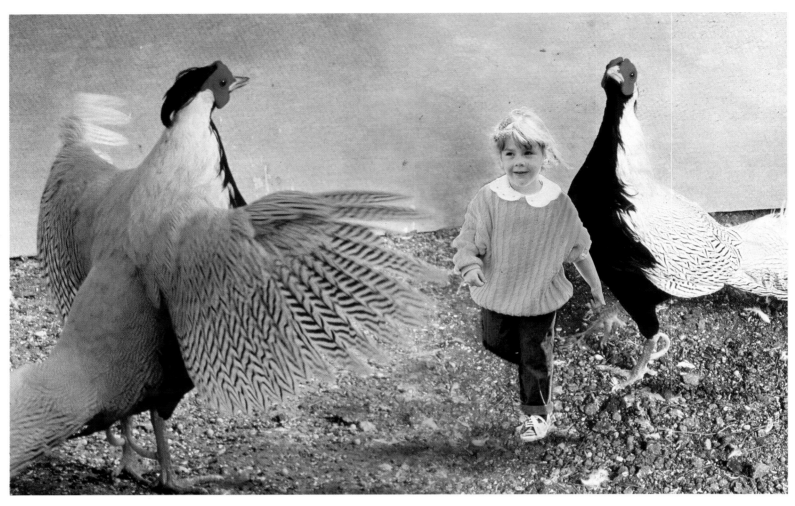

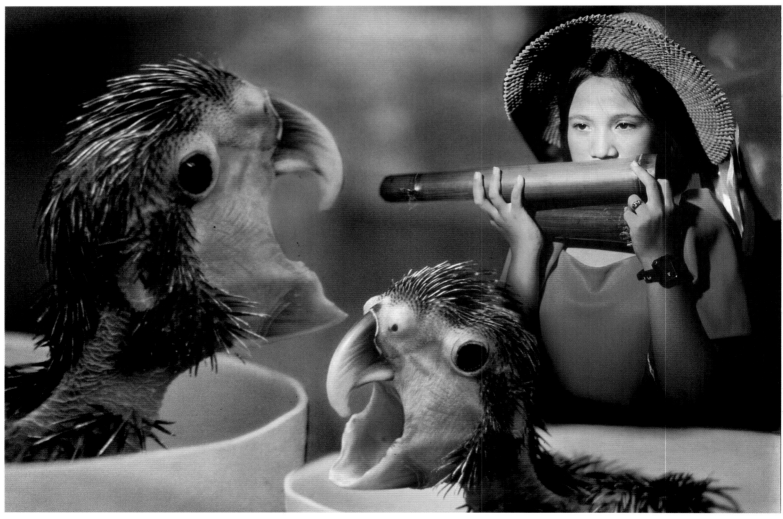

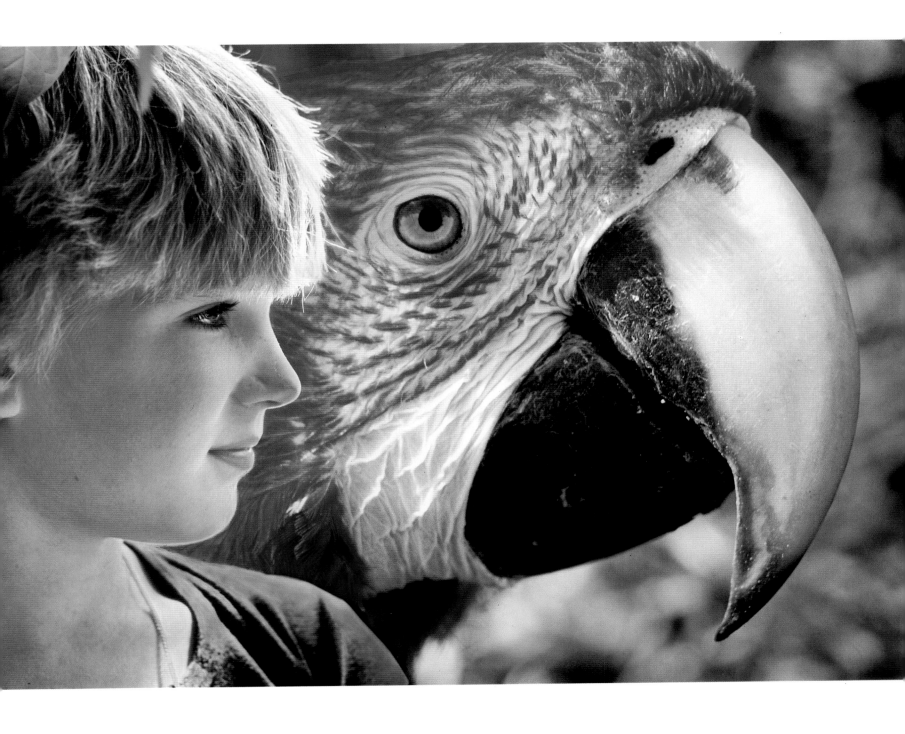

Imitation is the sincerest of flattery.
Charles Caleb Colton

Life is like playing a violin solo in public and learning the instrument as one goes on.
Samuel Butler

Where did you get your eyes so blue?
Out of the sky as I came through.
George MacDonald

The Children of the World

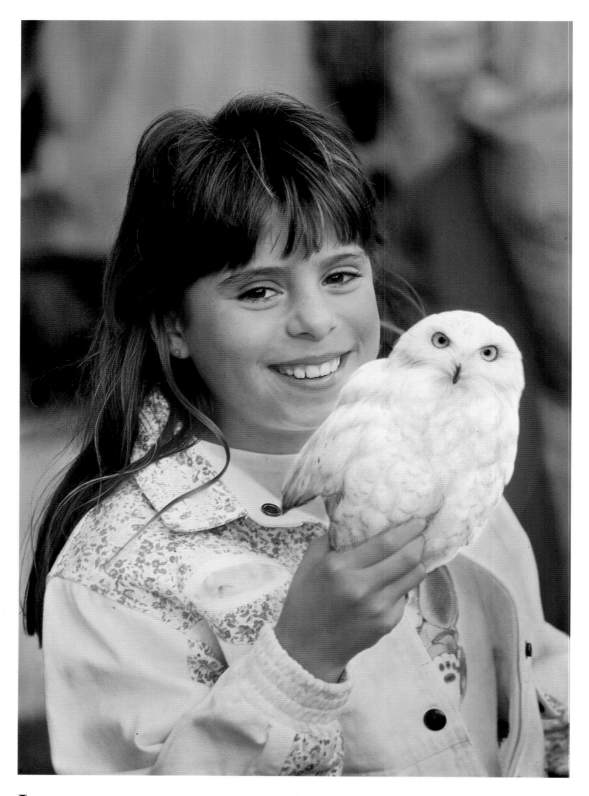

Loving human beings is the virtue
of humanity, understanding
them a science.

Confucius

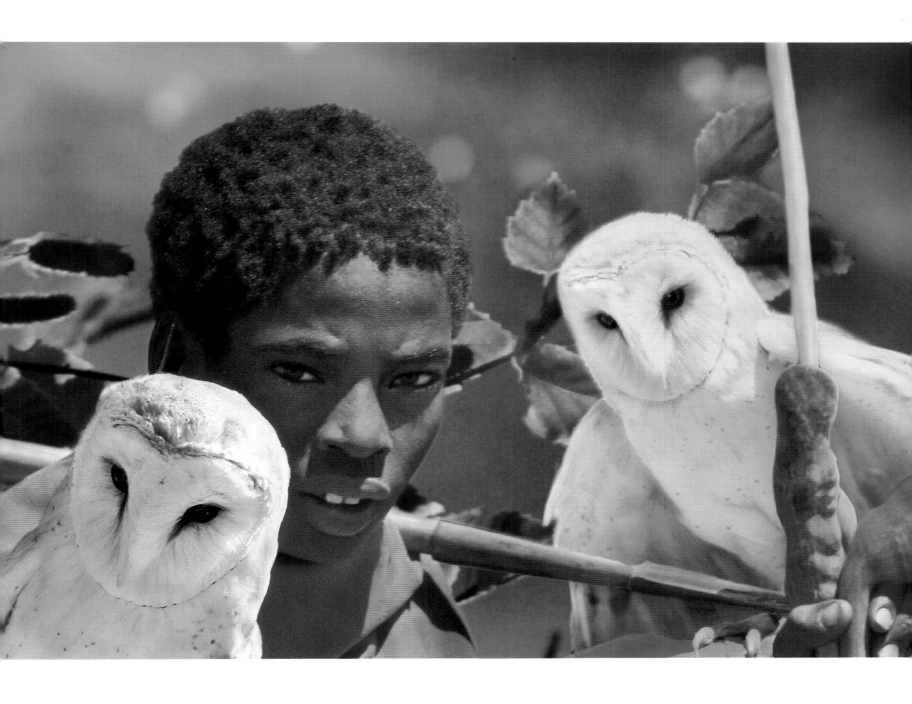

Lord, grant that I may always desire
more than I can accomplish.

Michelangelo

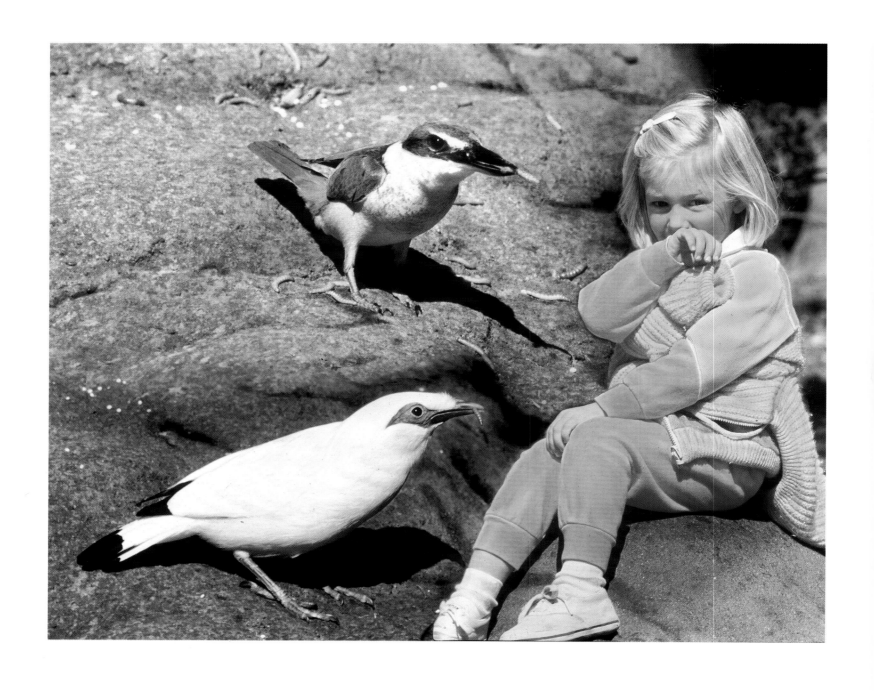

The way you give counts more than what you give.
Pierre Corneille

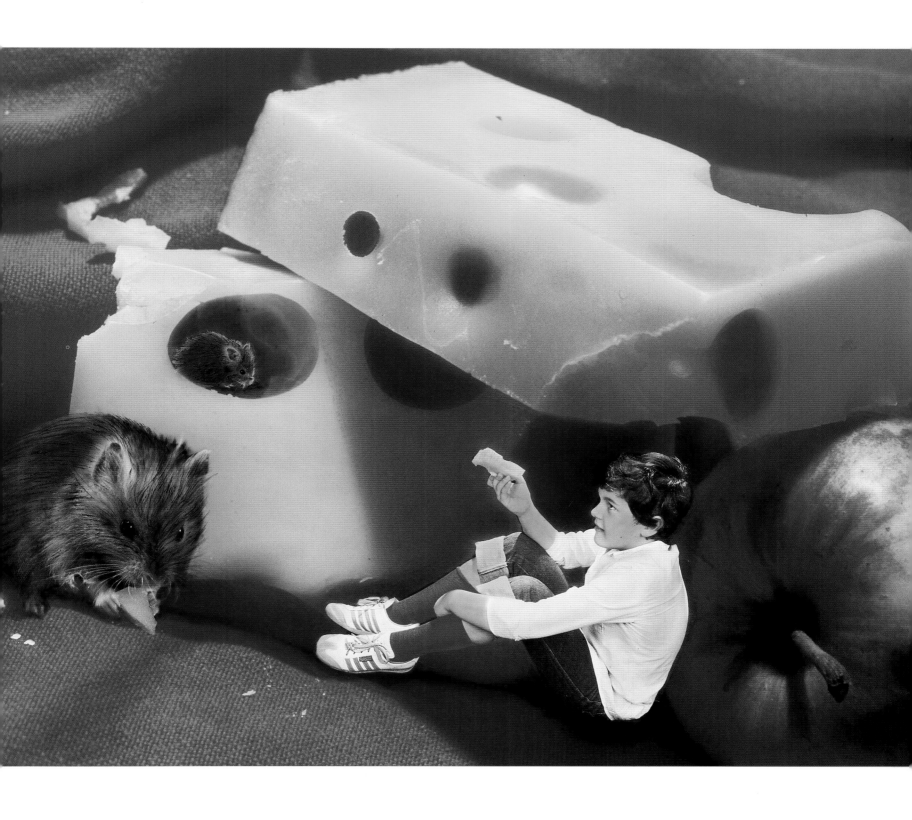

Traps are for fools; poor mice get caught, rich mice don't.
Trilussa

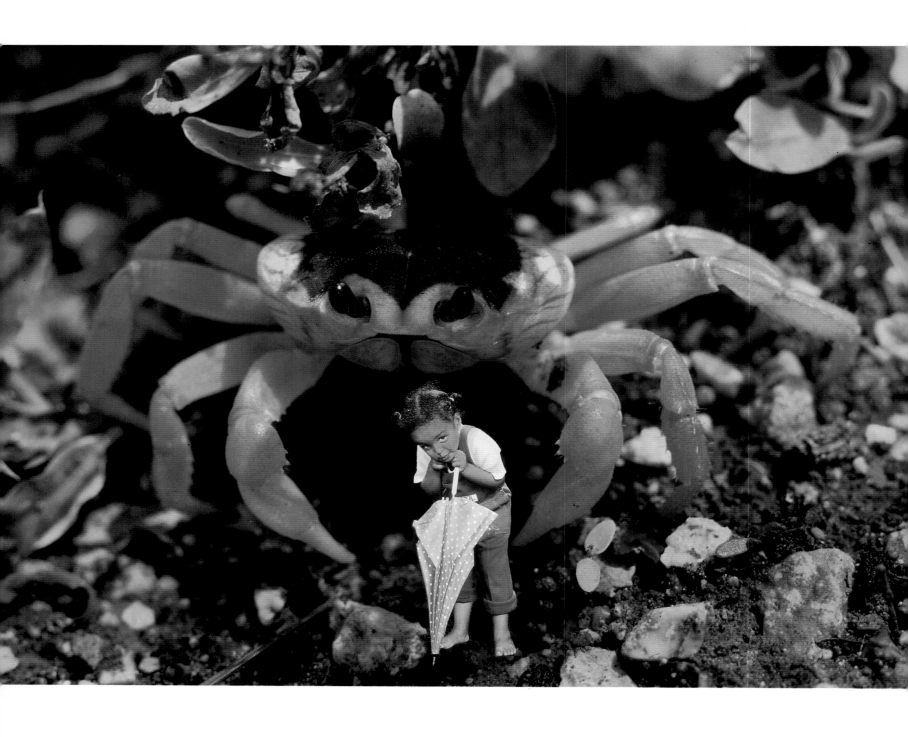

Conscience is just a little voice
which makes you feel very small, very small.

Sanaker

Do not give me advice. I know how to make
mistakes by myself.

Pitigrilli

Few things are harder to put up with than the
annoyance of a good example.

Mark Twain

70

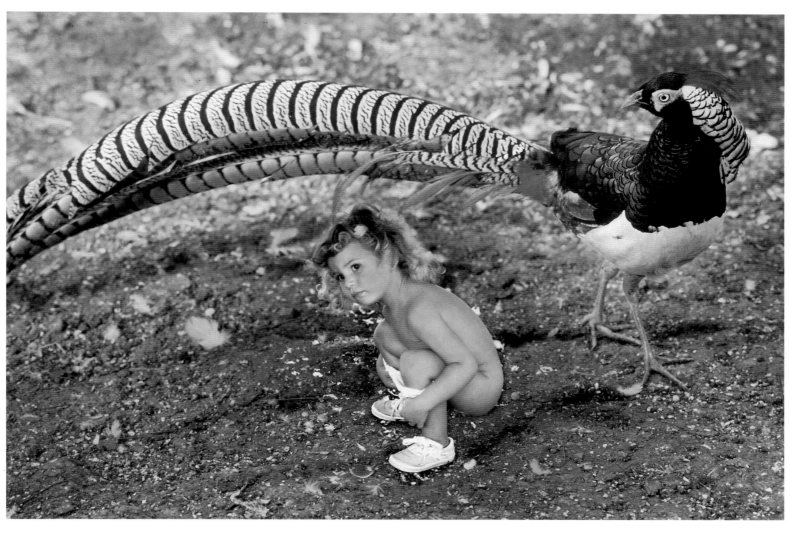

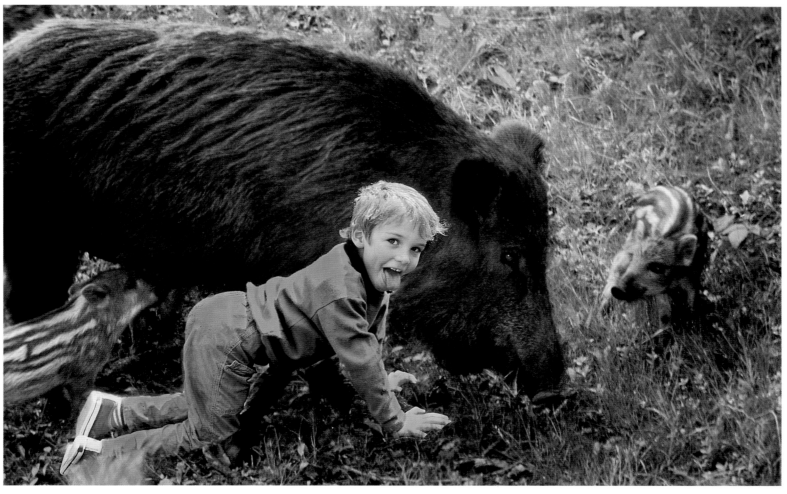

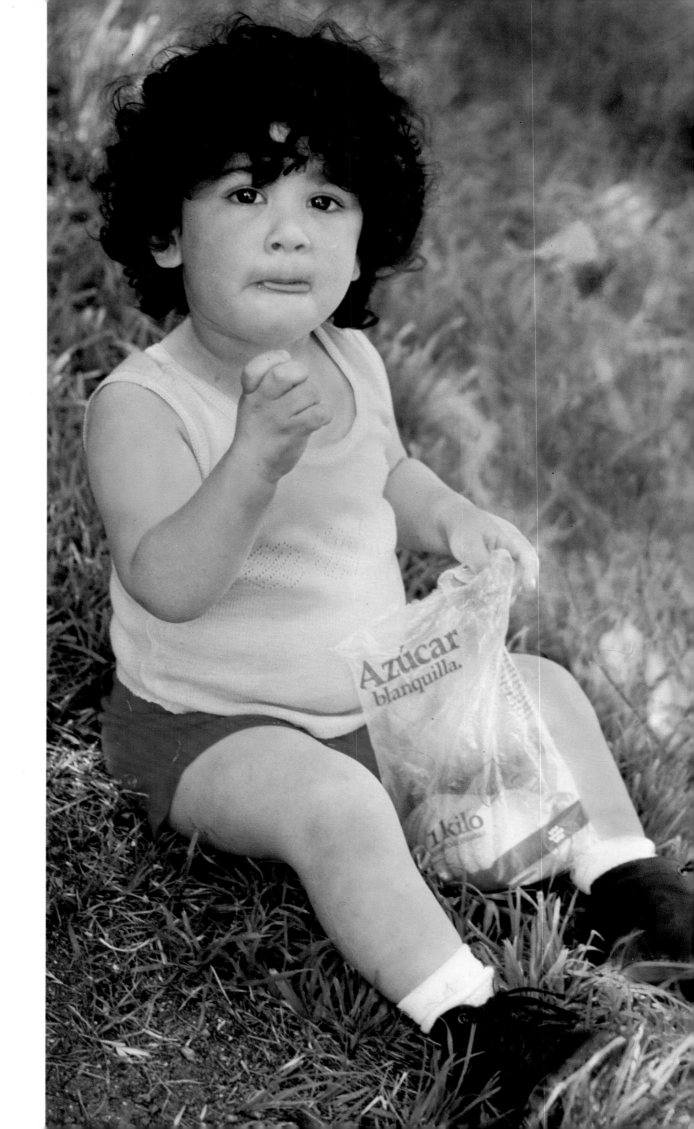

A great proverb
dear to power
says that "being
is in having."
Giuseppe Giusti

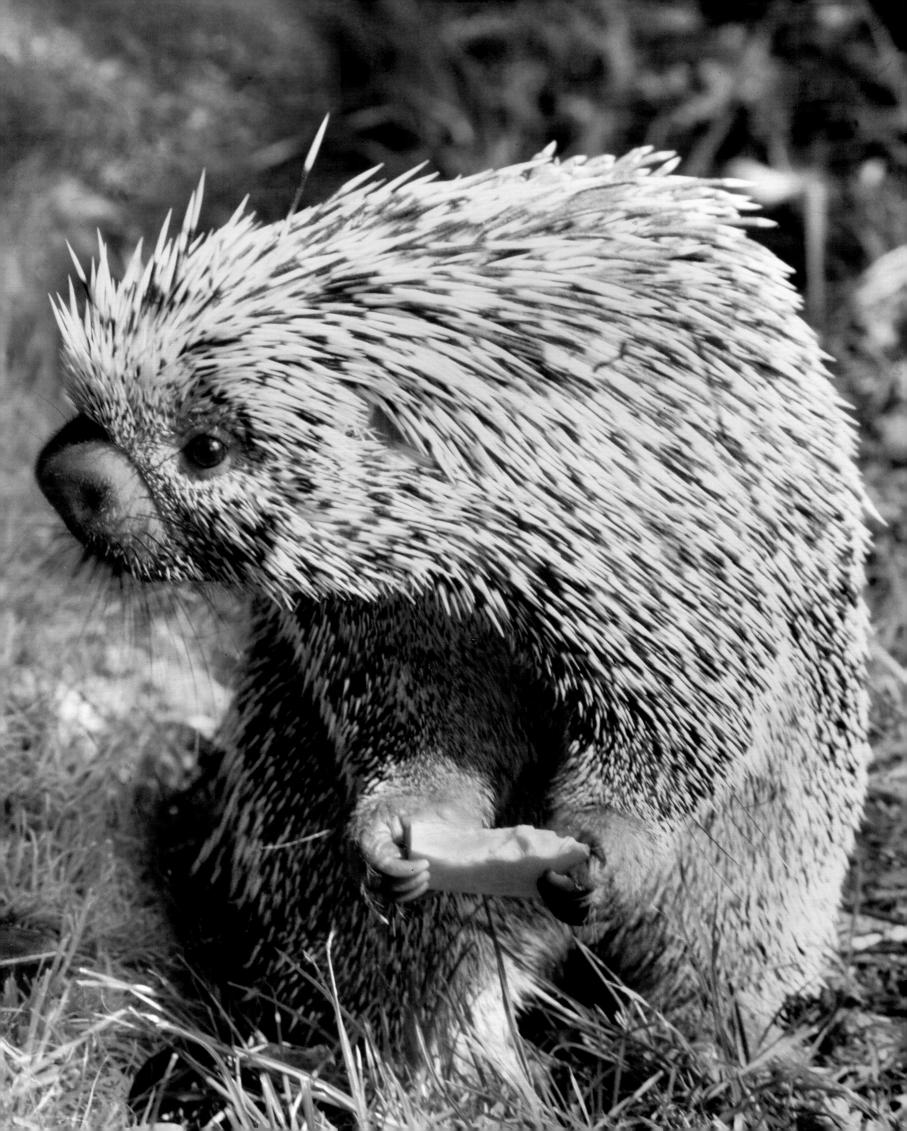

The Stage of Life

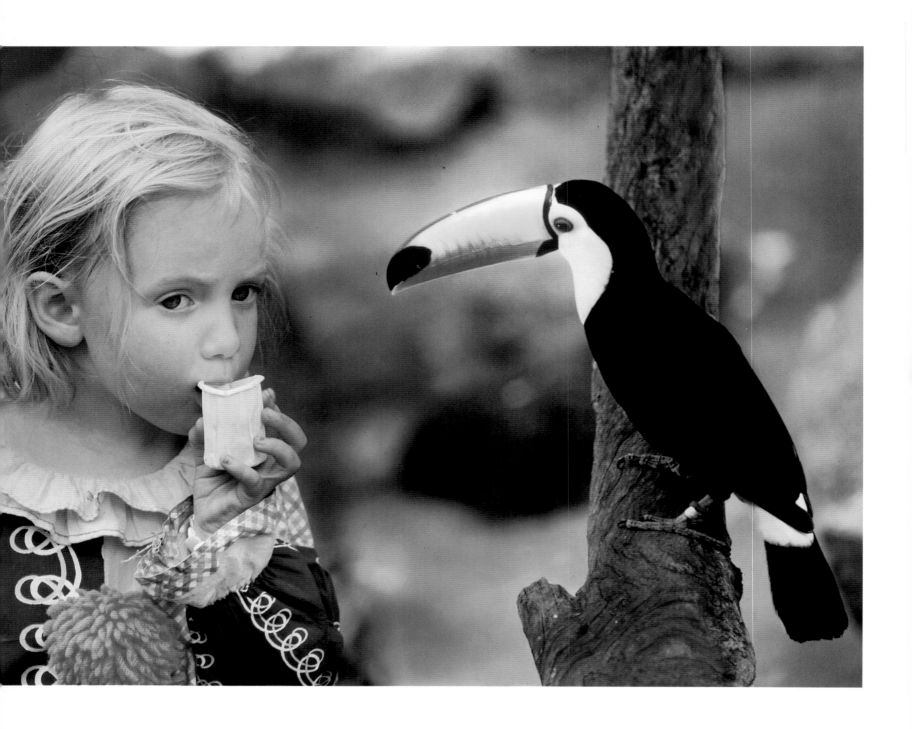

We used to have actresses trying to become stars; now we have stars trying to become actresses.

Sir Laurence Olivier

This world is a comedy to those that think, a tragedy to those that feel.

Horace Walpole

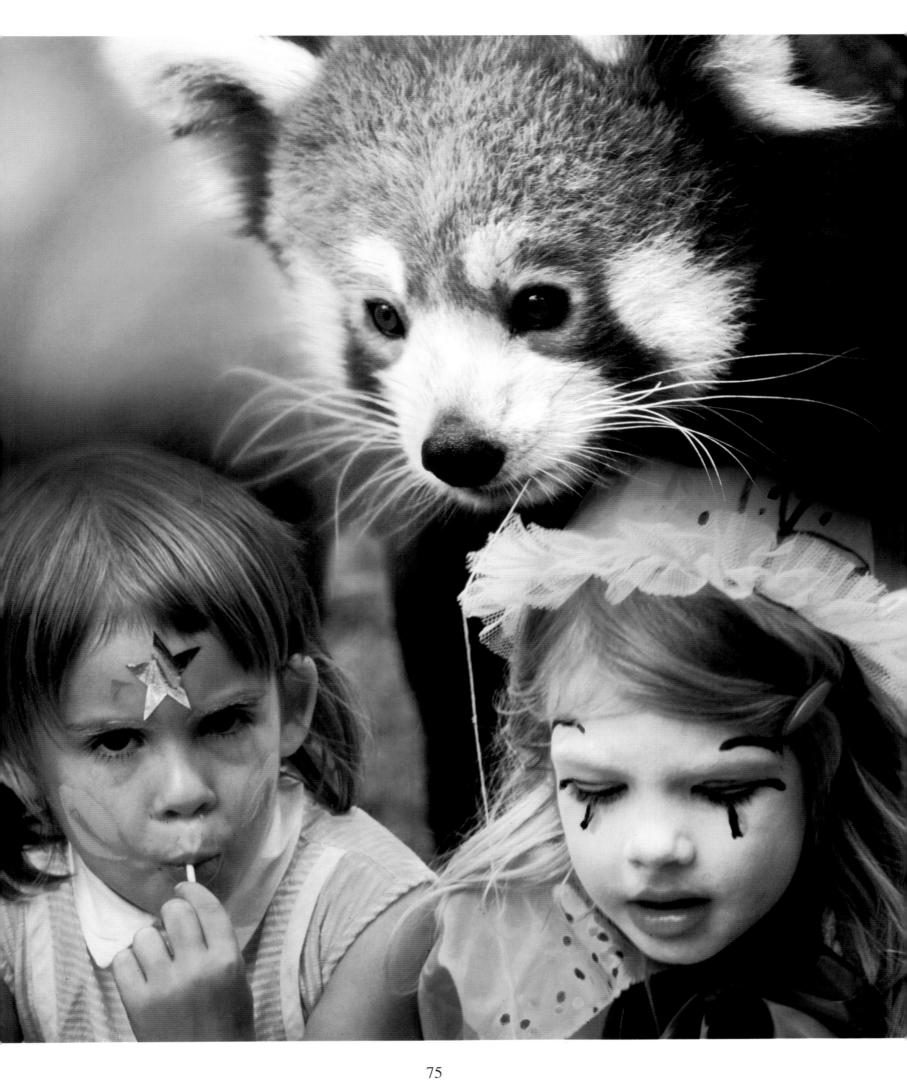

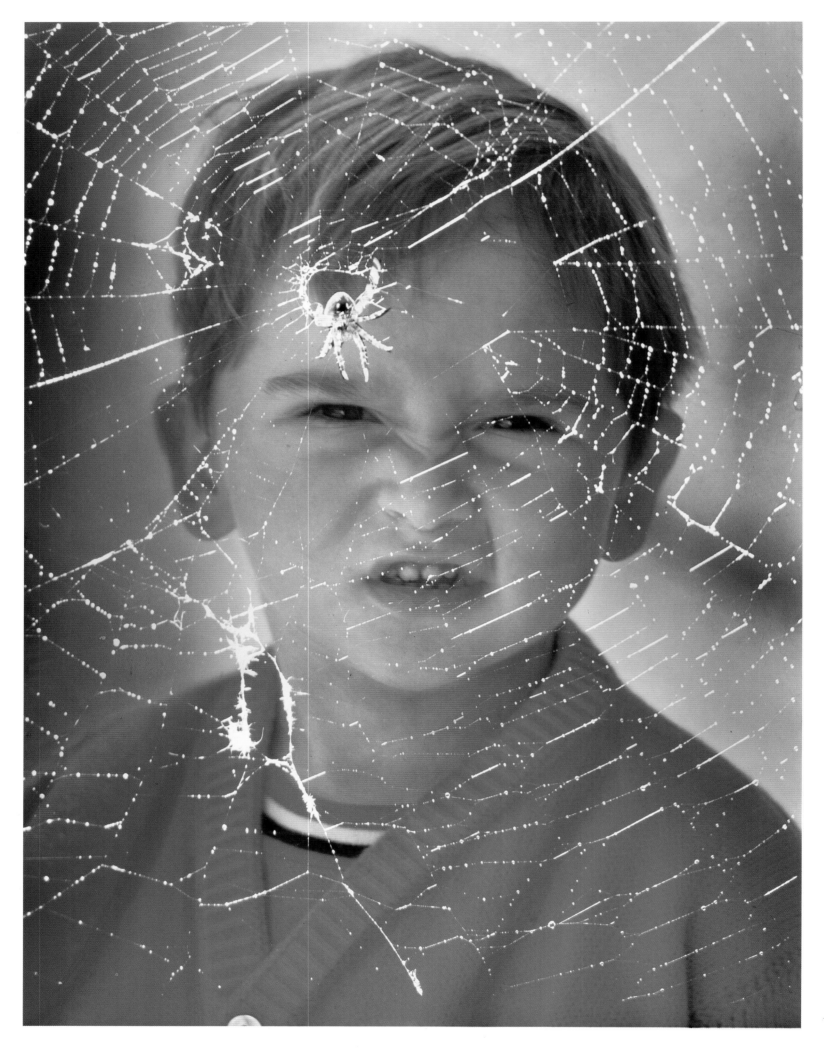

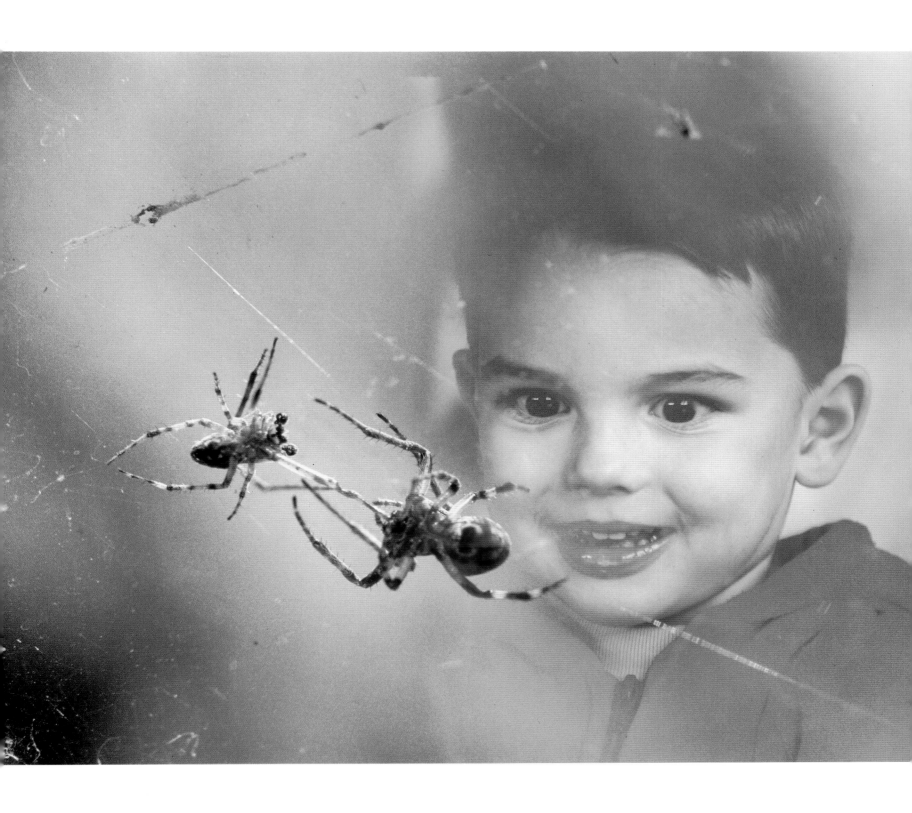

Experience is never limited, and it is never complete; it is an immense sensibility, a kind of huge spider-web of the finest silken treads suspended in the chamber of consciousness, and catching every air-borne particle in its tissue.

Henry James

Experience is the name everyone gives to their mistakes.

Oscar Wilde

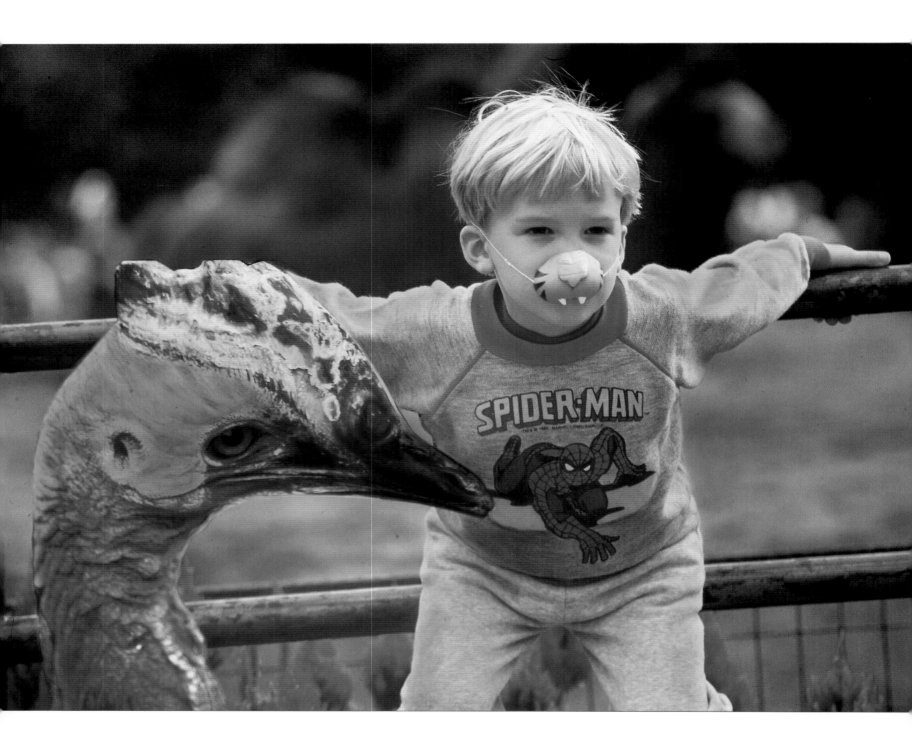

Often appearance deceives, and we
must not always judge from what we see.

Molière

Strange how much you've got to know before
you know how little you know.

Anonymous

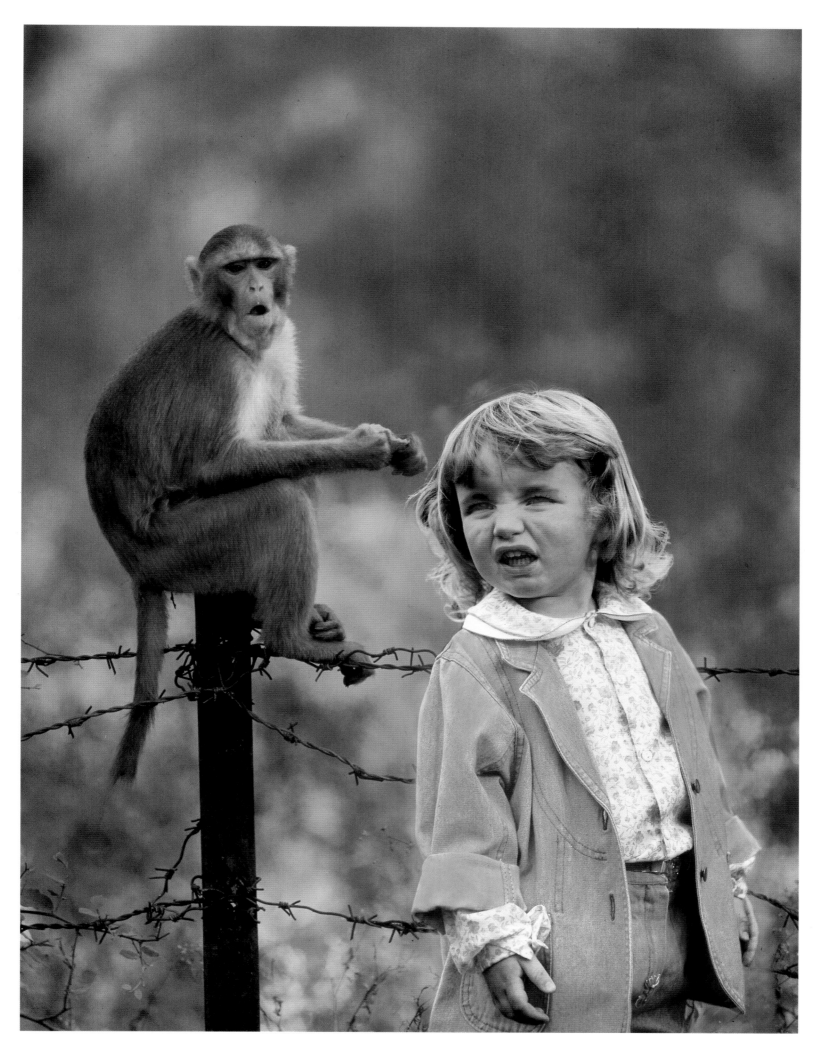

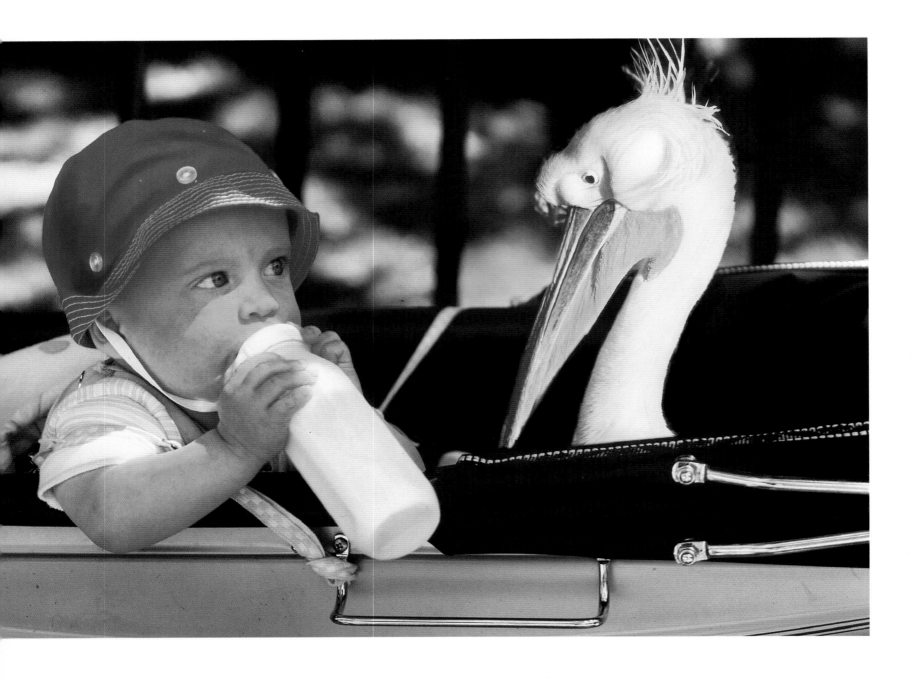

There is no finer investment for any community than putting milk into babies.

Winston Churchill

Few children fear water unless soap is added.

William F. Gaines

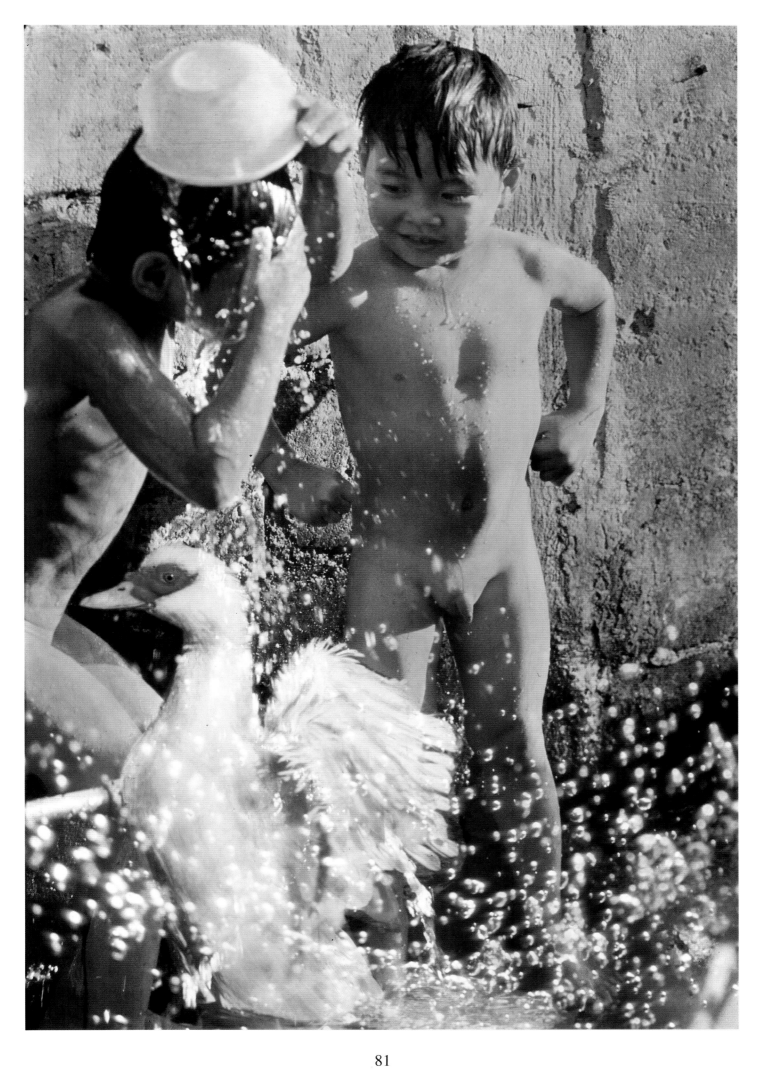

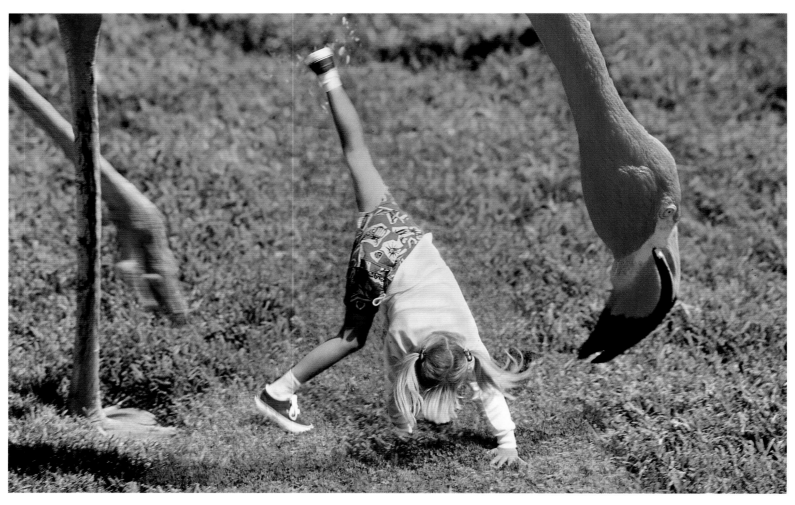

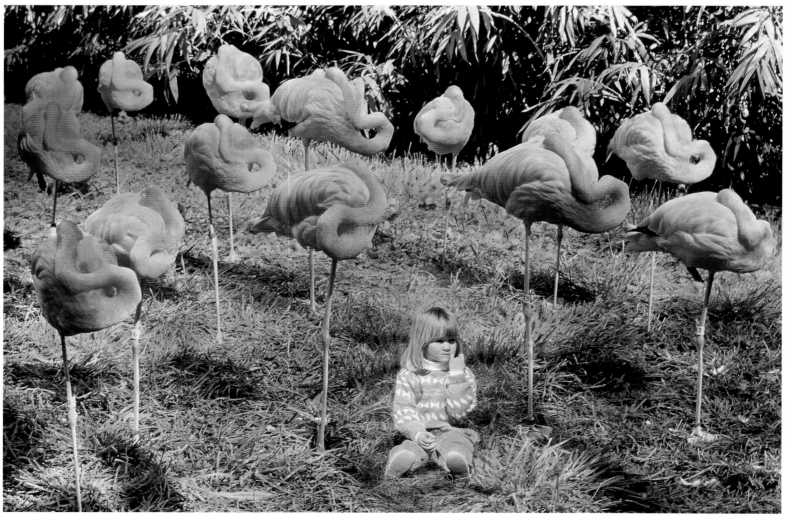

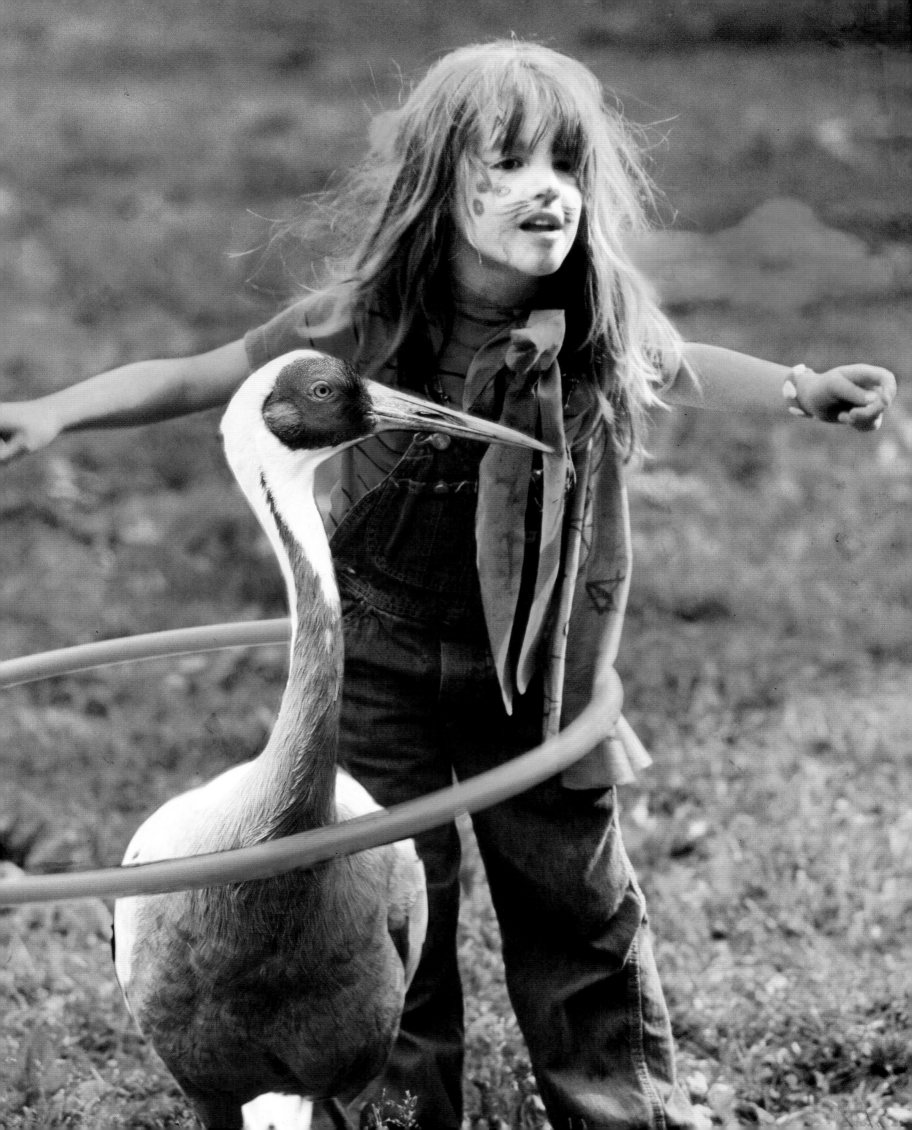

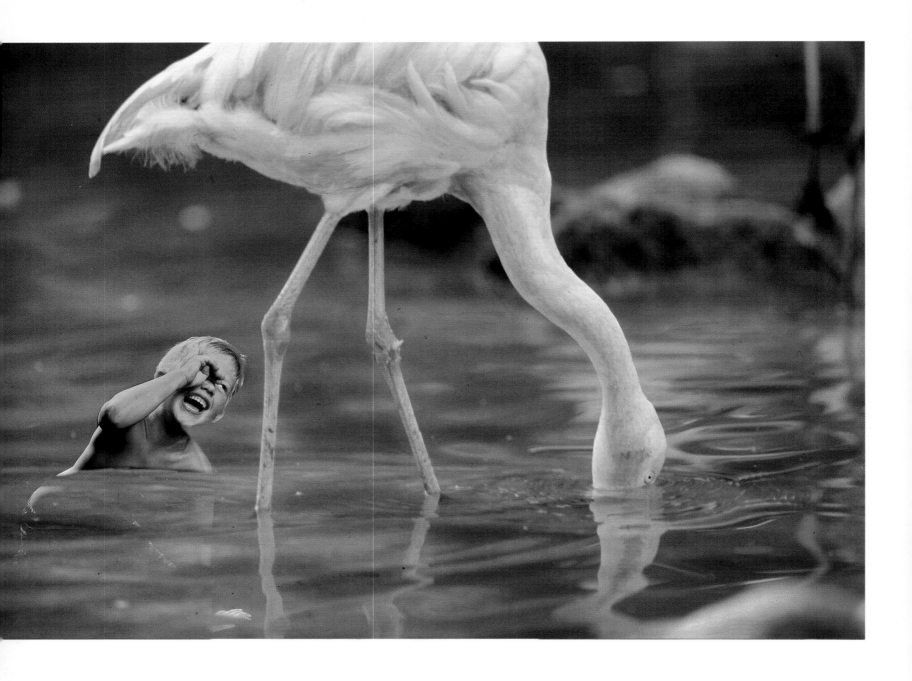

When a thing is funny, search it
for a hidden truth.
George Bernard Shaw

◁ The greatest rule in any education is not to save
time but to waste it.

Jean Jacques Rousseau

Life's made for living, and giving and sharing.
Grace E. Easley

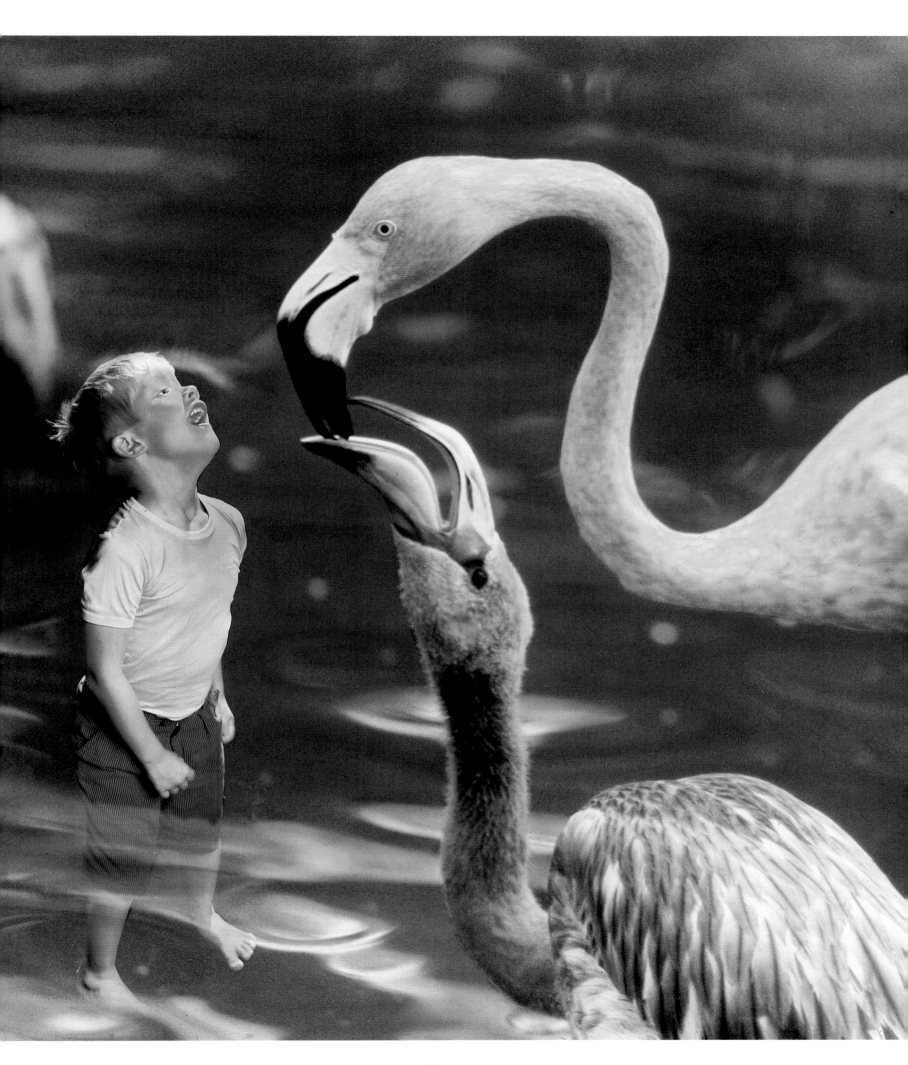

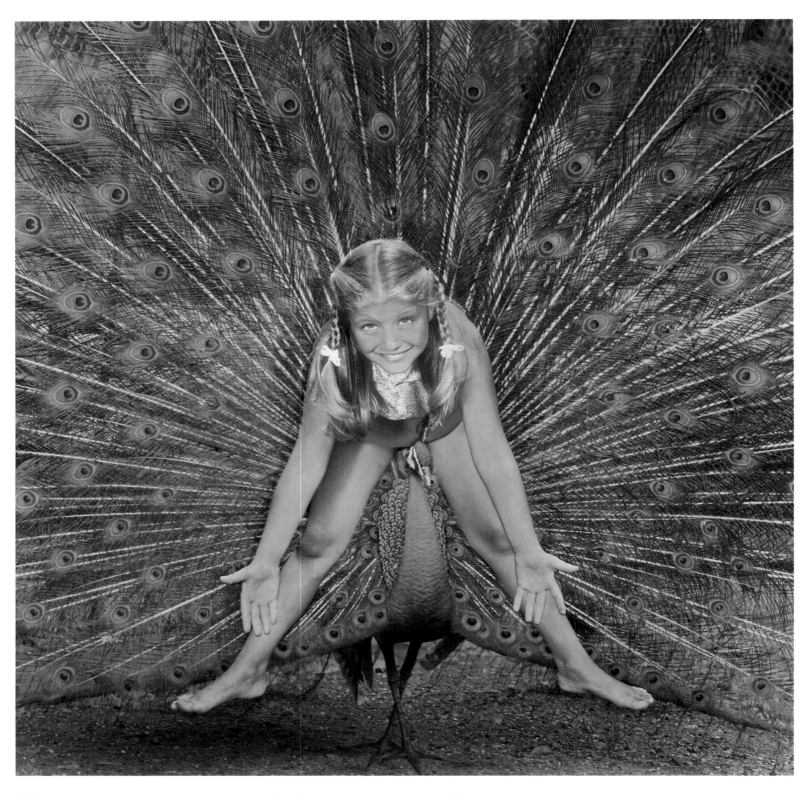

There is no better cosmetic for beauty than happiness.

Lady Marguerite Blessington

Remember that the most beautiful things in the world are the most useless; peacocks and lilies for instance.

John Ruskin

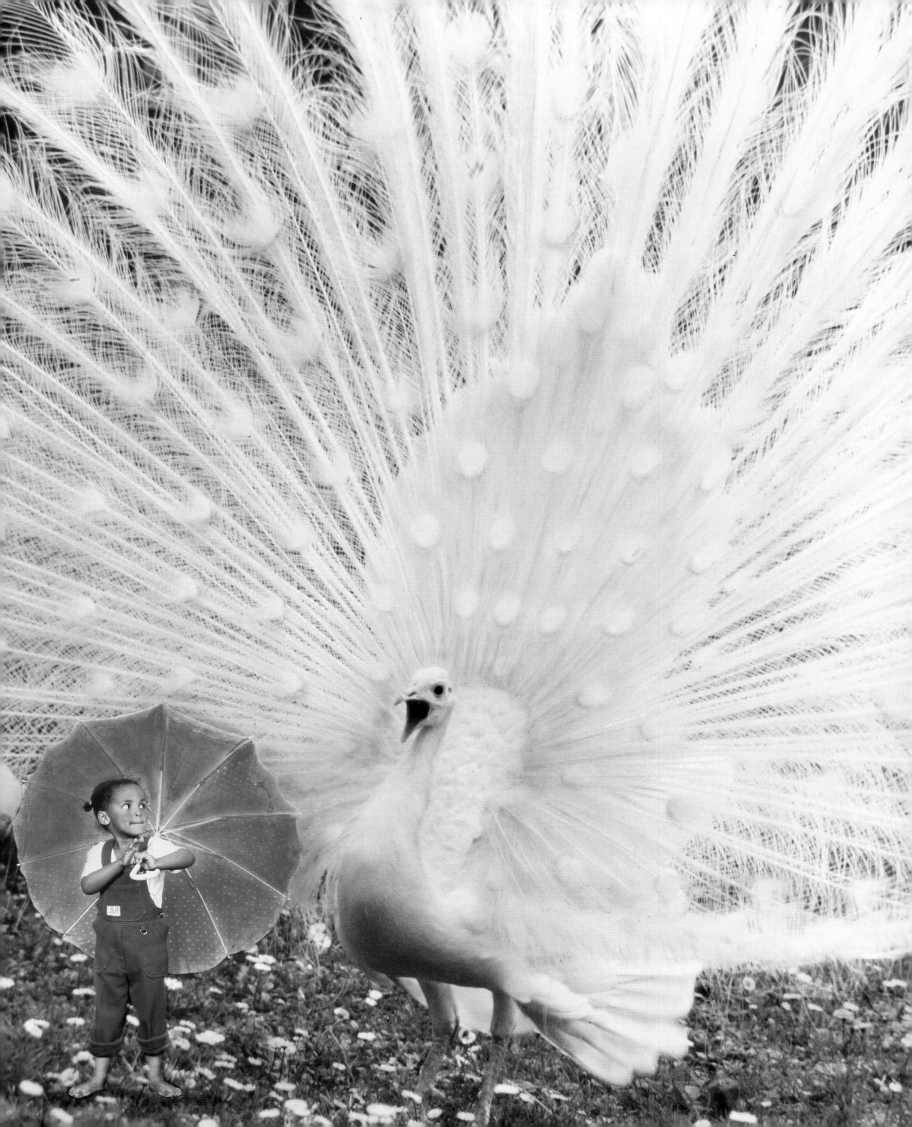

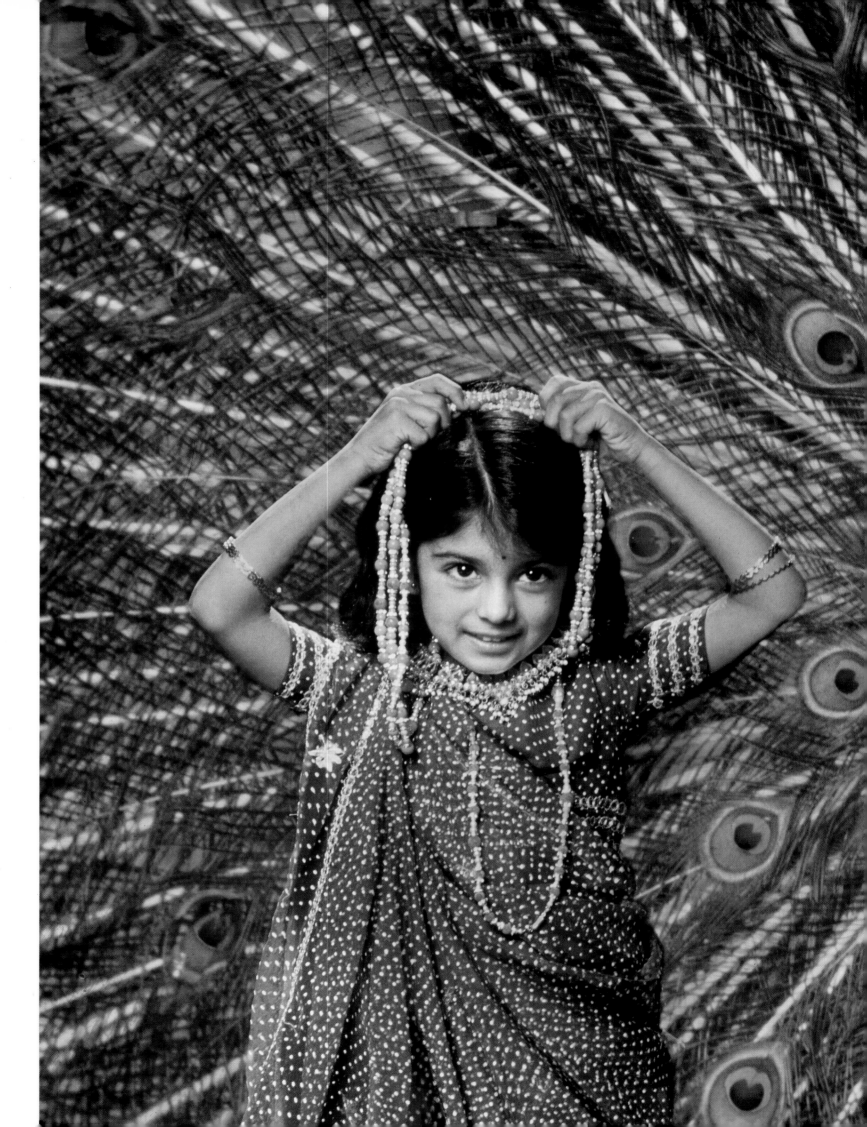

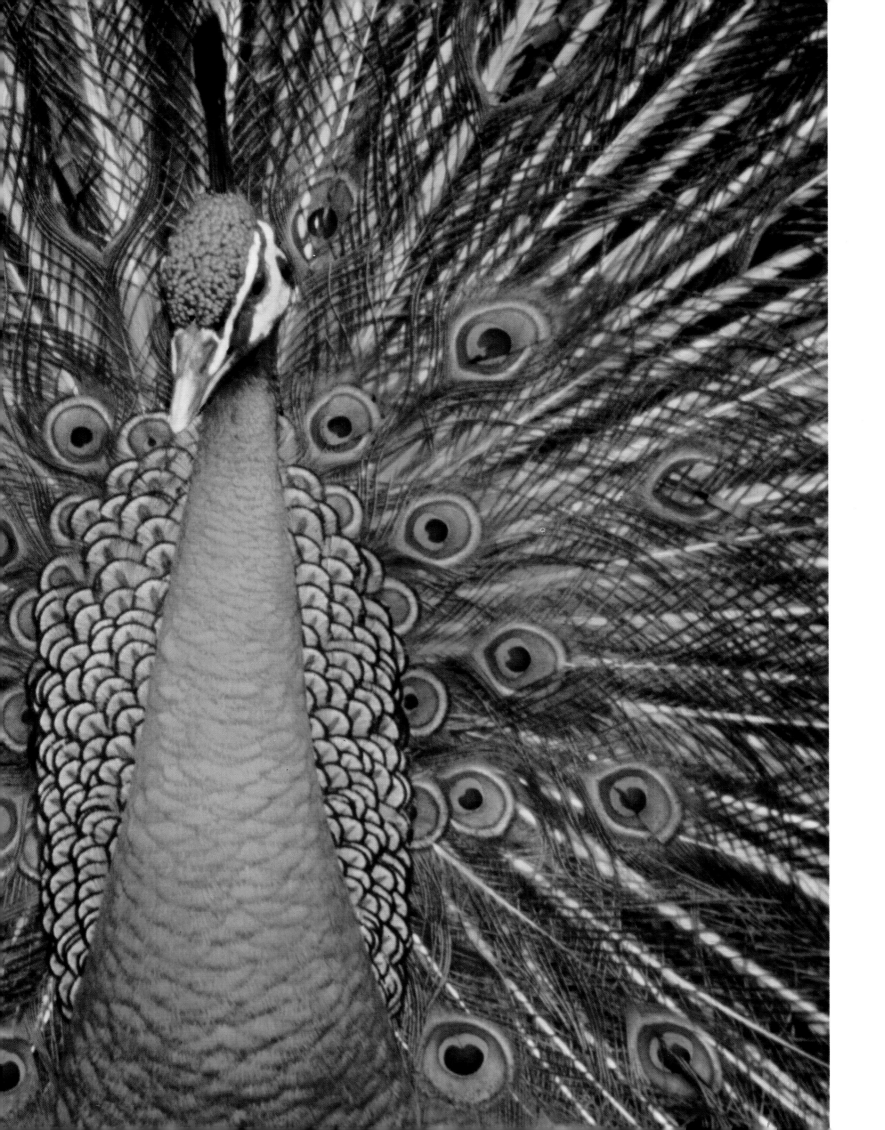

In Harmony with Nature

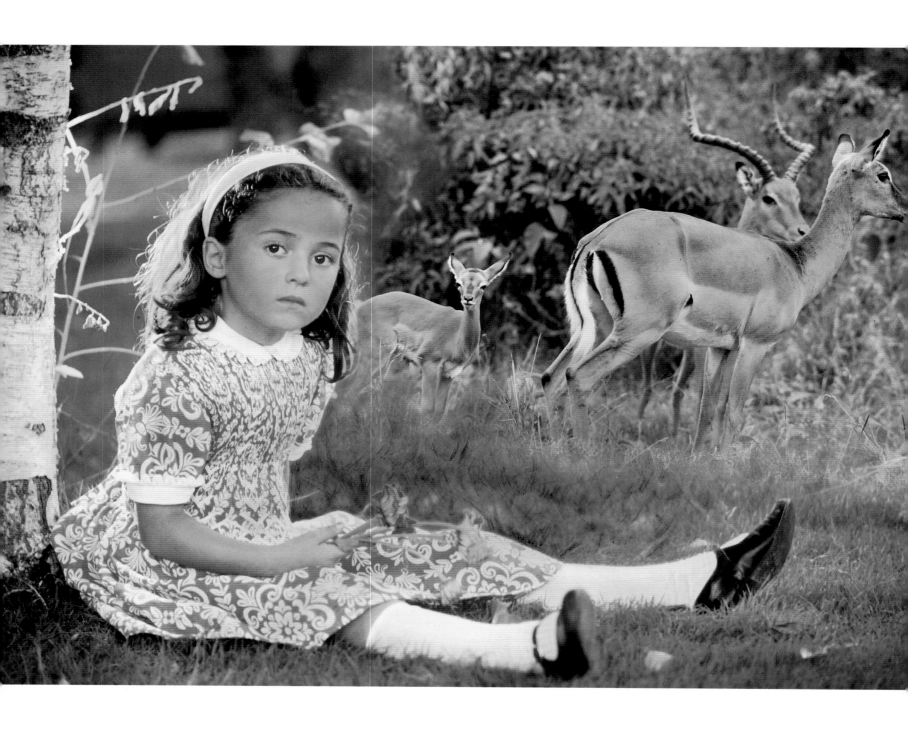

There is a pleasure in the pathless woods....
There is society, where none intrudes…
Lord Byron

◁ The hardest hearts are moved by beauty.
Saint Augustine

When we love, nature is no mystery.
De La Tour Chambly

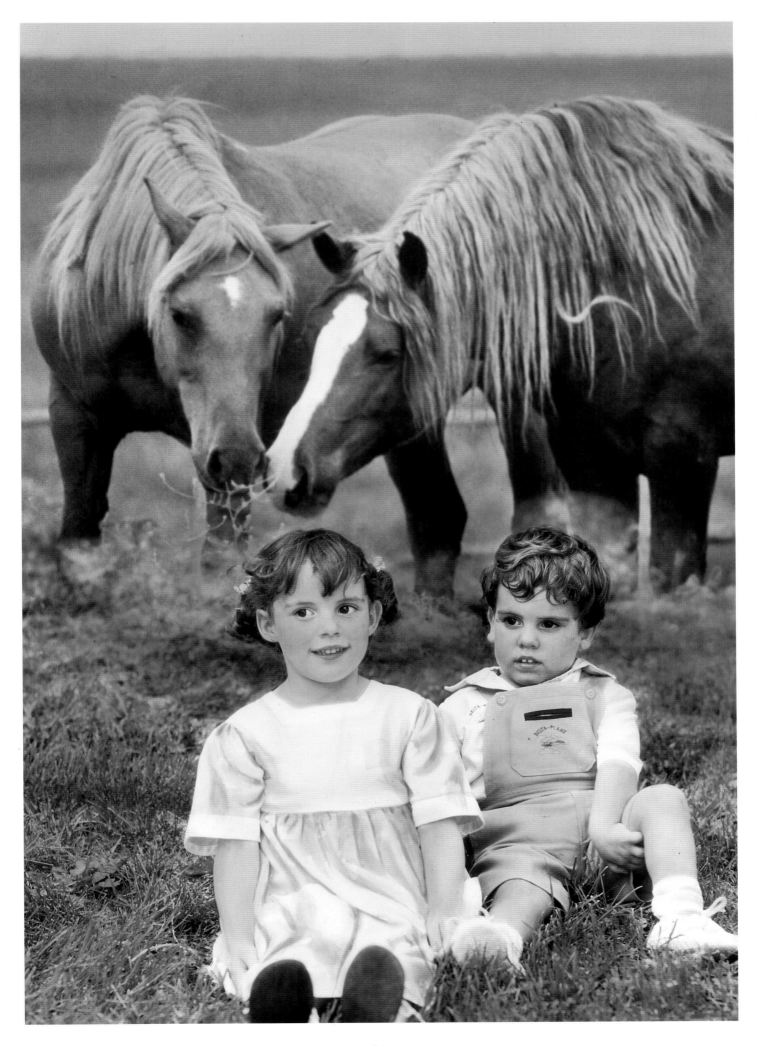

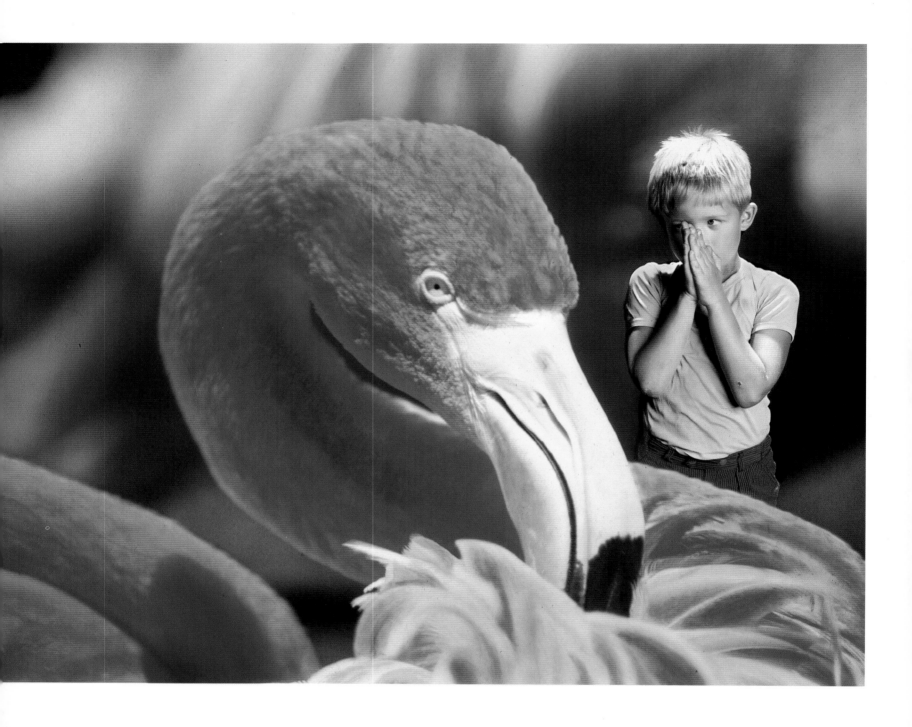

A sincere prayer
brings a new feeling every time.

Fëdor Dostoevski

When you want to know if it is raining, do not
look for others with their umbrellas open;
stretch out your hand and judge for yourself.

Pitigrilli

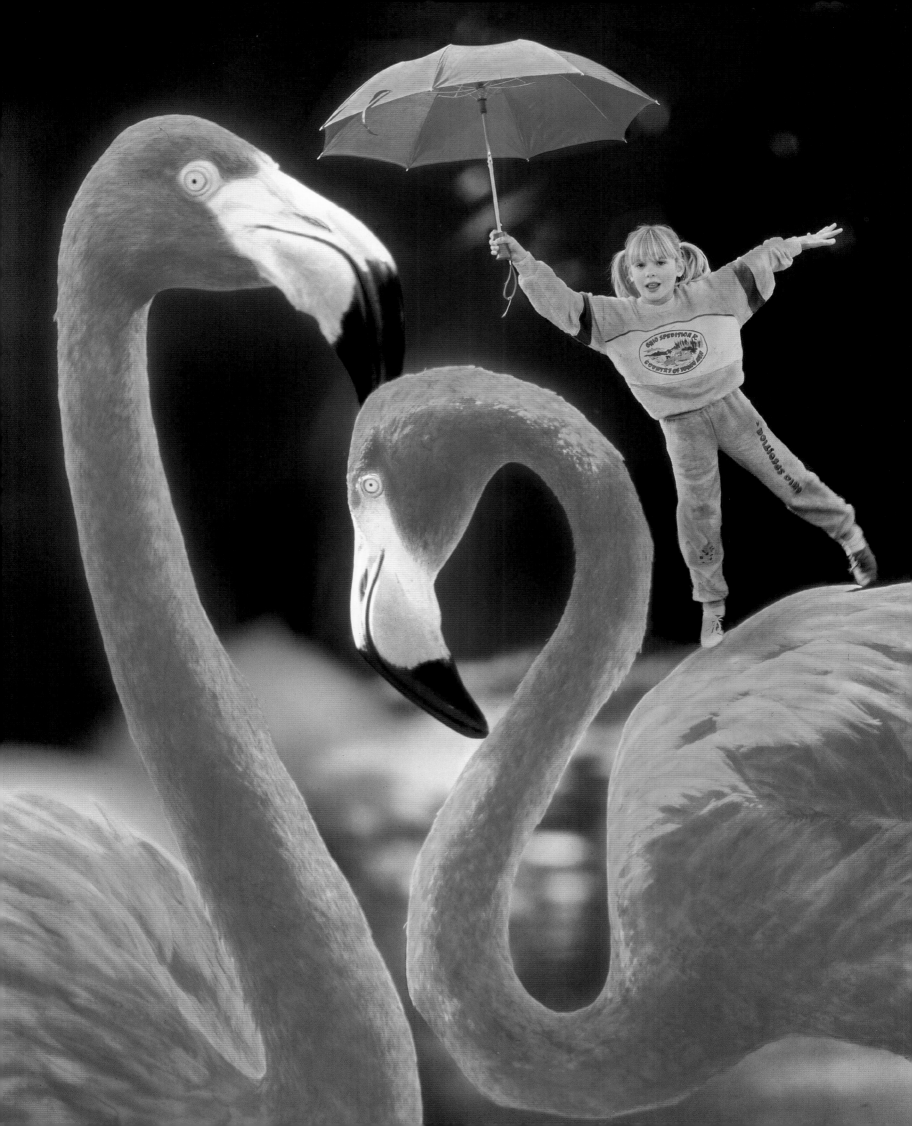

The Rights of Children

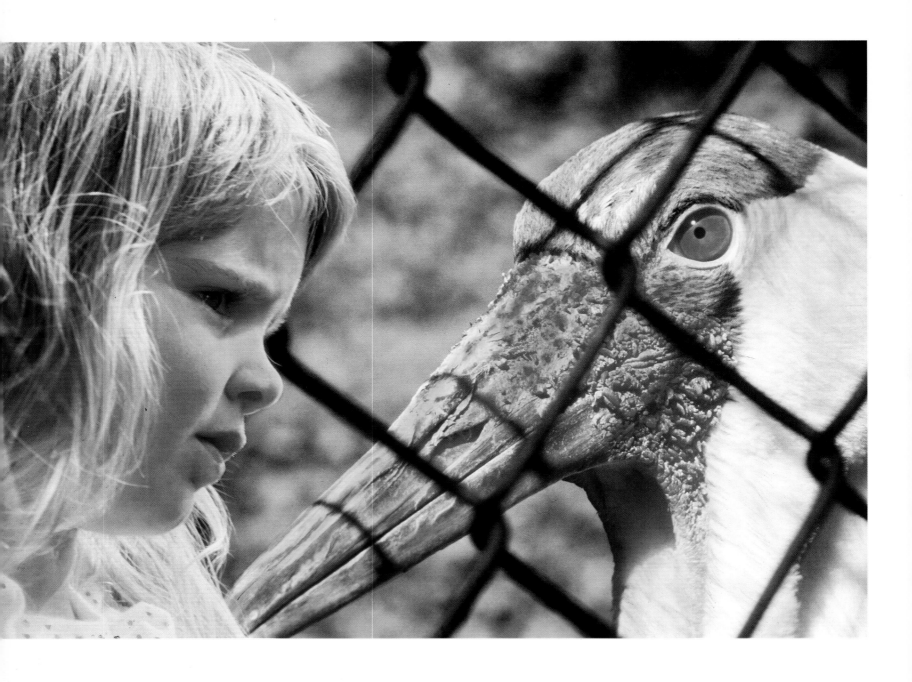

Personal liberty is the paramount essential to human dignity.

Edward George Bulwer-Lytton

Half the pleasure of solitude comes from having with us some friend to whom we can say how sweet solitude is.

William Jay

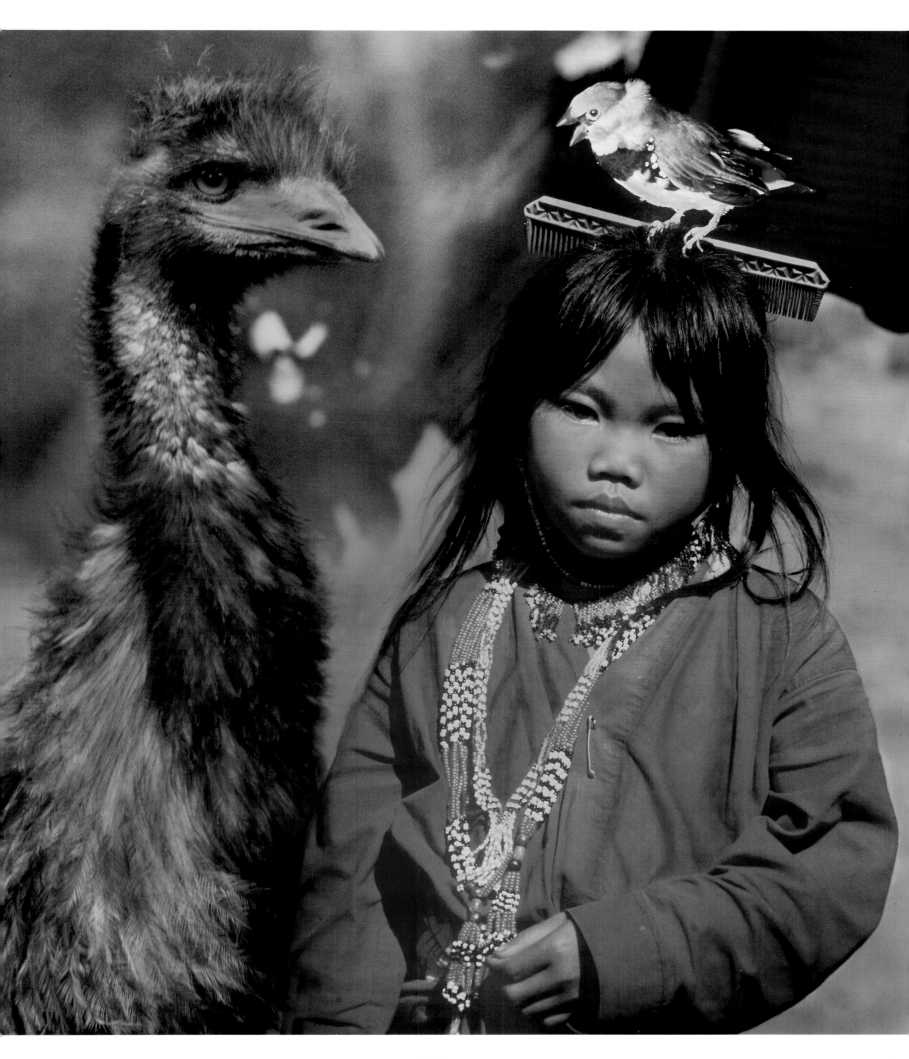

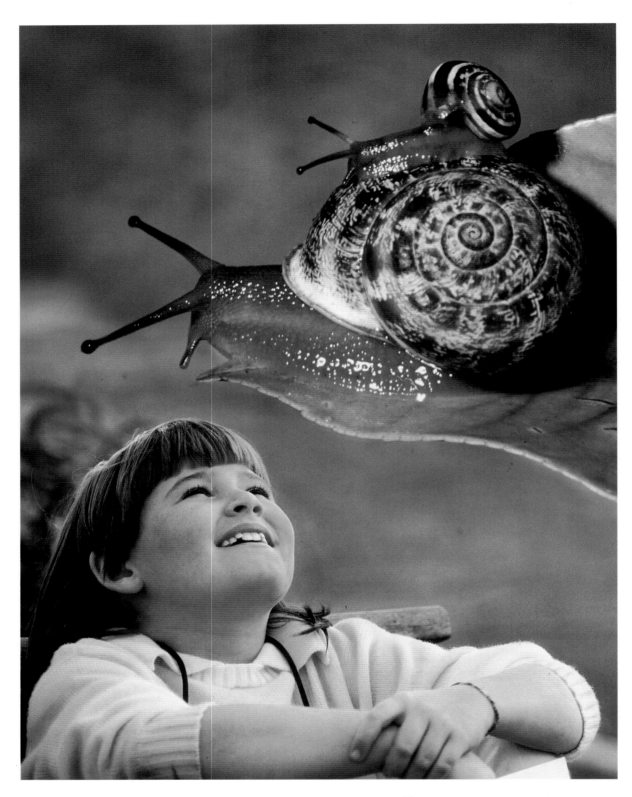

The snail,
which everywhere doath roam,
carrying his own house still,
still is at home.

John Donne

Laziness moves so slowly
that poverty has no trouble
reaching it.

Confucius

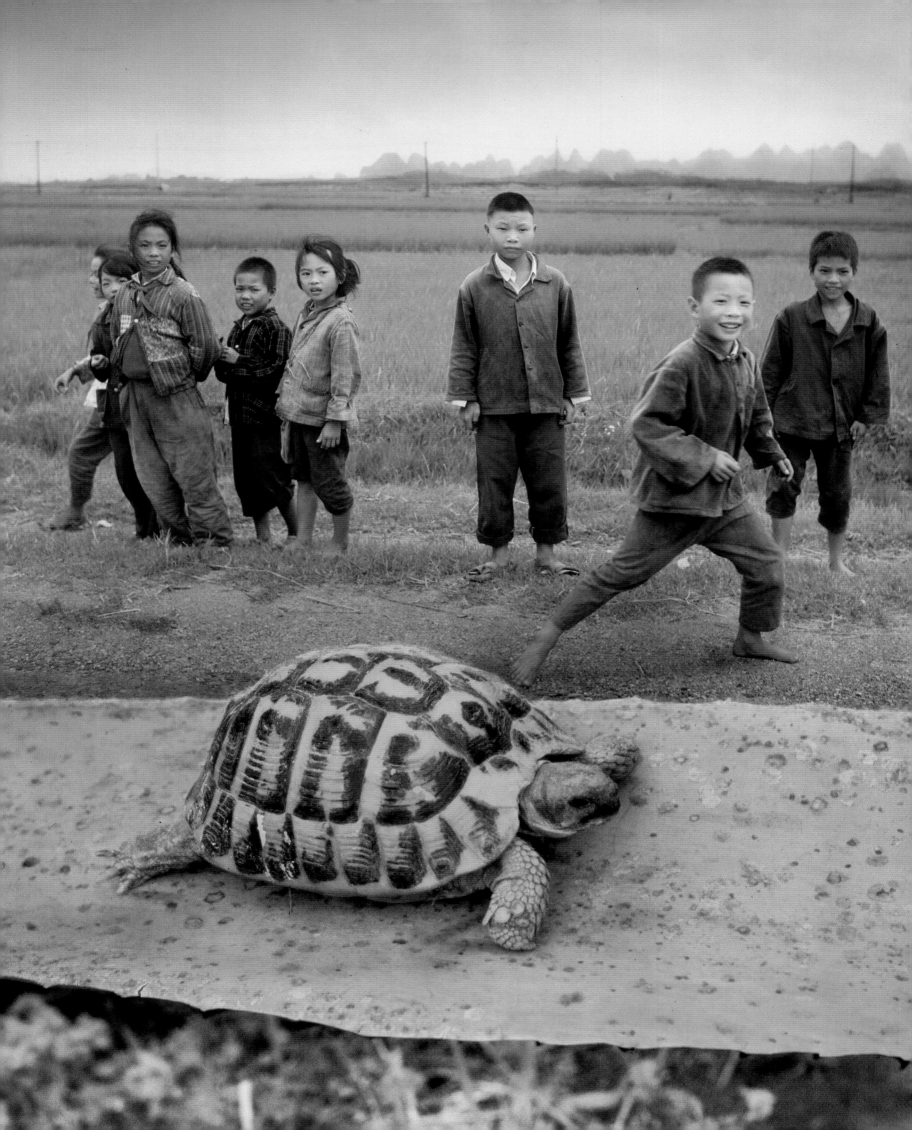

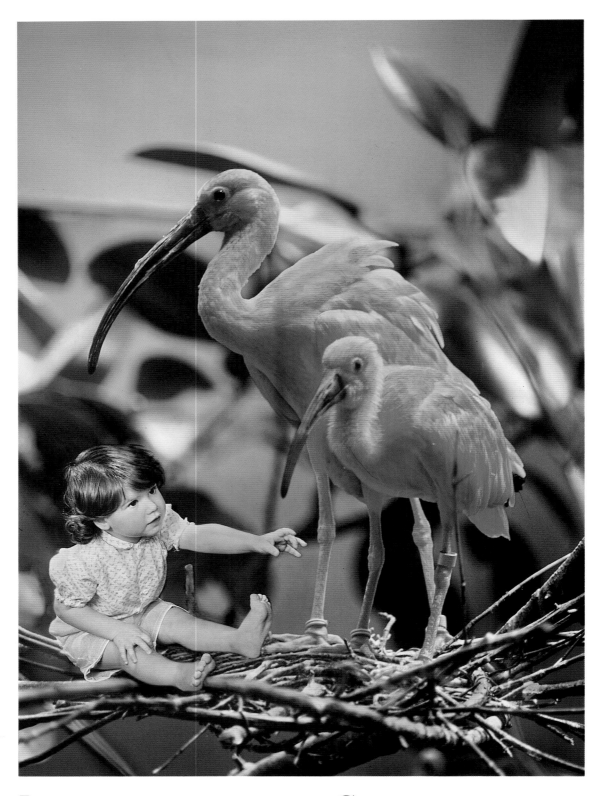

Imagination is more important than knowledge.

Albert Einstein

Good breeding consists in concealing how much we think of ourselves and how little we think of the other person.

Mark Twain

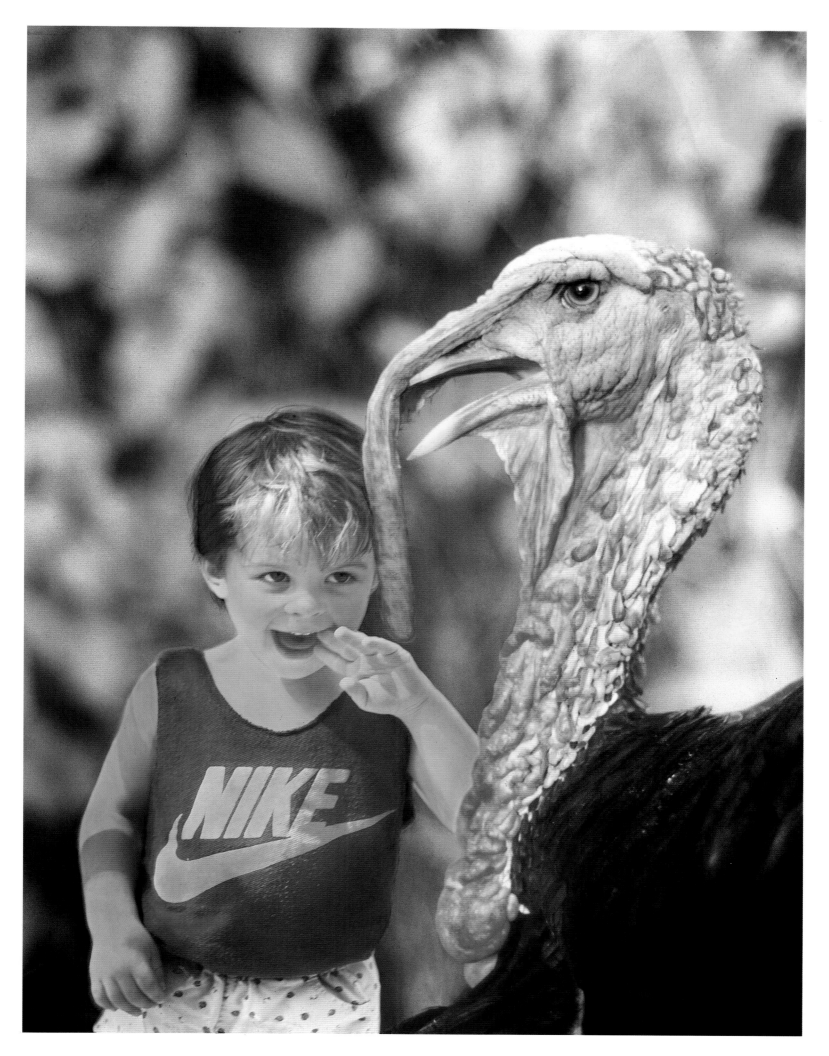

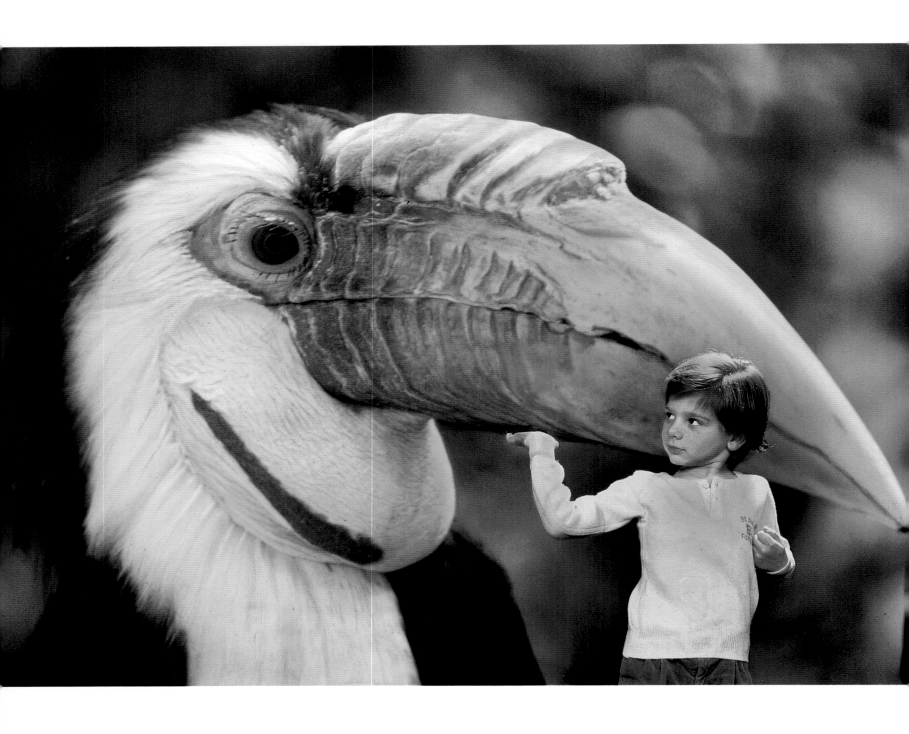

Is it impossible to enjoy idling thoroughly
unless one has plenty of work to do.

Jerome K. Jerome

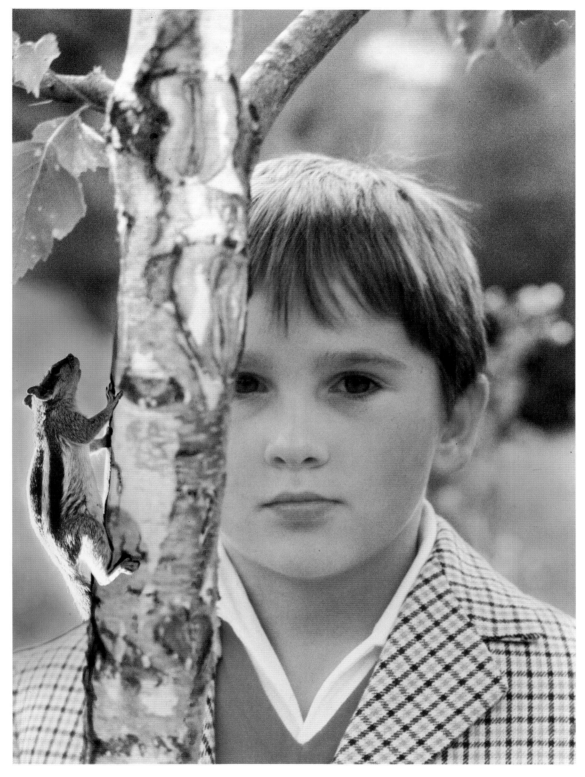

Civilization is just a slow process of learning to be kind.

Charles L. Lucas

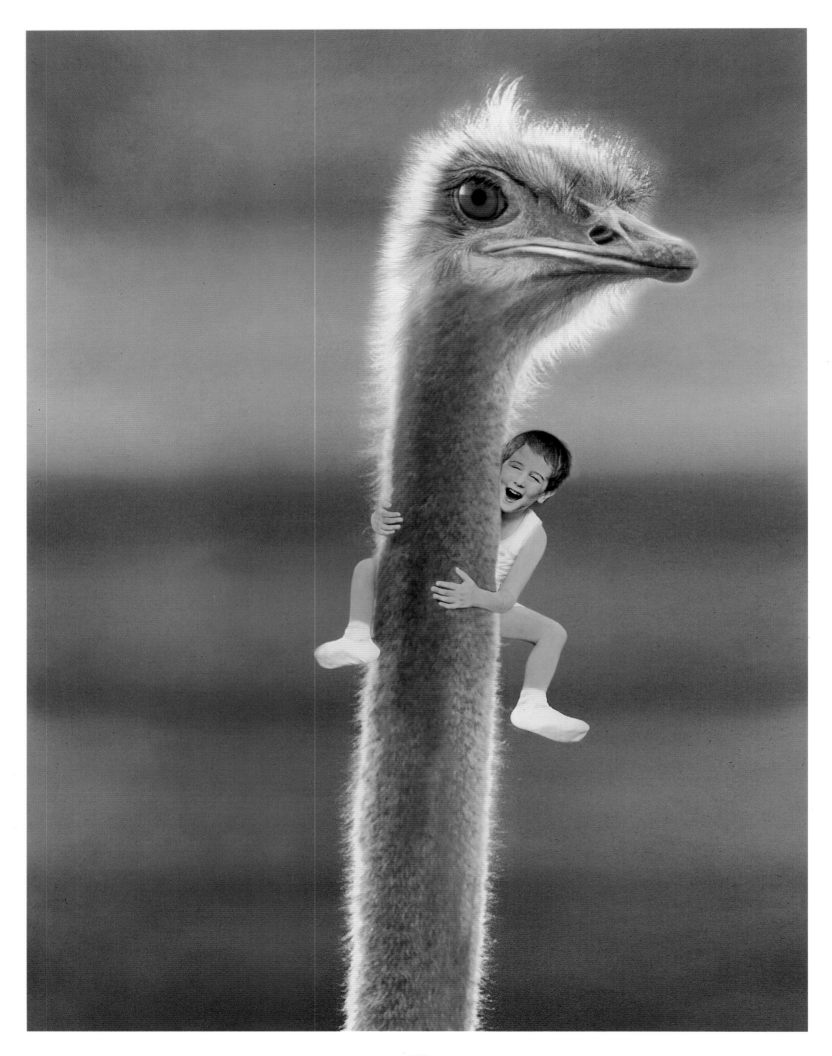

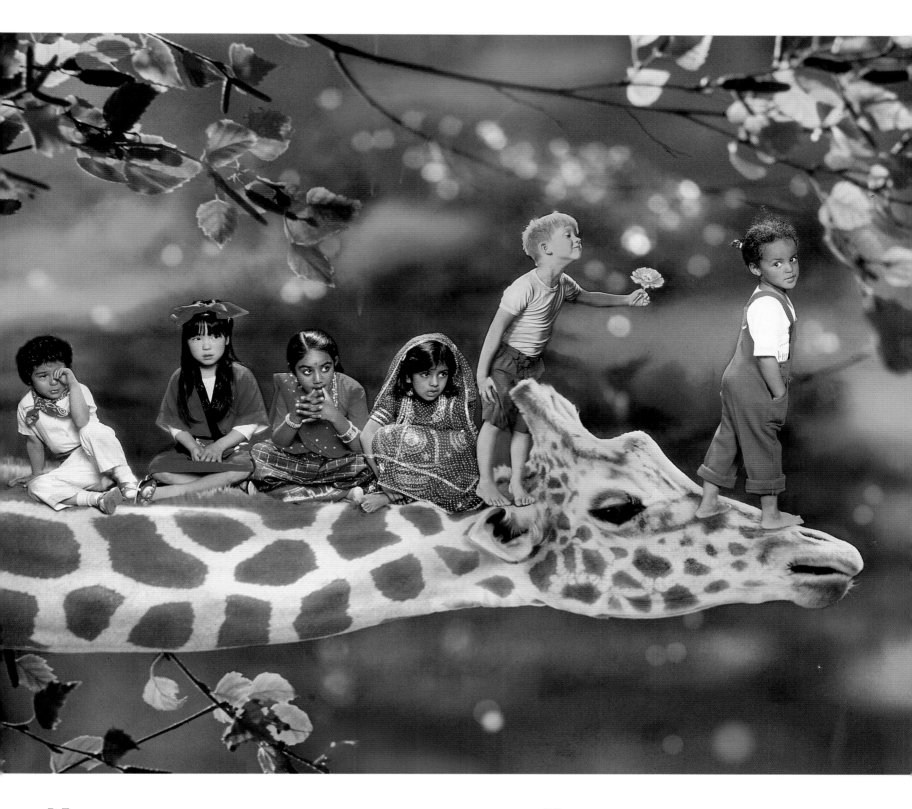

No one reaches a high position without daring.

Syros

There is no other way to be happy: live for others.

Follerean

The greatest remedy for anger is delay. ▷

Lucius A. Seneca

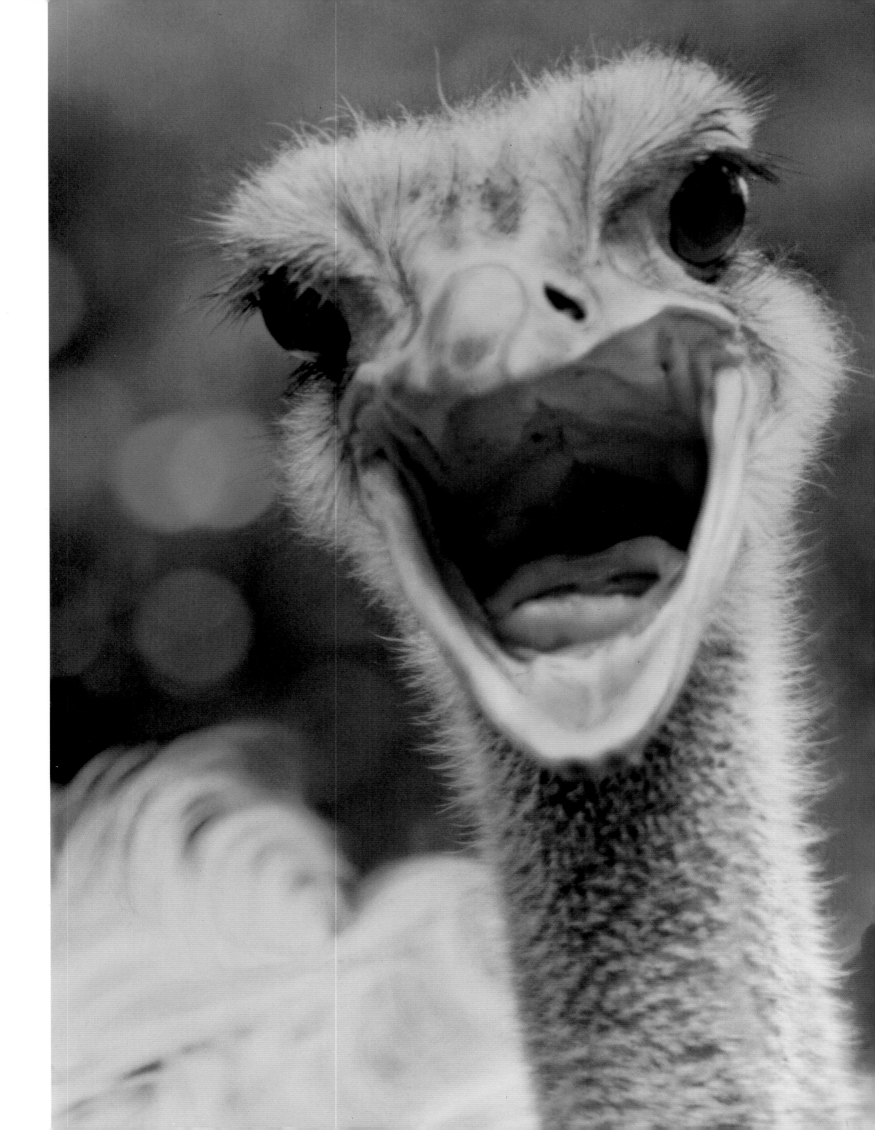

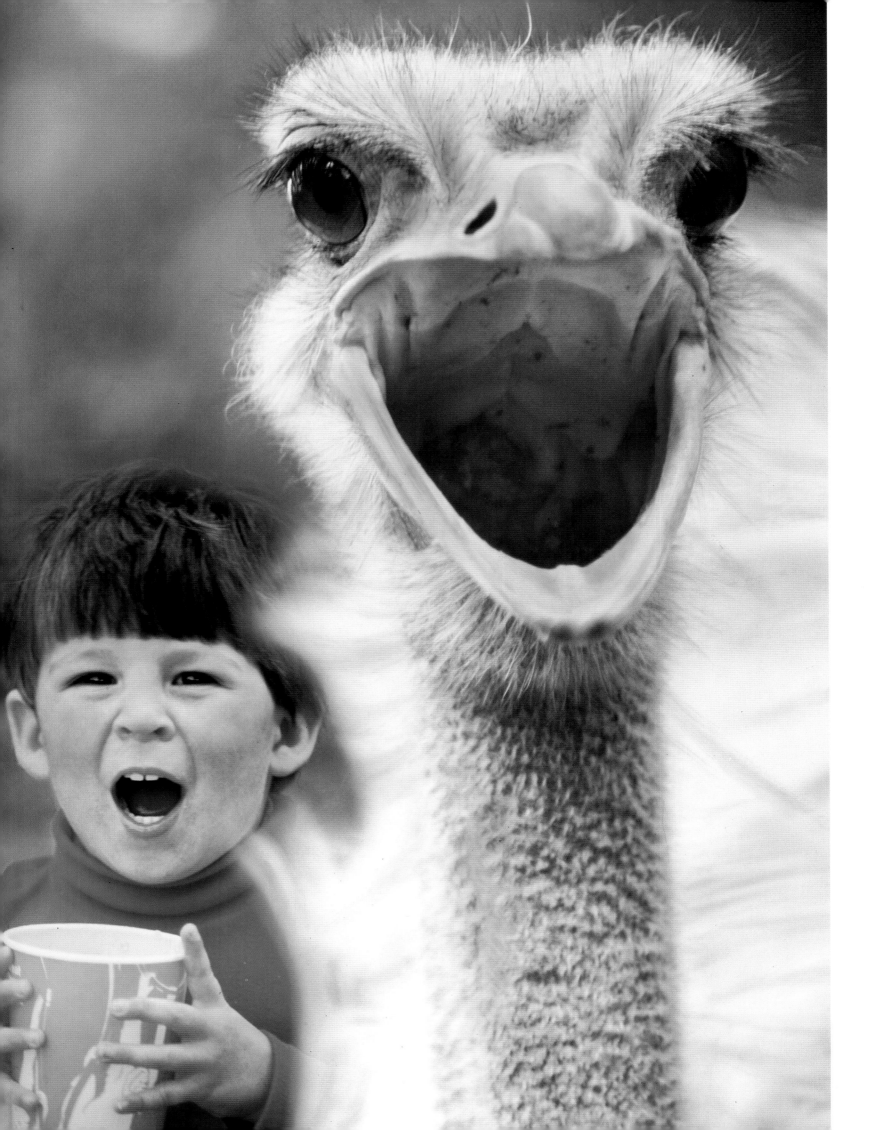

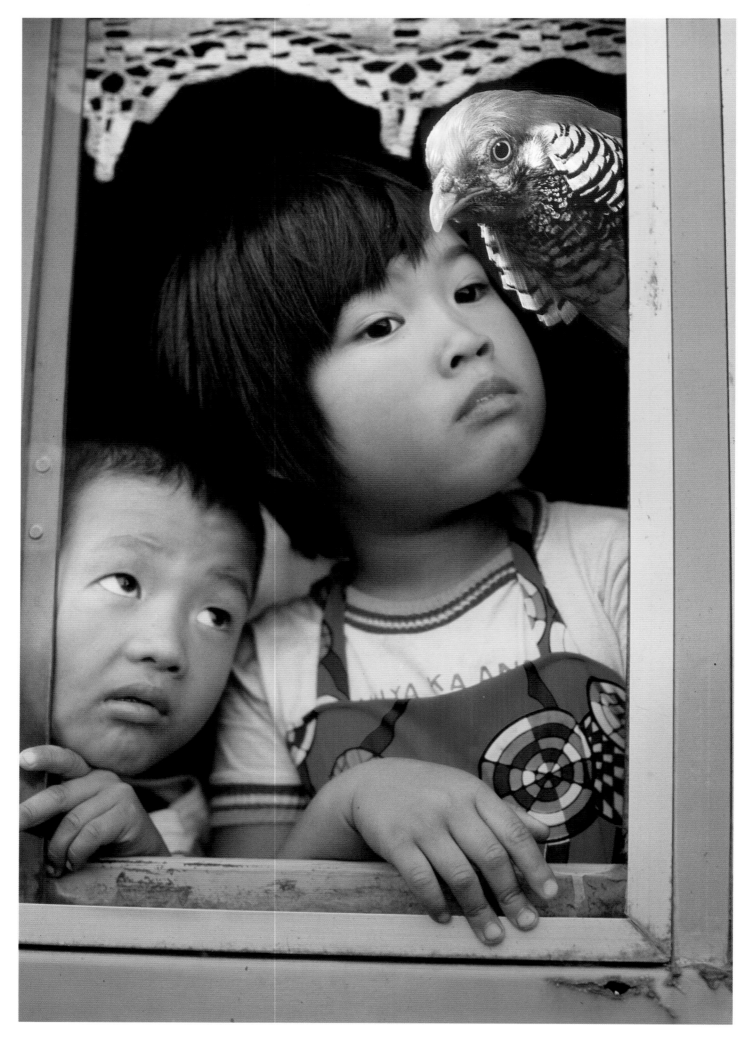

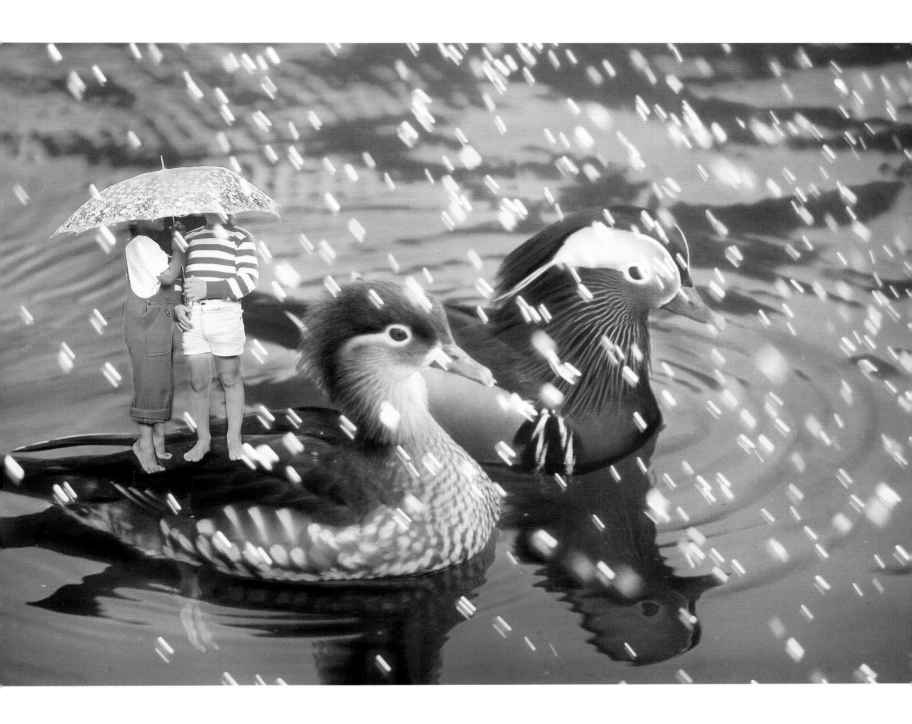

I am very fond of the company of ladies;
I like their beauty, I like their delicacy,
I like their vivacity, and I like their *silence*.

Samuel Johnson

You must not lose faith in humanity.
Humanity is an ocean; if a few drops of the ocean
are dirty, the ocean does not become dirty.

Mahatma Gandhi

Togetherness in Life

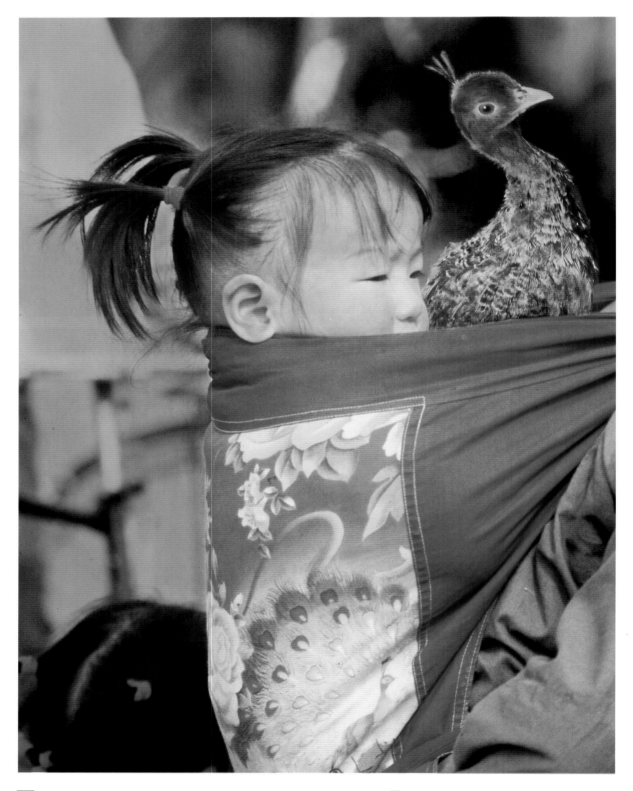

The trouble with modern comforts is that they are very uncomfortable.

Henry Ford

Love is the humblest force, but also the most powerful in the world.

Mahatma Gandhi

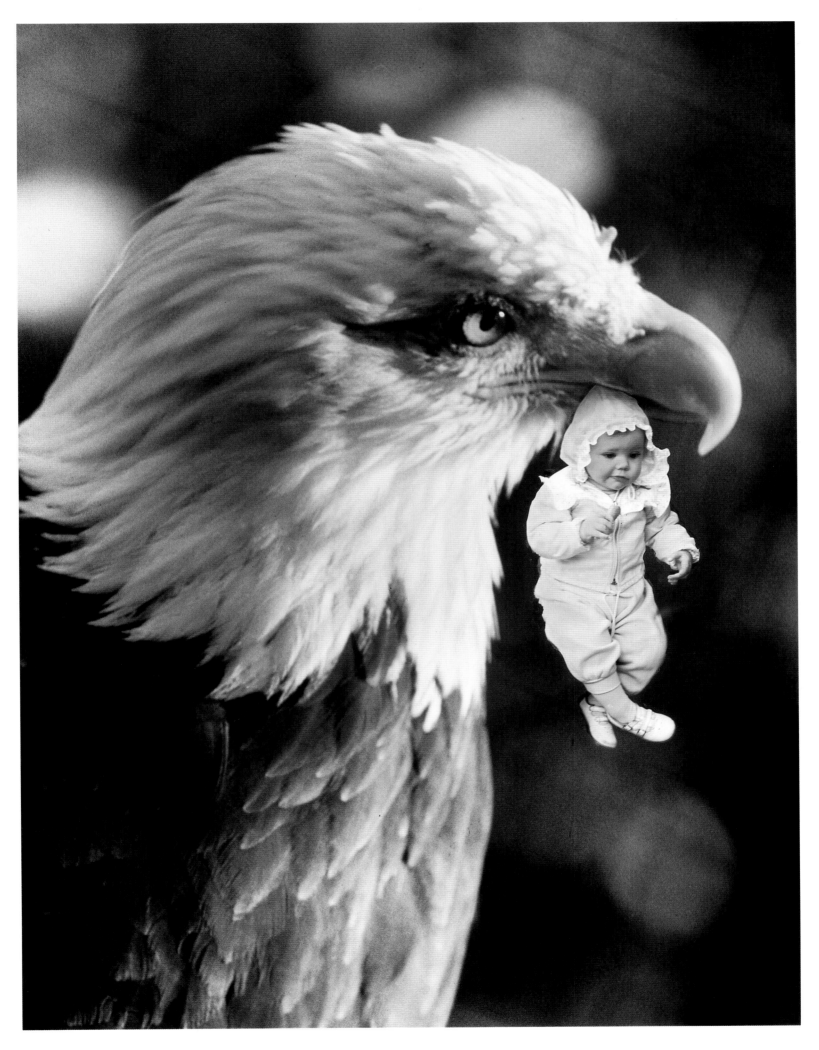

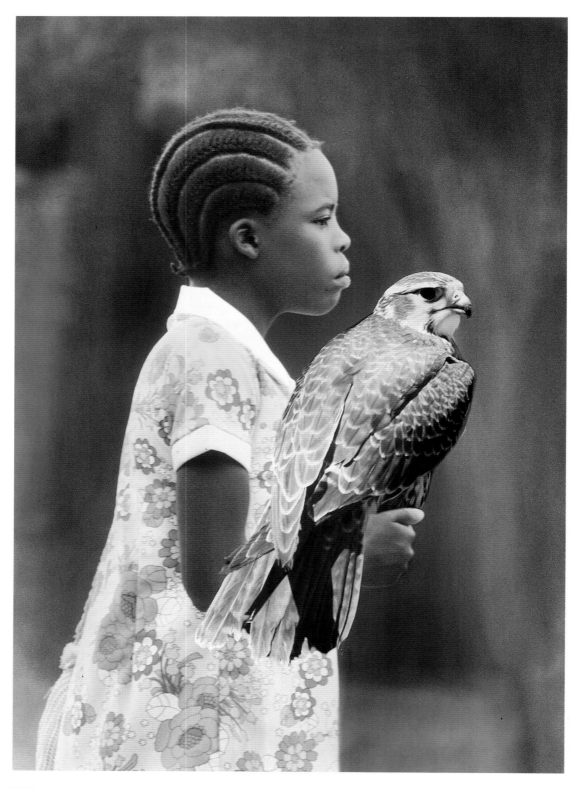

You will only grow up
when you are alone.

Hindu proverb

The spirit's strength makes
us giants.

A. P. Dossi

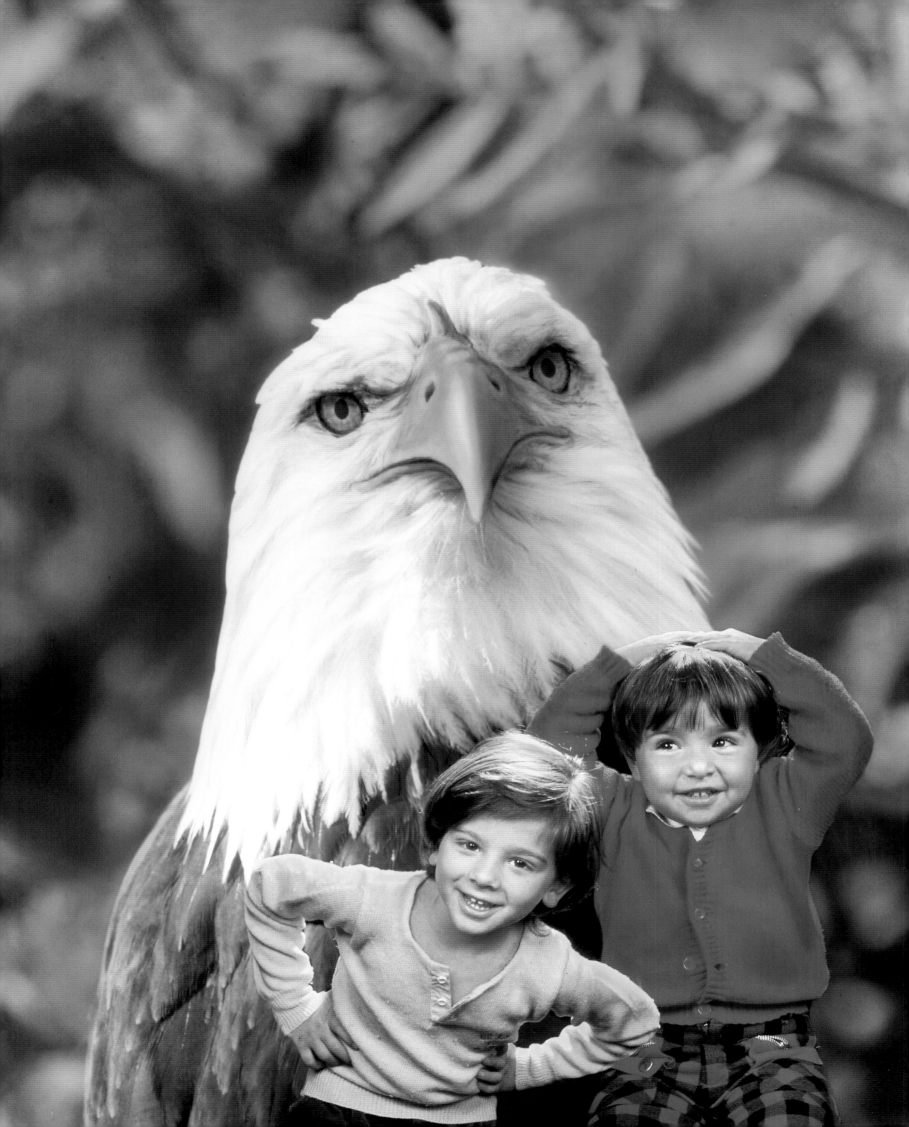

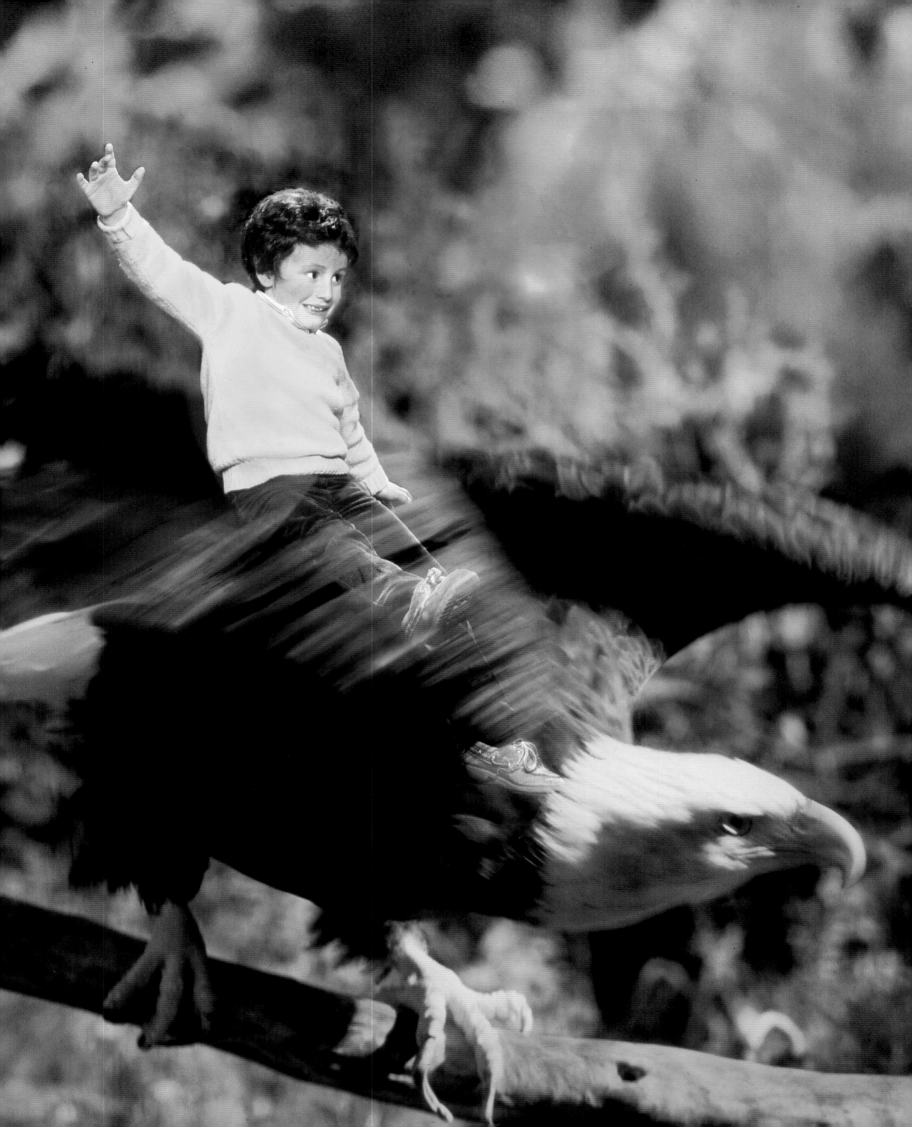

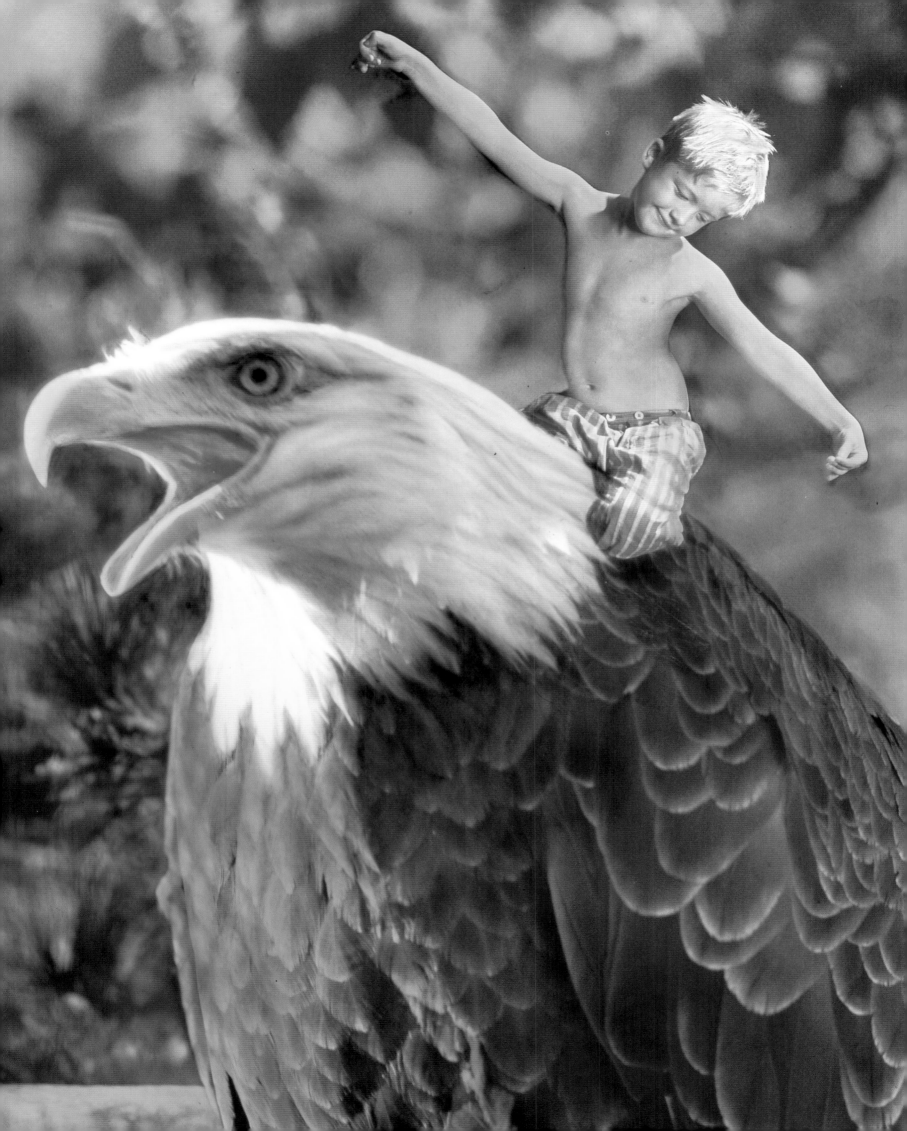

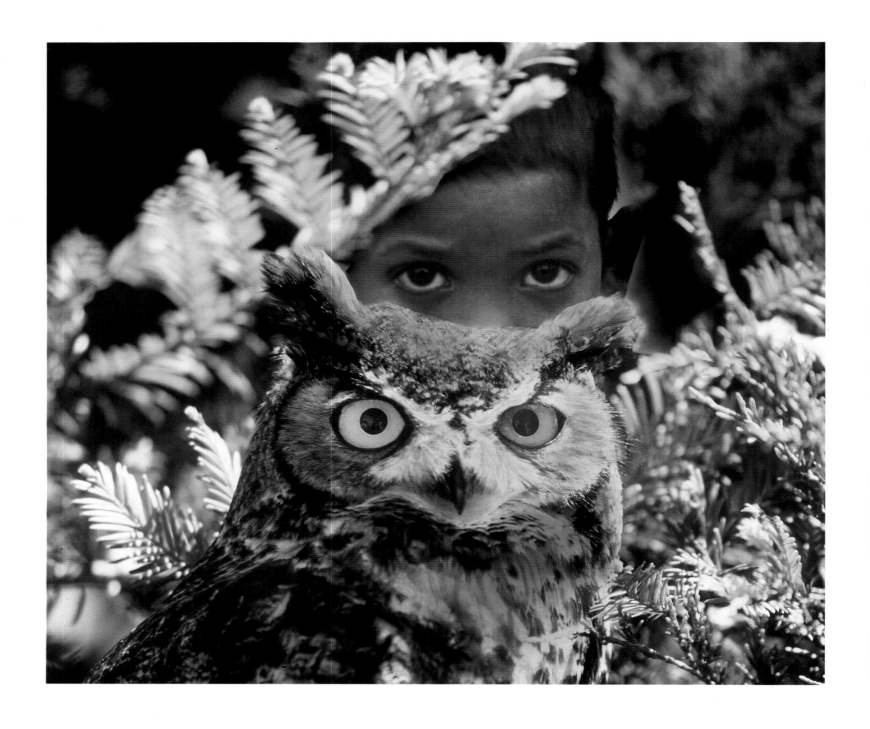

Everyone should see himself through his neighbor's eyes, at least once.

Petit Senn

Great men are not measured by their fortunes but by their virtues.

Cornelio Nepote

◁ Togetherness with everything that lives.
Friedrich Hölderlin

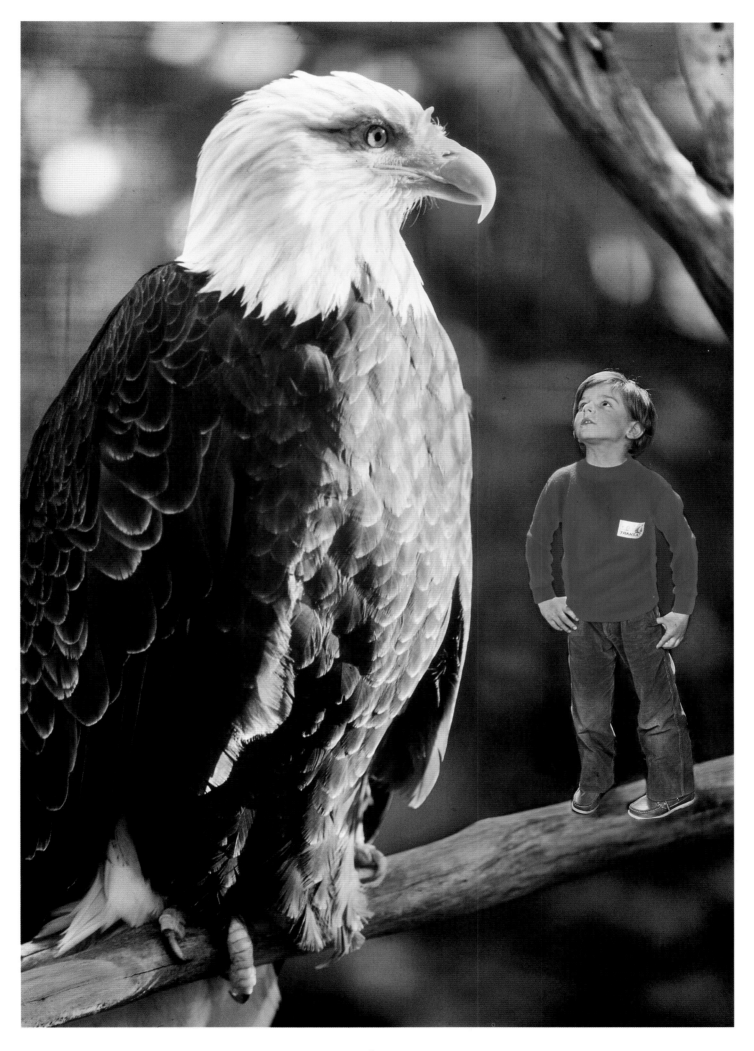

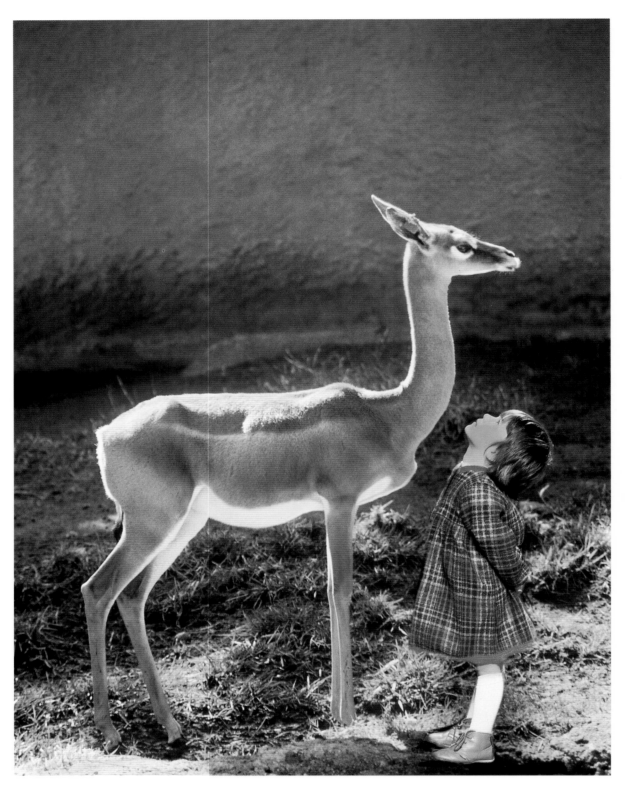

The great are only great because we are on our knees. Let us rise!

P. J. Proudhon

I dreamed, and saw that life was joy;
I woke up, and saw that life was service;
I served, and saw that in serving was joy.

Indian poem

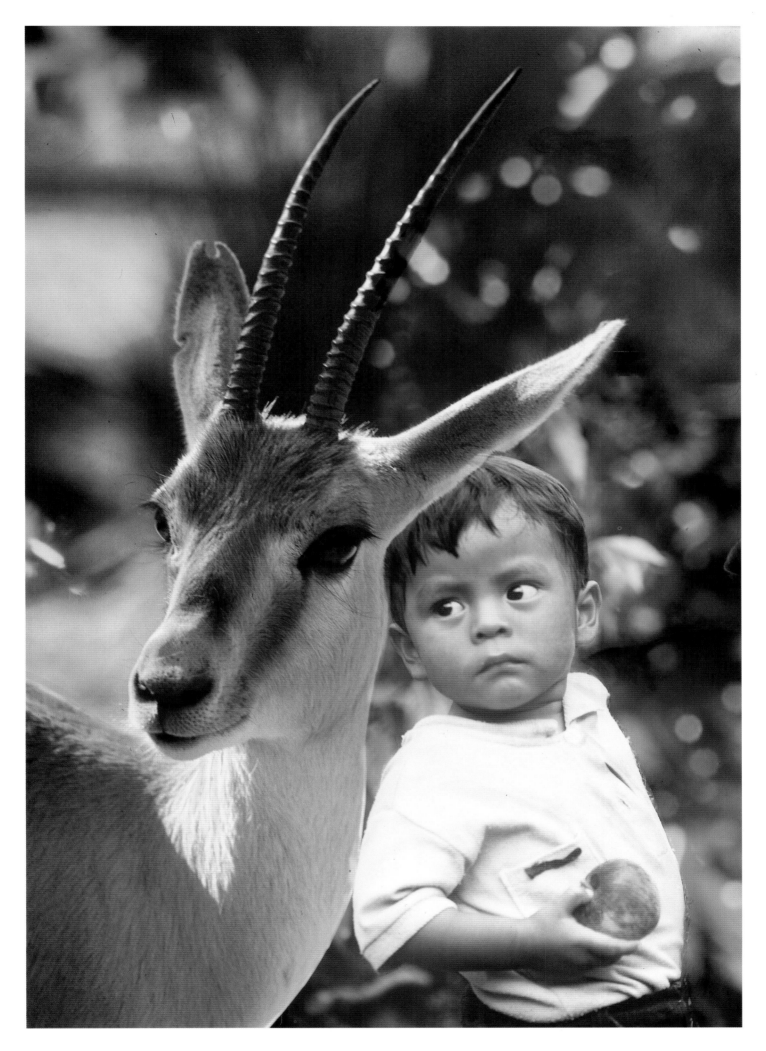

Prudence and Fear

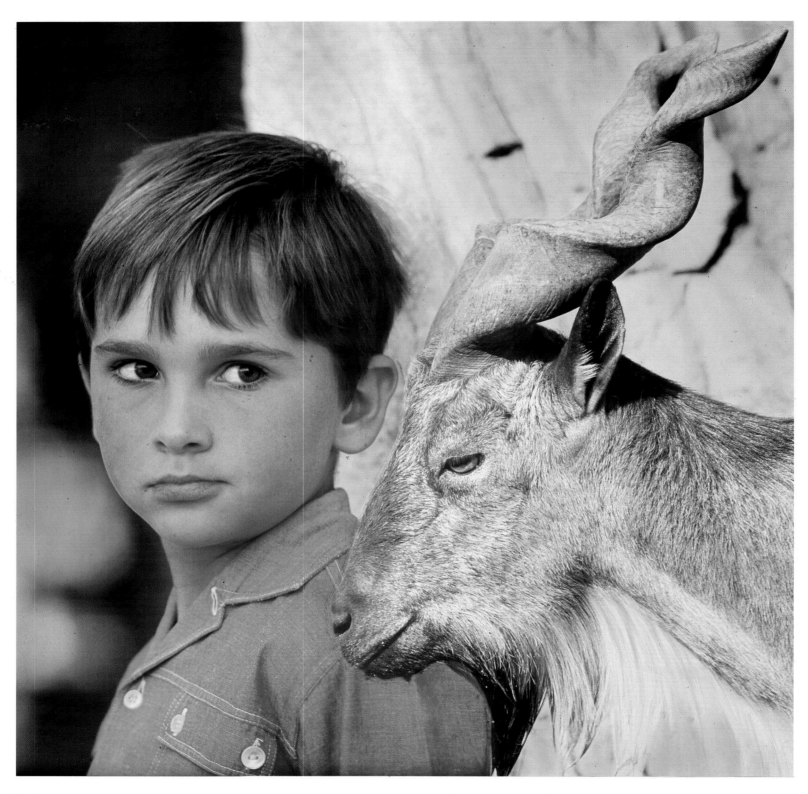

The great man is he who does not lose his child's heart.

Mencius

Among all the wild animals, the one which bites more dangerously is the slanderer, and among the domestic ones is the flatterer.

Diogenes

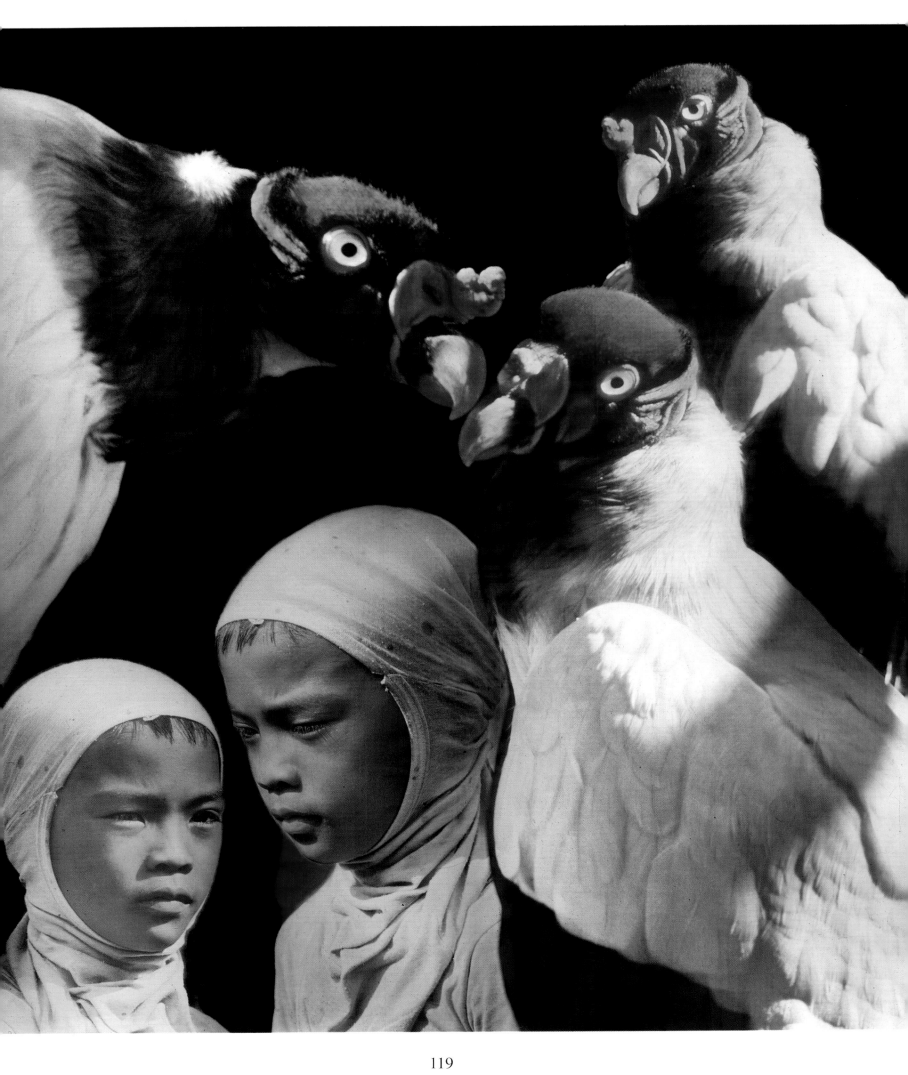

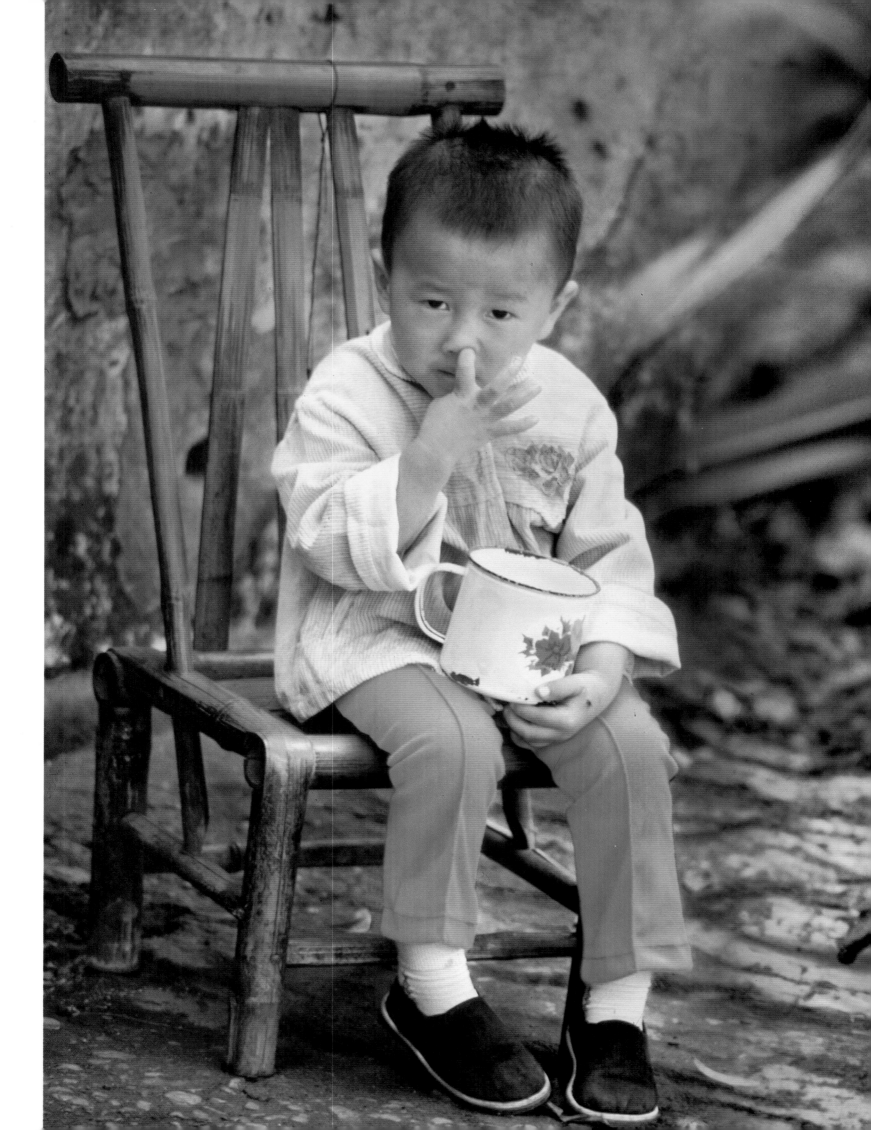

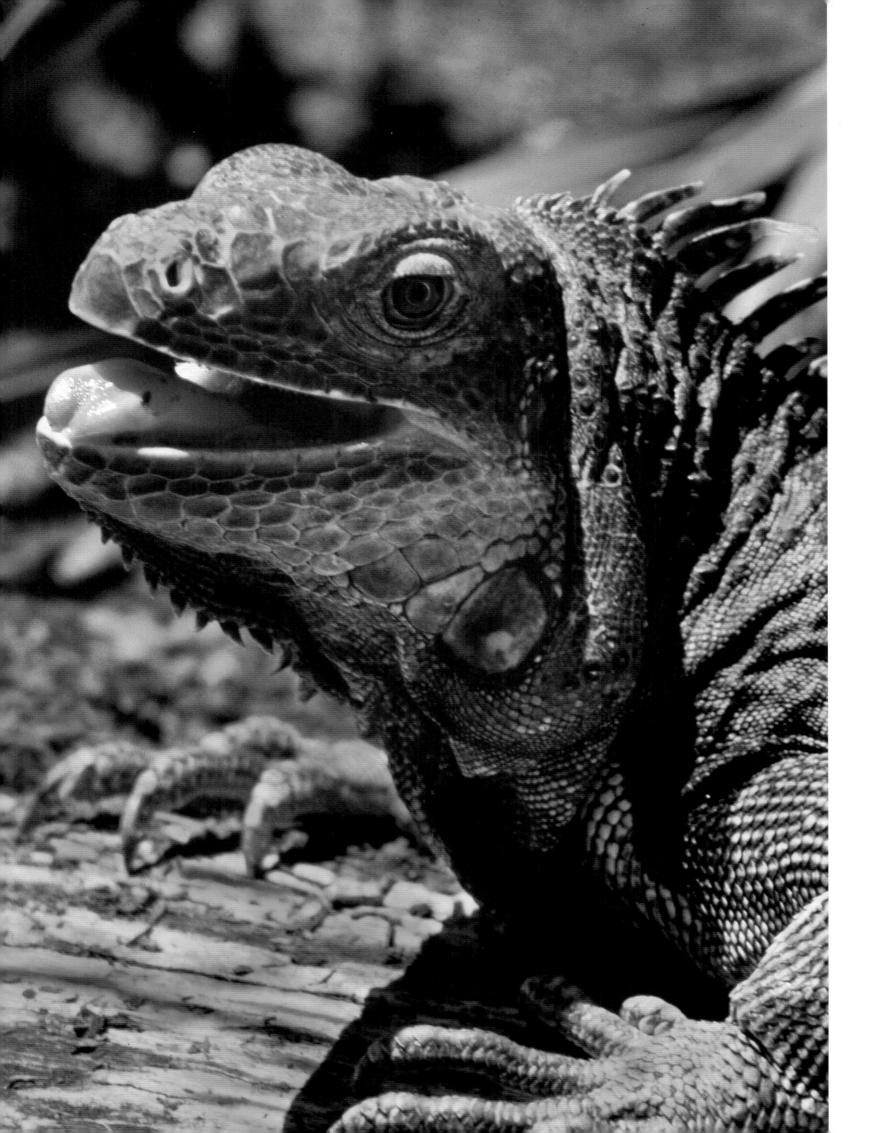

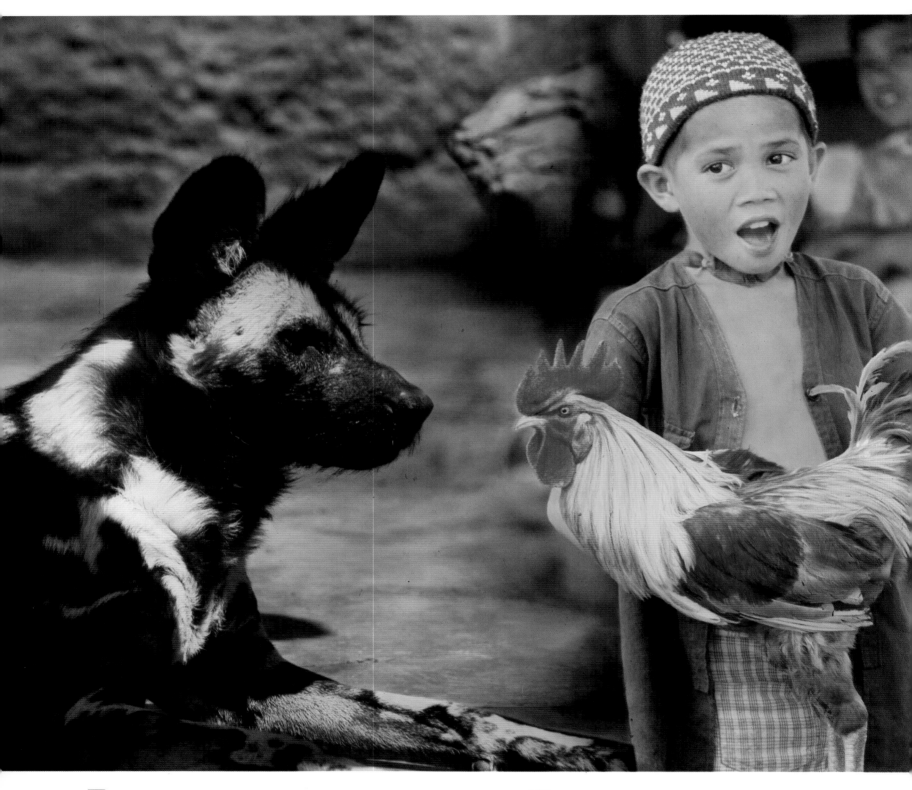

The only way to win a war is to prevent it.
George C. Marshall

◁ A beautiful face is a silent commendation.
Francis Bacon

"It's not for myself I plead," said the fox, "but I think the hens ought to be driven into the wood. There is always something for them there."

Thomas Haynes Bayly

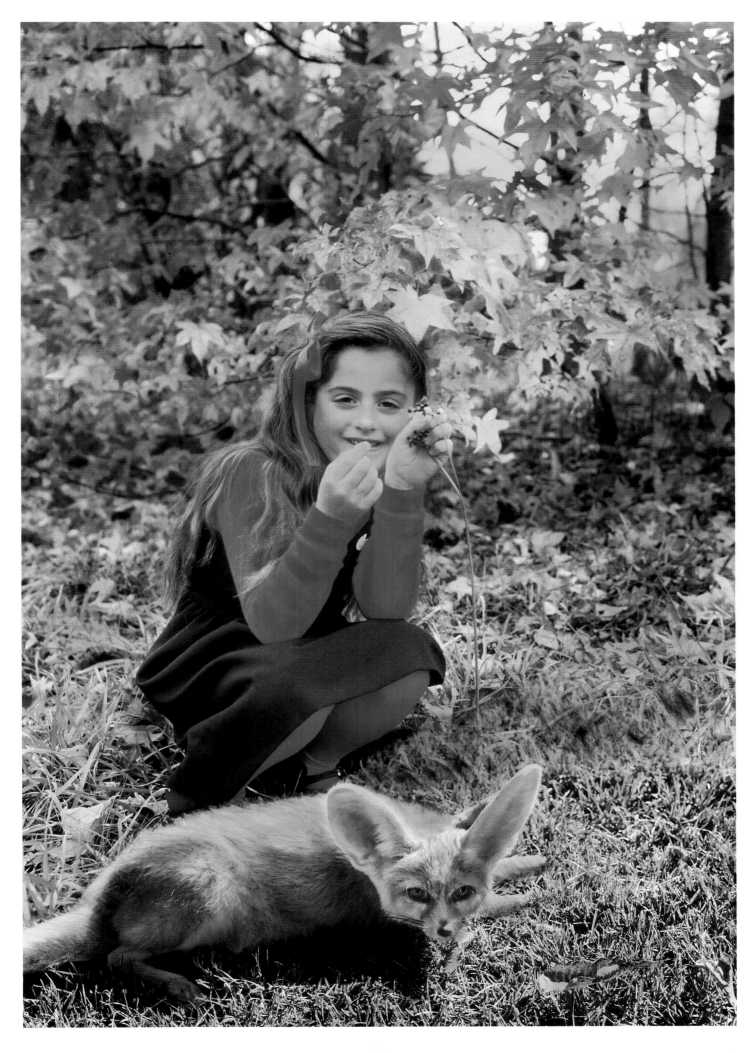

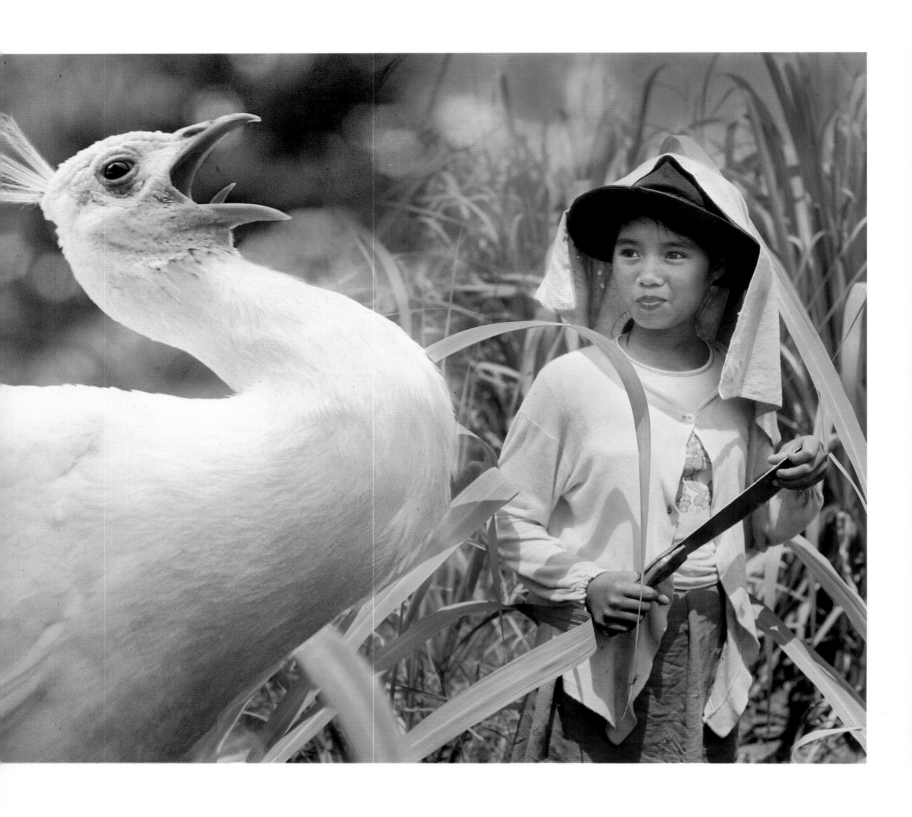

Knowledge and reason speak;
ignorance and irrationality shout.
Arturo Graf

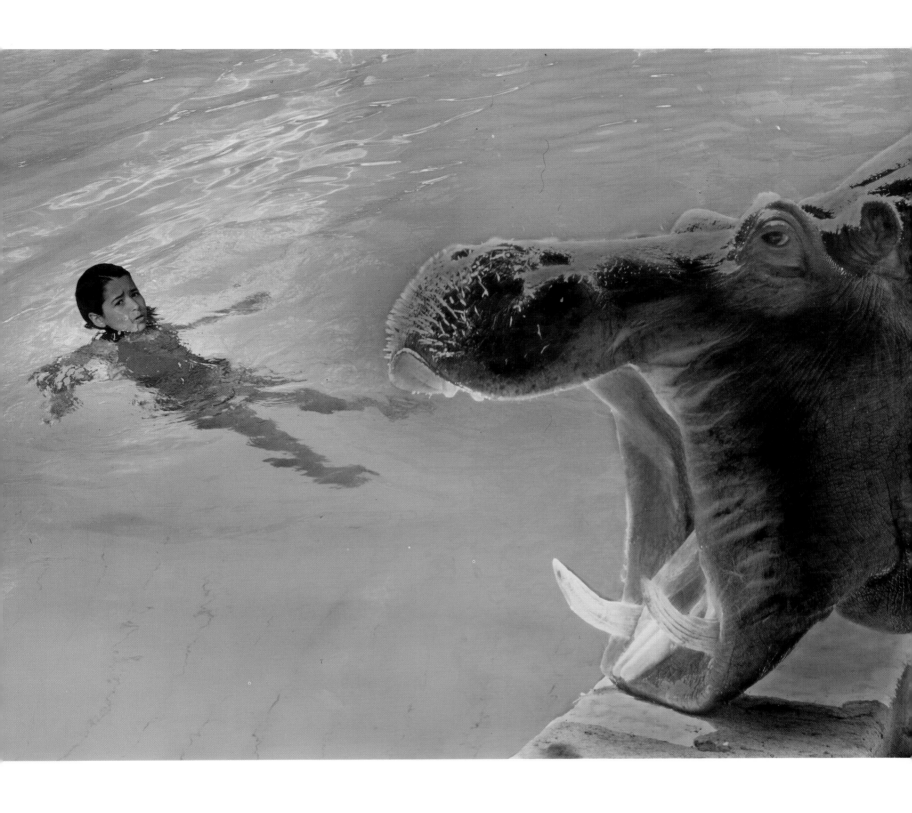

If one could win shouting,
the donkey would be a hero.
Danish proverb

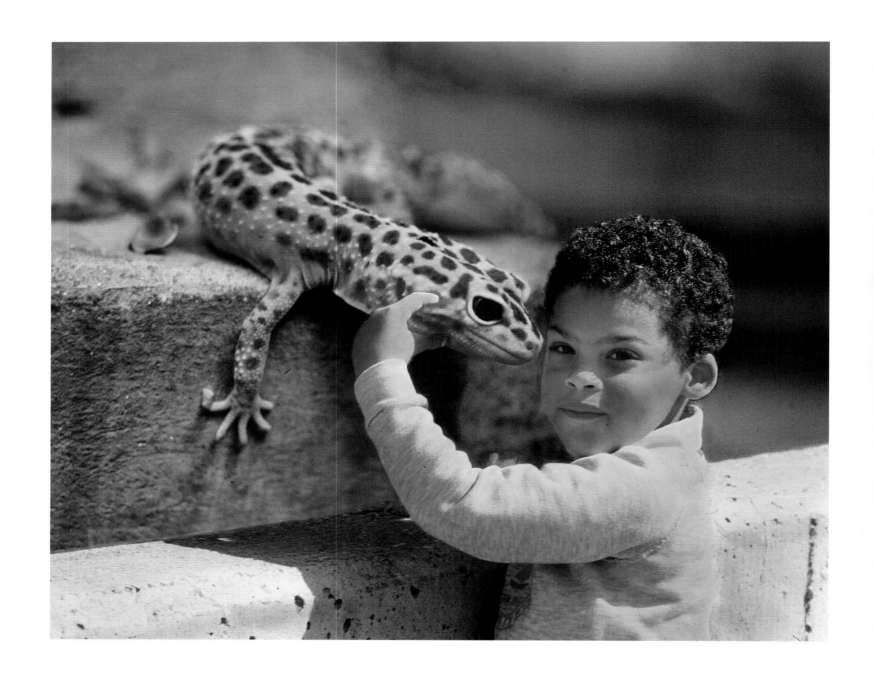

The game of fortune is changeable like the moon.
Jean de La Fontaine

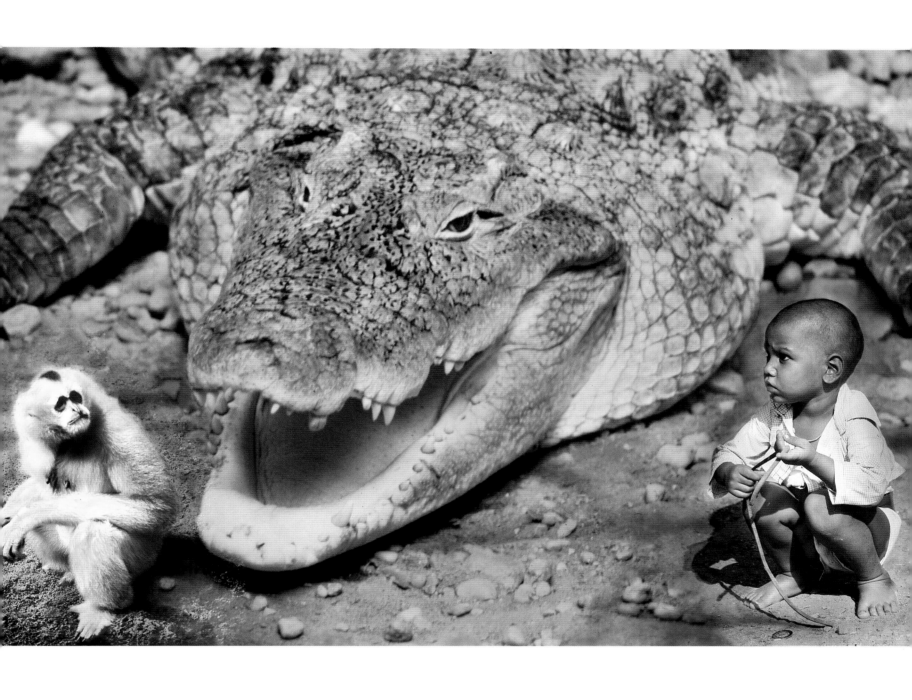

Everything comes to those who can wait.
François Rabelais

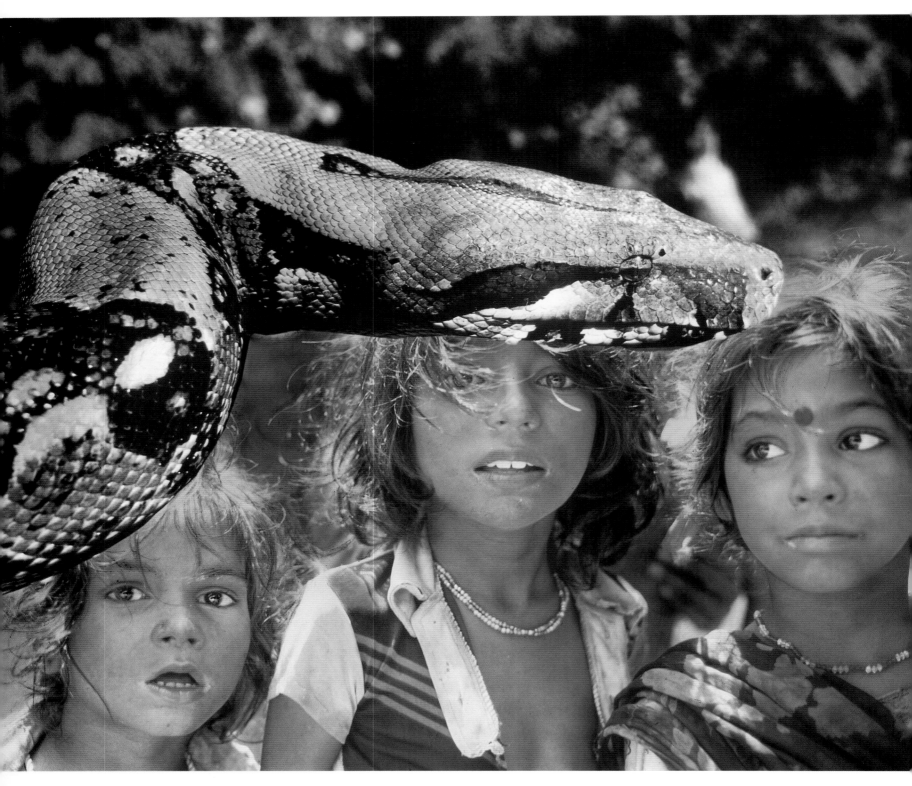

There is some soul of goodness in things evil,
Would men observingly distil it out.

William Shakespeare

No man is good enough to govern another
man without that other's consent.

Abraham Lincoln

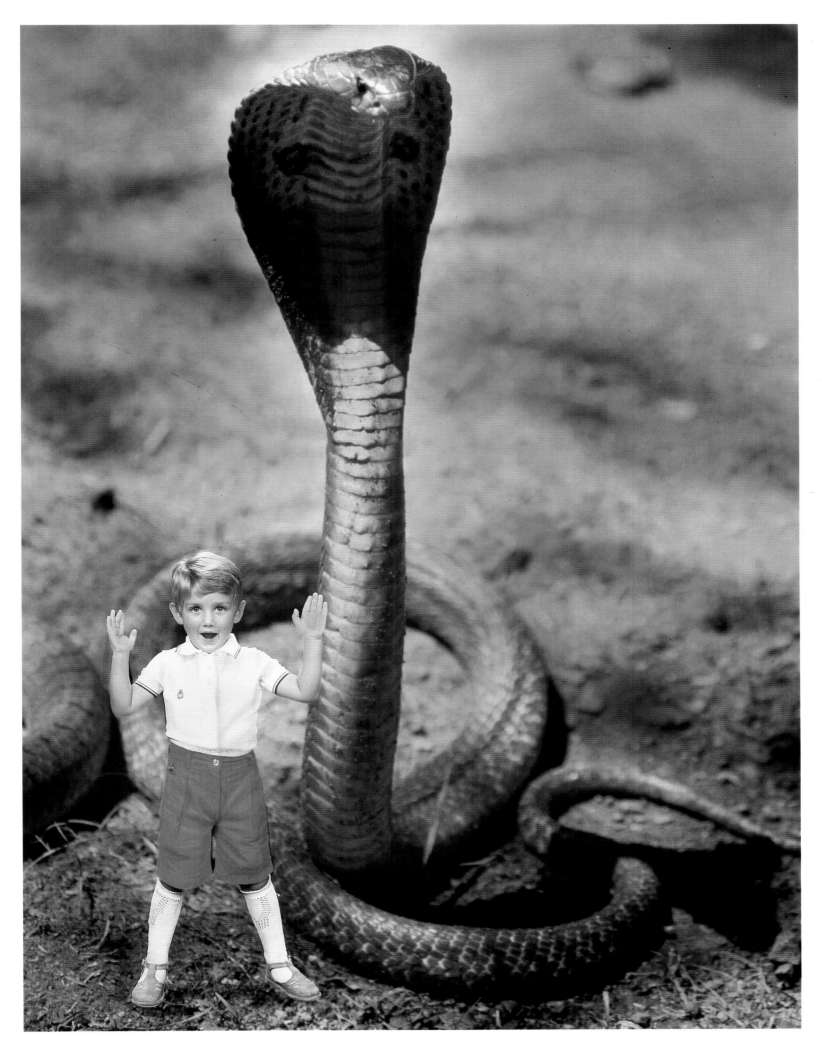

Living Free

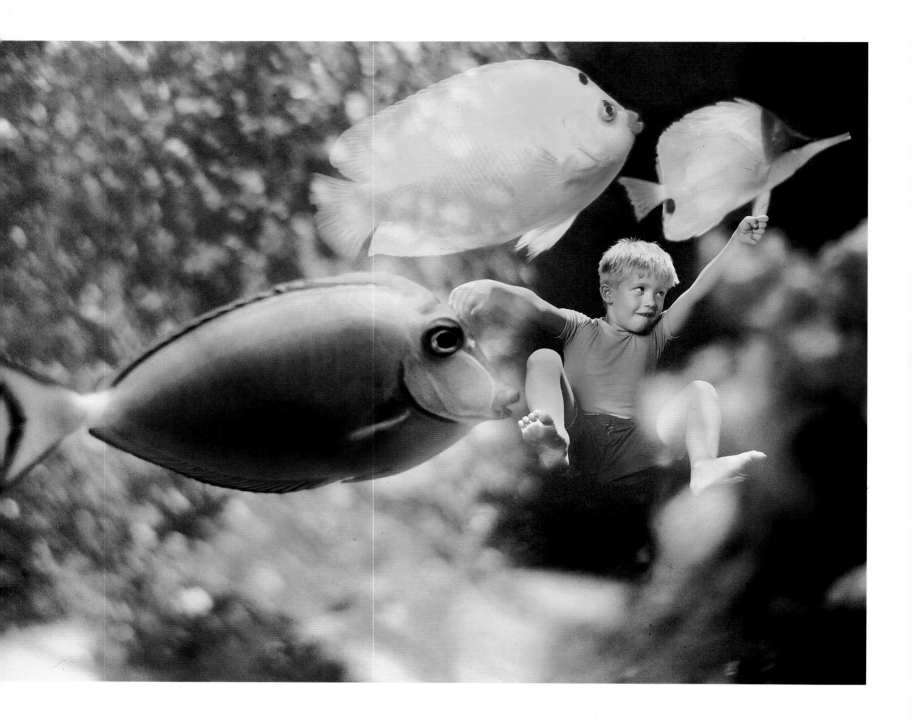

Roll on, thou deep and dark blue Ocean — roll!...
Man marks the earth with ruin — his control
Stops with the shore.

Lord Byron

No human being, however great,
or powerful, was ever so free as a fish.

John Ruskin

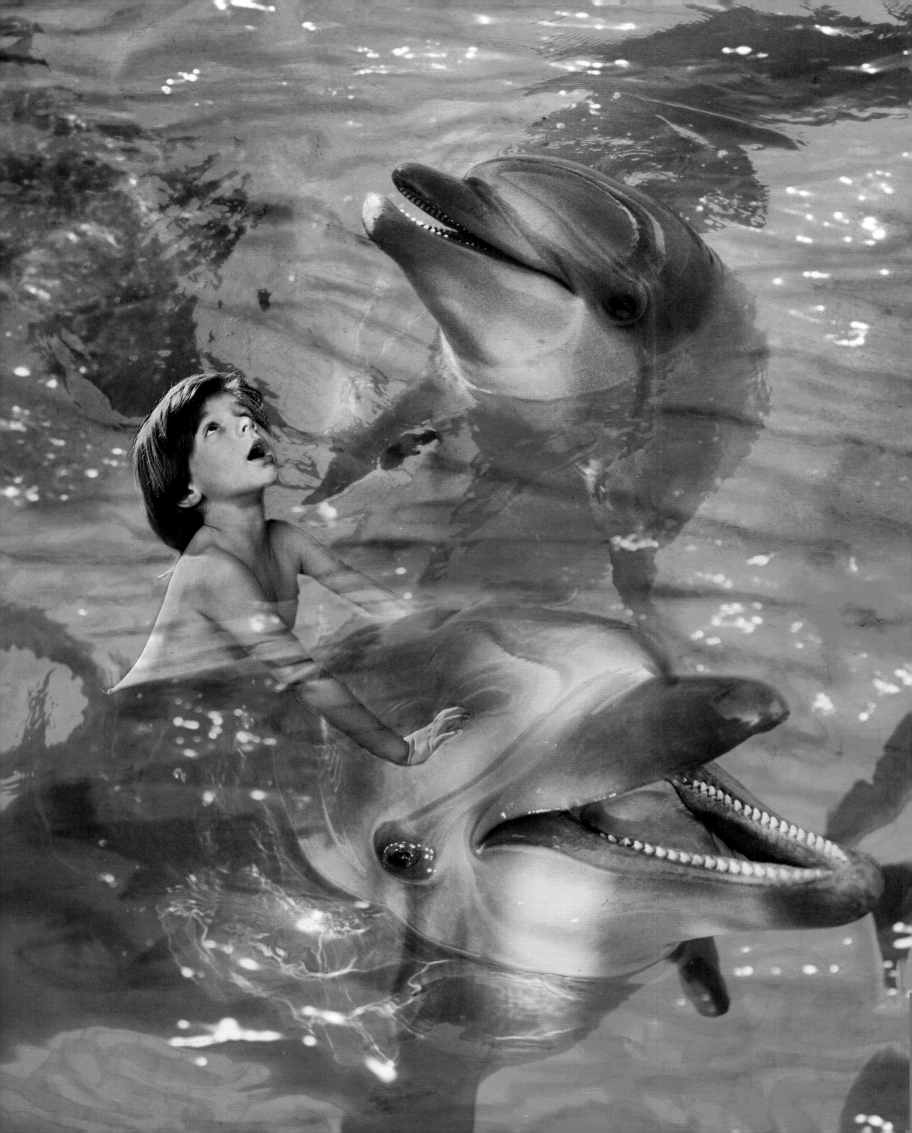

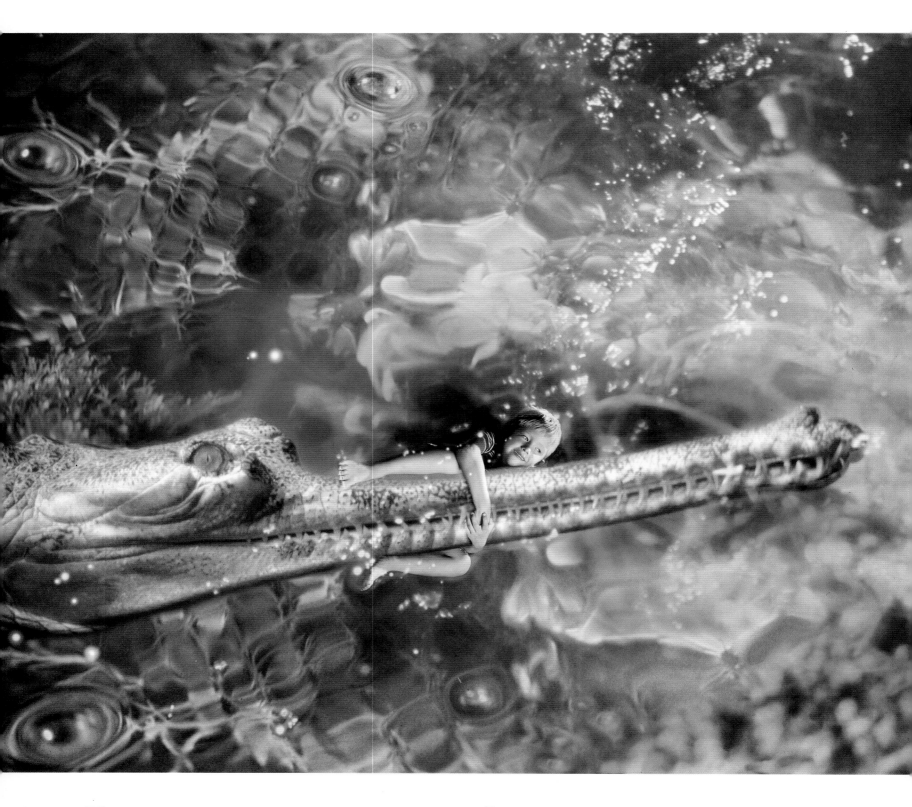

The world is a nettle; disturb it, it stings.
Grasp it firmly, it stings not.

Owen Meredith

Life's made of losses, and crosses and crowns.

Grace E. Easley

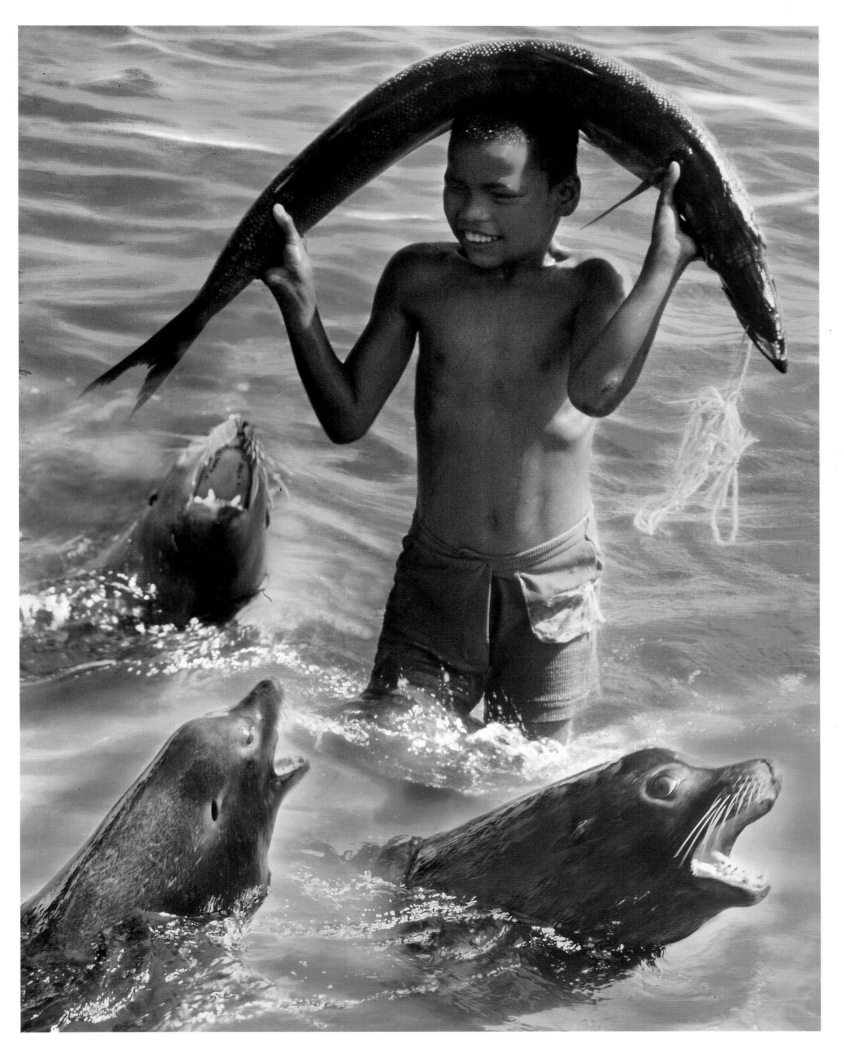

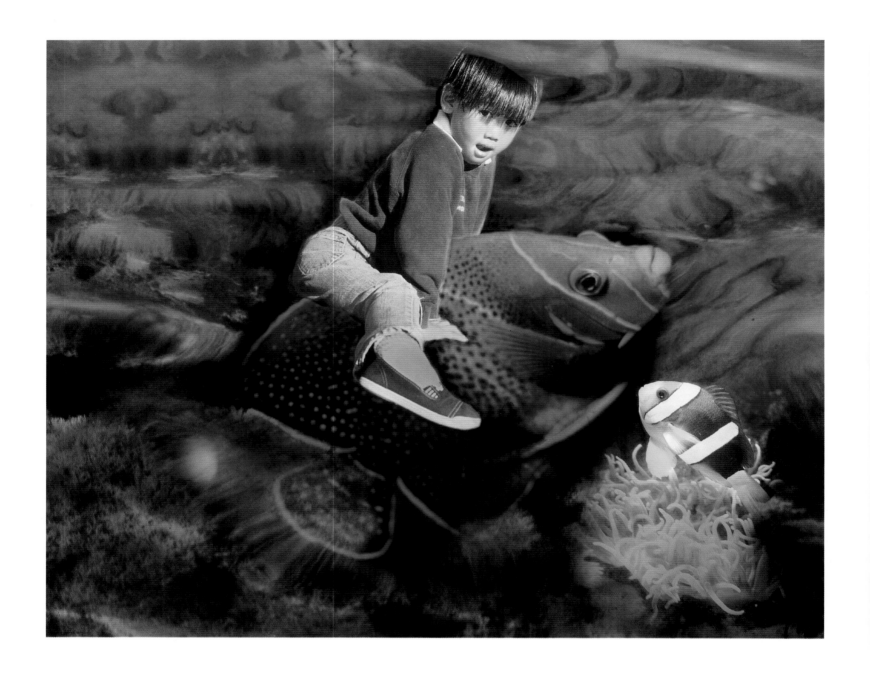

I've a friend, over the sea;
I like him but he loves me.
Robert Browning

There is a magic in the distance,
where the sea-line meets the sky.
Alfred Noyes

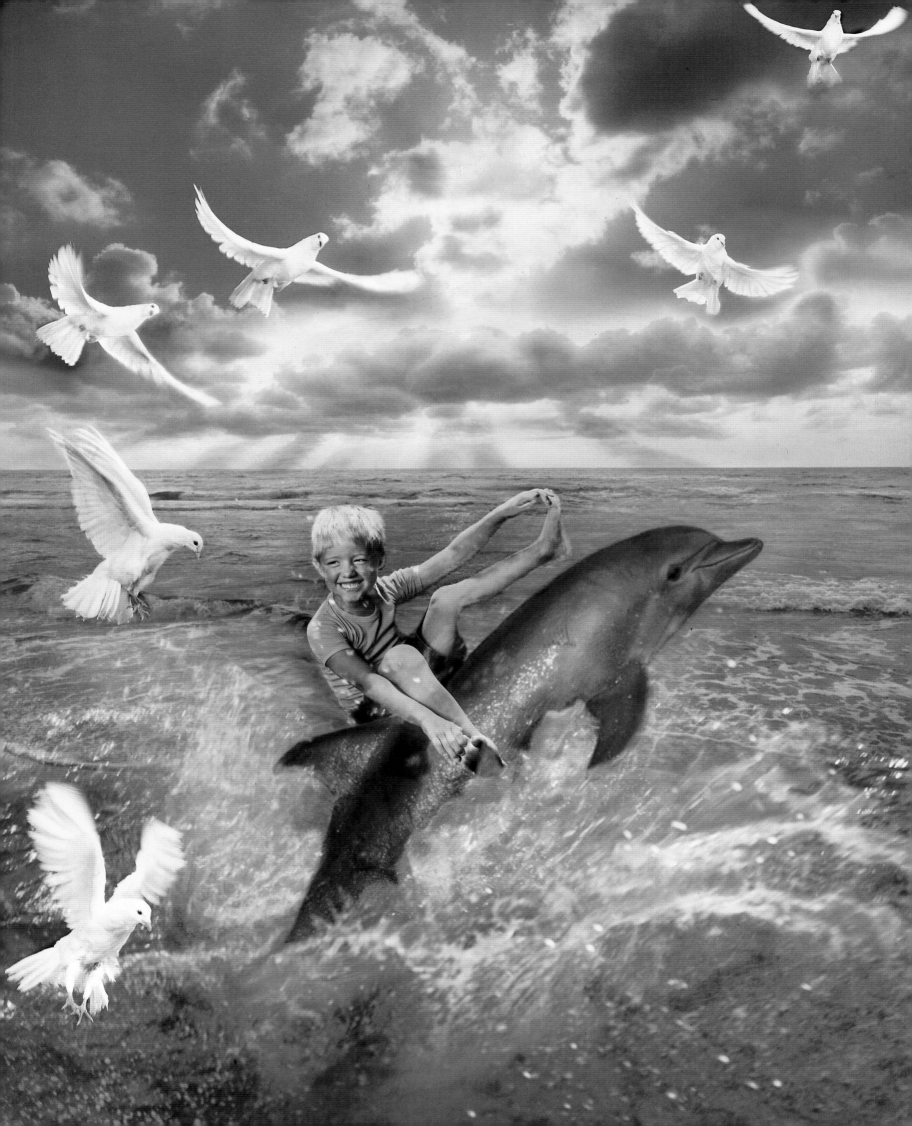

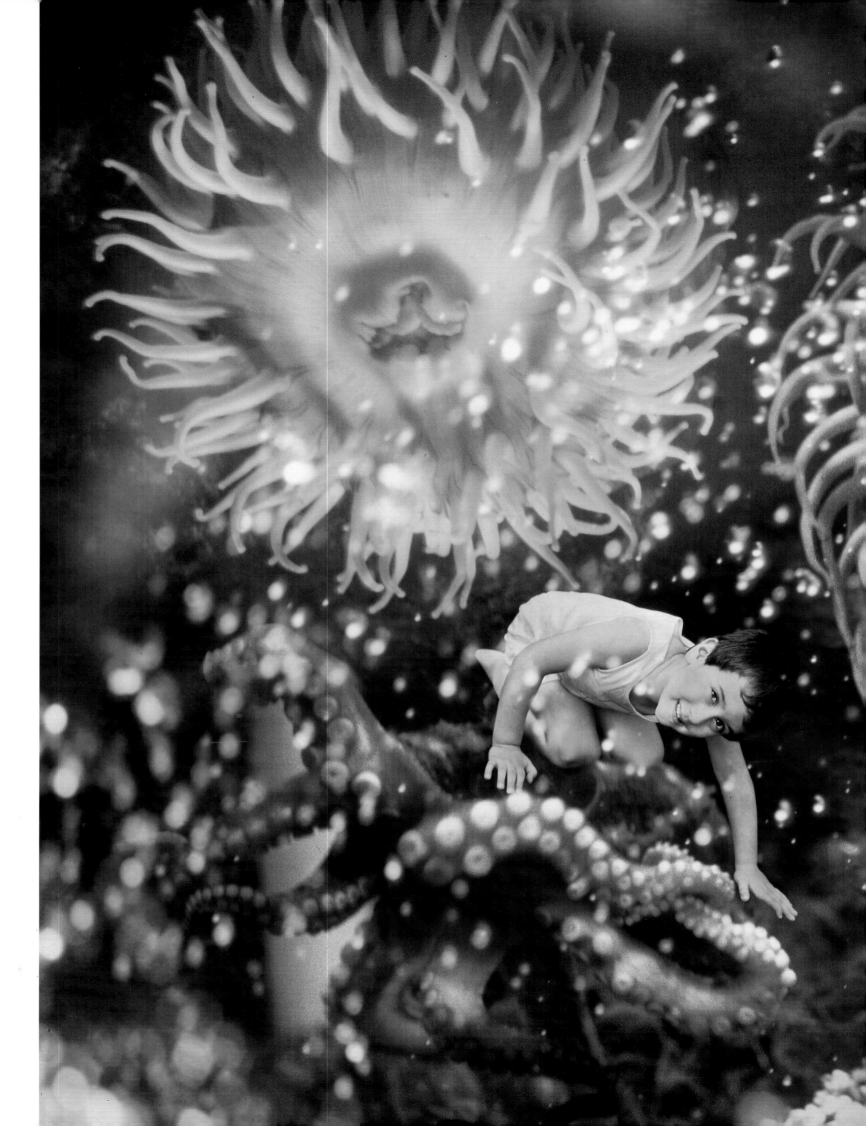

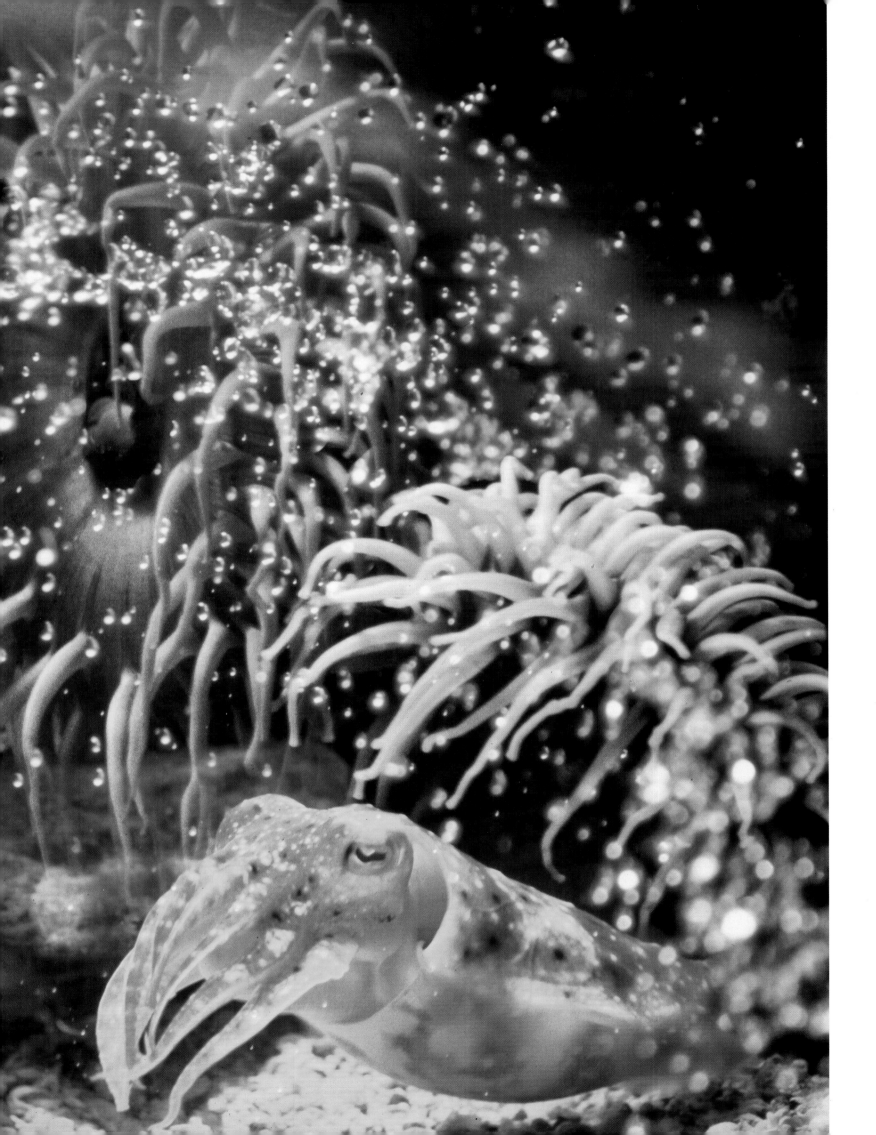

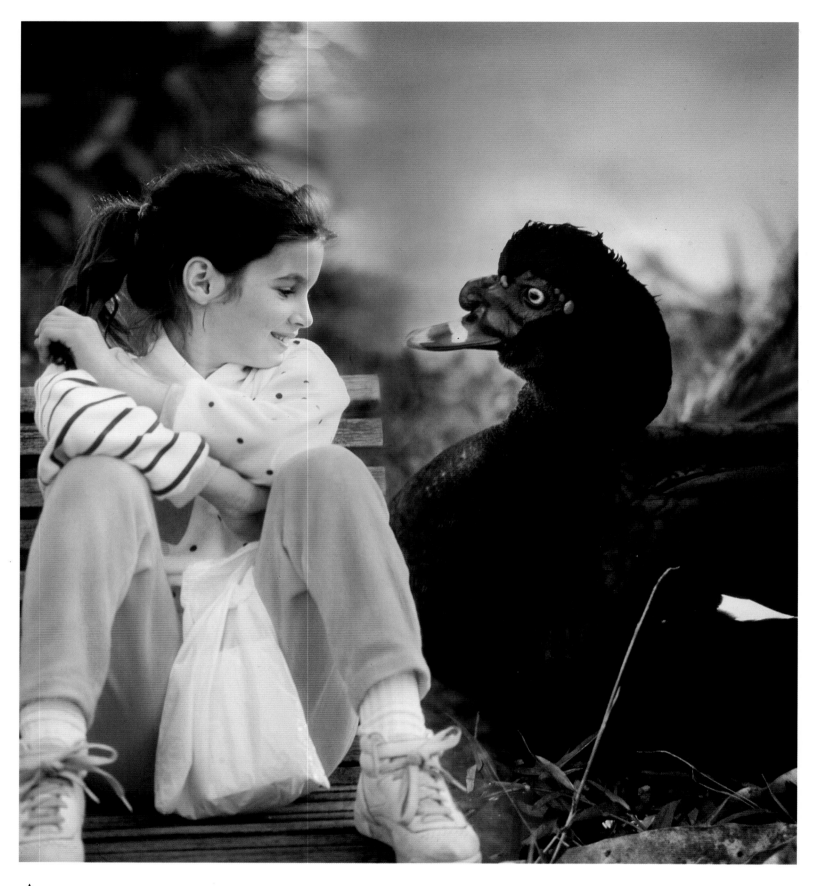

A smile can add a thread to the very brief weft of life.
Laurence Sterne

◁ And I have loved thee, Ocean!
Lord Byron

THE OFFENDED INNOCENCE

The True Causes of So Many Childhood Dramas

ERNESTO CAFFO

The notion of childhood has, in all societies, been all too often forgotten, its great possibilities negated, often breached in visible but mostly in invisible ways. Although some things have changed in our days, abuses on minors by adults, often precisely by those same people who ought to protect them — as their parents — violence, and abandon are a constant expression in all cultures and social classes.

Many children are not accepted by those who should take care of them from birth: many children are denied the tenderness needed for a harmonic growth, tenderness that represents an inalienable right. All too often children lack adult parents who can understand and follow them in their development process. Such a process is hindered when the child is without a suitable adult model unable to assume a role that no one has taught him, he cannot perform in a natural way, frequently because of personal experience.

Often a parent cannot understand the child, especially if the child does not fulfill the adult's unrealistic expectations. A handicap, even if minor, an undesired sex, and other "accidents of birth" can all be motives for a reluctant parent not to invest in his child. It is important that parents be taught to understand their children's language in order to help both their physical and their emotional growth.

Children-parents and Adult-children

The quality of life of many children is unacceptable. Although conditions are improving in some parts of the world, in many countries millions of children live in the streets without either protection and family care. This is only one of the unacceptable realities that face children. It is a widespread fact in many developing countries, mostly in South America. However, we find the same condition of abandonment in wealthy, more developed countries throughout the world as well.

Too many children have grown up abandoned, alone against everybody, learning too soon how to pretend to be an adult, often involved in criminal actions along with the "grown-ups"! For example, eight million children in the Brazilian *favelas* inhale vapors to forget the anguished condition in which adults force them to live; wandering alone or in groups they wait, without hope, for time to go by. These are youth that flee from the adult world that takes advantage of their weakness. The dramatic number of *meninos* or *meninas de rua*, constantly growing, especially in the Latin American cities, shows how entire generations of human beings have been abandoned, not only by their families but also by society as a whole.

For many of them illness or death is a tragic reality. In Asia more than one million children younger than sixteen years old are exploited in the prostitution industry, serving mainly international tourism. Millions of minors are also "enrolled" in dangerous operations, or are sold as objects, mostly in the clandestine adoption markets.

Beyond these official figures, however, there is a vast hidden reality that statistics do not account for.

When Life Loses Its Sense

In order to survive, millions of children must play the role of adults, learning quickly how to avoid the violence and risks of the adult world. When you look into their eyes you do not see that natural childlike response, that desire for protection and help; they show instead an apparent cold control, often mixed with a pervasive sadness.

These young children live in a false adult dimension in which fantasy and play do not fit; exploitation of the other, be it child or adult, are mandatory in order to survive. The behavior of these children-adults is often characterized by constant violence against others and against themselves; suicide is not rare. For children without a future, life does not have much meaning; it can be stolen from others and from themselves, as in a meaningless absurd game.

One need not look far away to find examples of violence on childhood. In our country every year thousands of children skip school, arm themselves with readily available weapons, and walk the streets in groups or gangs. Ignored or abused by apparently "normal" families, many, too many children do not find in school a reference for their growth and too little is done to rescue them. And a great number of them live in institutions that are not able to provide the necessary love.

Loneliness and Lack of Guidance

In many cases children have no adult figure to follow, no one with whom they can share their problems. The feeling of loneliness caused by parental neglect causes a severe instability and lack of confidence that is seldom expressed openly but often is hidden behind an opposite behavior. Many children who strive to appear mature conceal weaknesses and a severe lack of self-confidence. These children do not ask for help until something shatters their apparently strong defenses. Only then — and it is often too late — do they accept

their weakness, seeking help up to then denied.

We often ask ourselves how it is possible for adults to abuse children. Child abuse does not represent an inevitable reality, a condition that has always been and that will always exist. Child abuse is not simply committed by "evil" or "sick" adults on innocent victims; it conceals a more complex expression of relational disharmony that involves the whole family and the greater social context. This problem cannot be managed by social services alone; it must be solved in an interdisciplinary way through prevention.

In many of the most shocking cases there is an excess of emotion or rage. But these feelings do not help us to understand the reality and cannot lead us to correct actions. Often one seeks "magical" or improvised solutions, pursuing the guilty and avoiding in fact the real causes. Behind this hastiness we often find incompetence and superficiality. To effectively help children and their families, and also in emergency cases, we need the involvement of several professions to determine the necessary actions for both the short and the long run. We must overcome temporary solutions and implement instead strategies that take into account family history and all other factors that contribute to the condition of distress. Only in the family and in the social context can resources be found that can become the building blocks of recovery.

Sudden Drama Is Caused by Lasting Problems

When we analyze sudden bursts of child abuse we always discover that such behaviors were only apparently unforeseen; often there were prolonged signs of distress that could have been discovered in time, avoiding for both the child and family harmful consequences, had we but looked for them. Those who could have noticed these signals and did not do so have avoided a great responsibility.

Children are an essential part of society, and the consequences of neglect and abuse in childhood are seen in many young adults who are themselves incapable of becoming parents. Children have the right to build their future on understanding and tenderness, with the help of adults who must provide a confident foundation. Parents must represent stable and assured shelters for the difficult situations that life presents us.

A family in distress, whether due to separated parents, mental illness, drug abuse, or myriad other problems, cannot provide a child the required security; it is therefore important that parents have access to someone who can help before the situation deteriorates beyond hope. New strategies are needed to help families and children in distress.

Fear of taking responsibilities pushes parents to delegate these burdens to external experts and agencies. This "escape" behavior is very dangerous: delegating educational tasks — for instance to television — destroys the authentic dimension that only parent-child relations can provide, leaving the child with the distressful feeling of being left alone in life.

How often solitude at an early age turns into a lack of hope in the future, a path to self-destruction, suicide, and dependence, a road leading to "juvenile delinquency." To help the children of our country and the world we must listen to the questions that need an answer from adults.

The United Nations has issued a "convention for the rights of the child," but each country must make concrete legislative and social investments. To give the necessary answers to future generations so that they can grow hope in an adult society, it is necessary that the "grown-up" commit to concrete and effective answers to youth needs, beyond merely formal declarations.

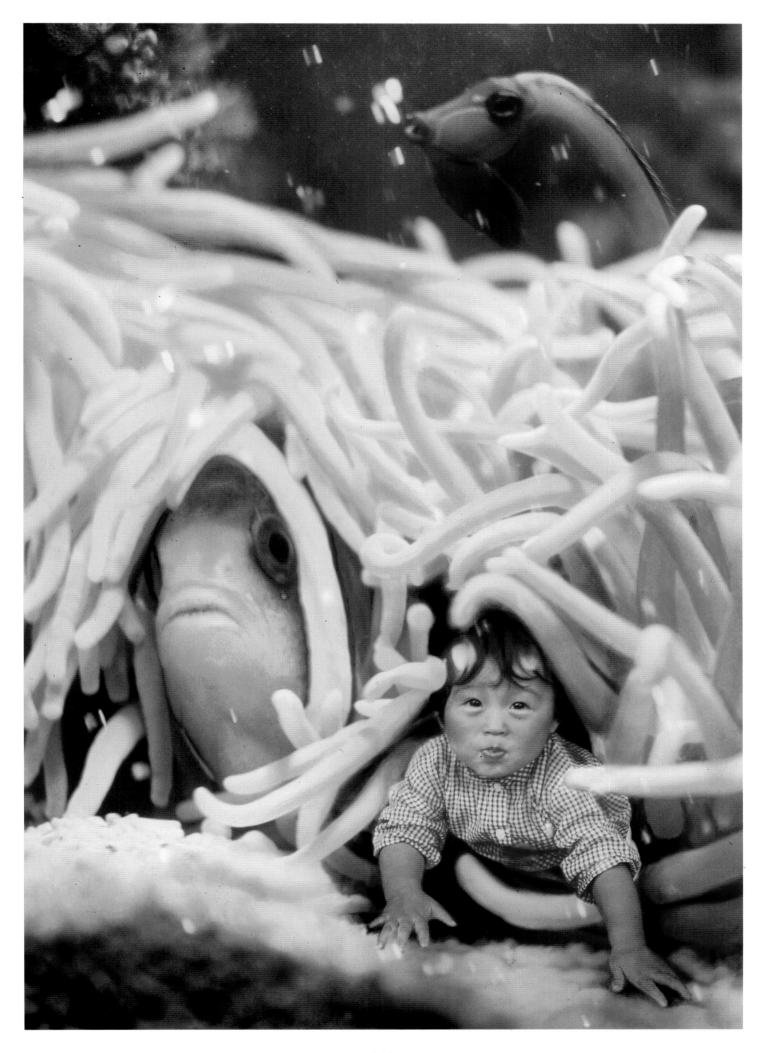

The Joy of Living

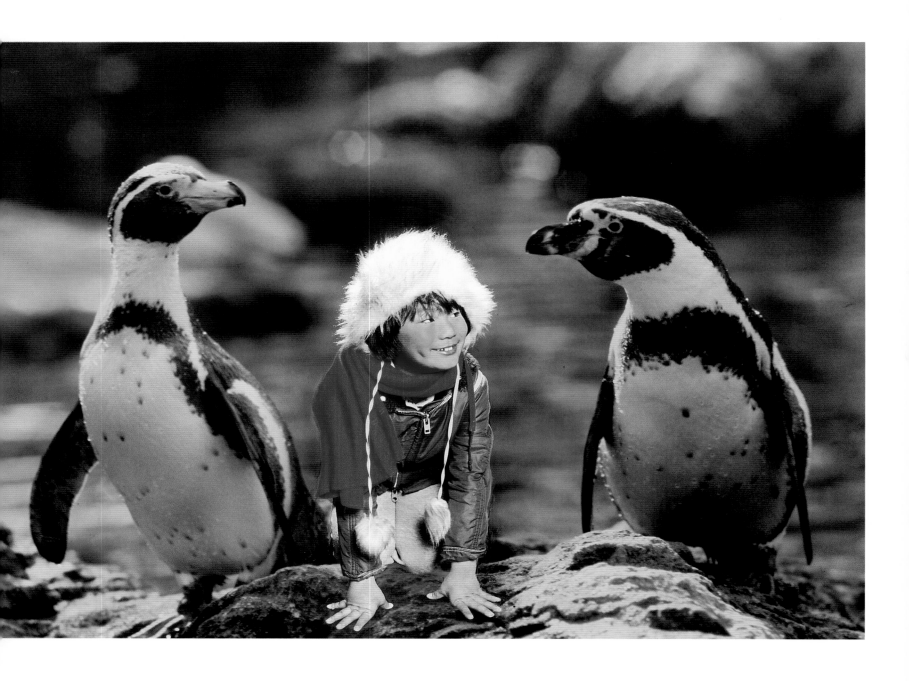

What would you not pay to see the moon rise, if Nature had not improvidently made it a free entertainment!

Richard Le Gallienne

◁ The spirit is the essence of ingenuity.
Aristide Gabelli

Happiness is a reward which comes to those who do not look for it.

Anton Chekhov

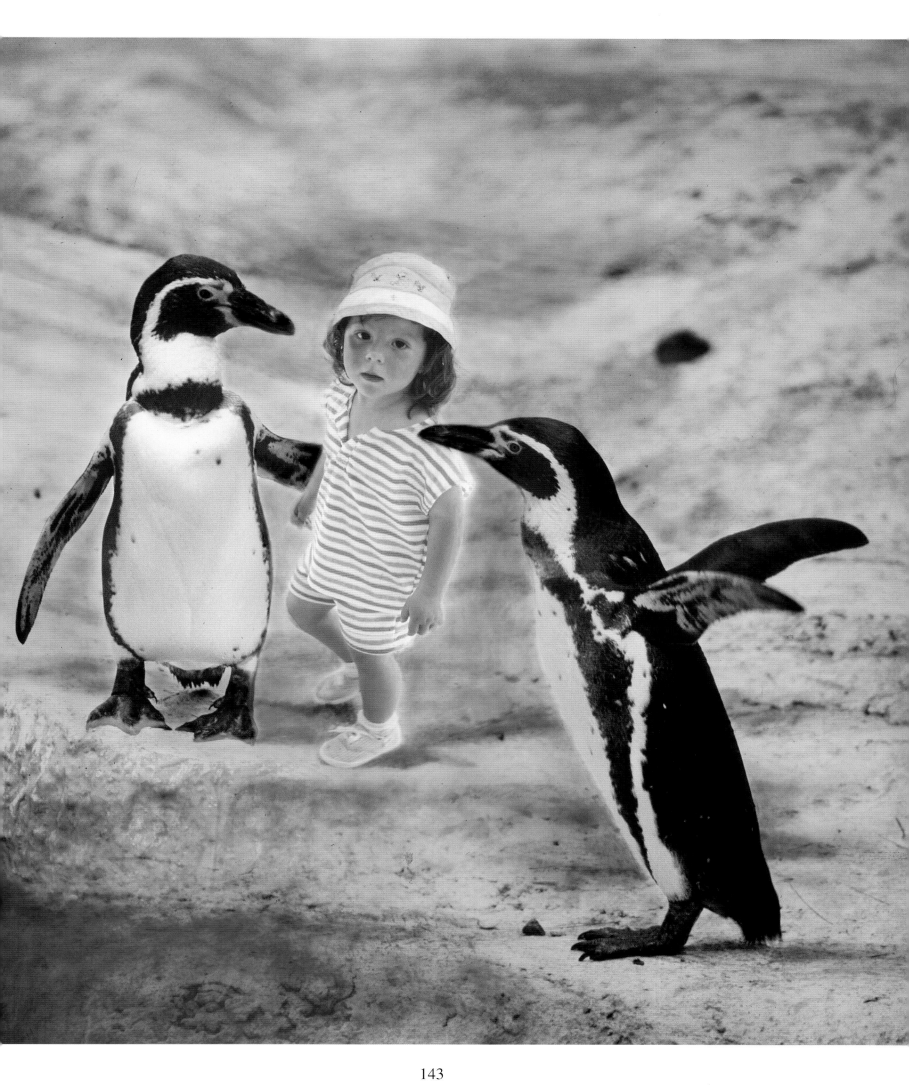

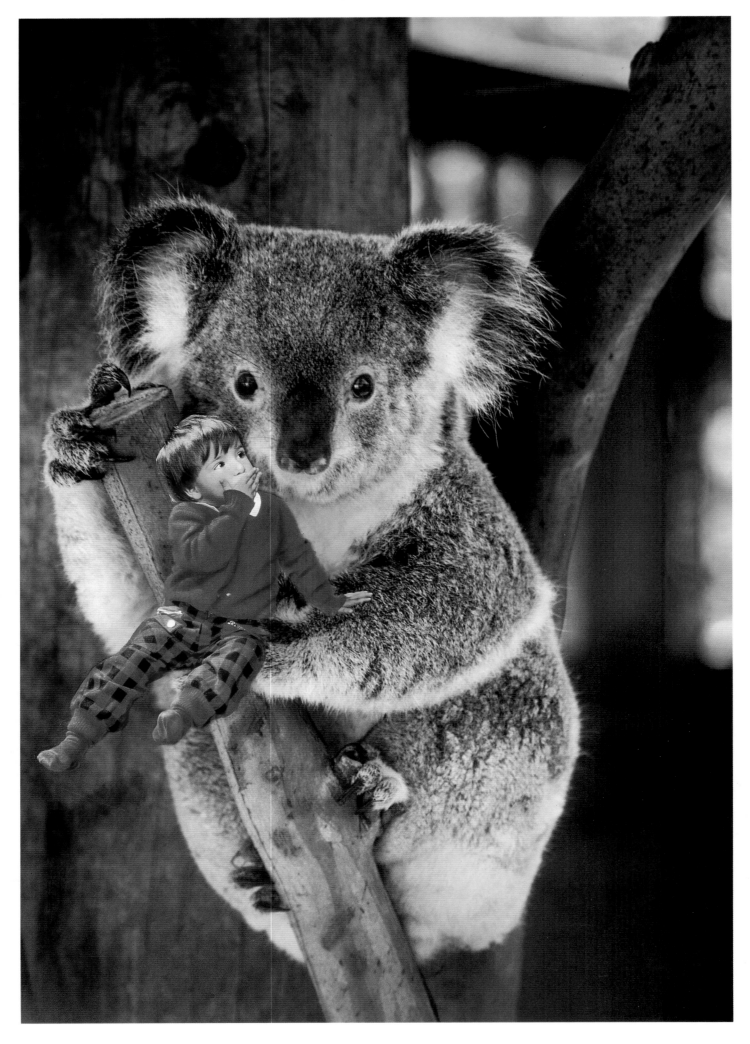

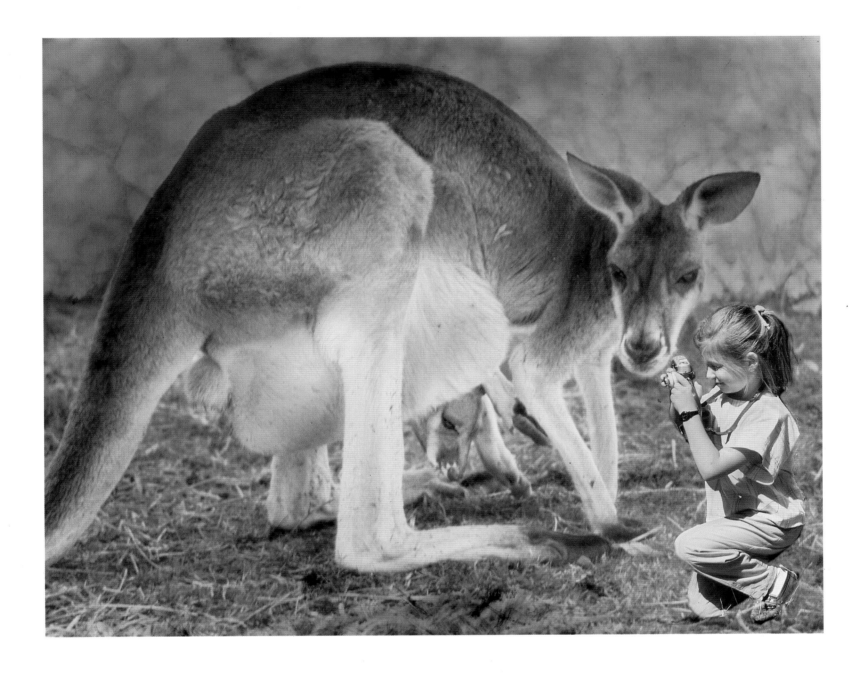

The supreme happiness in life is the conviction of being loved.

Victor Hugo

Photography is discovering the world and ourselves, filtering reality through our own feelings with creativity, originality and a bit of fantasy.

Gina Lollobrigida

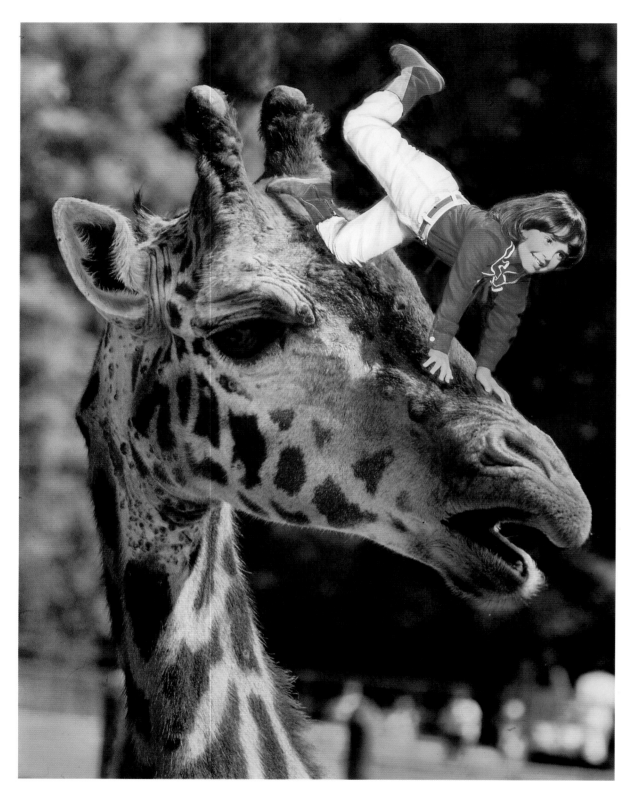

In poets and artists there is the infinite.

Victor Hugo

What women do
must be done twice
as well as men
to be half appreciated.

Charlotte Witton

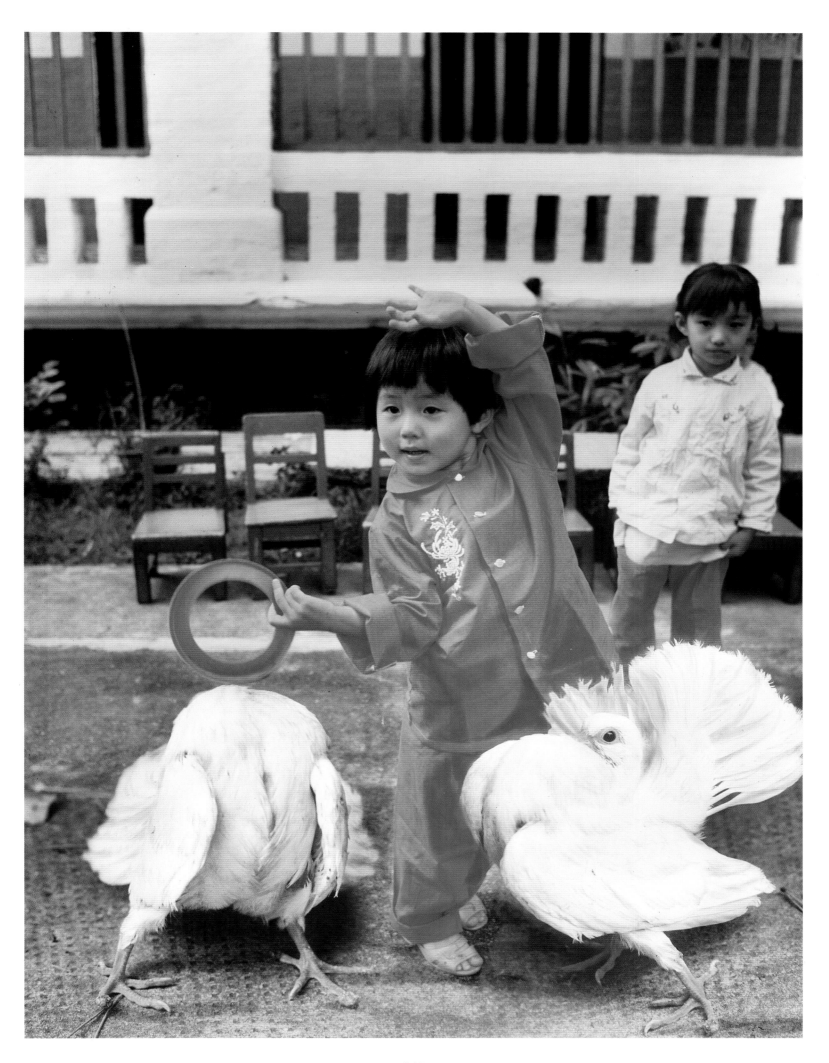

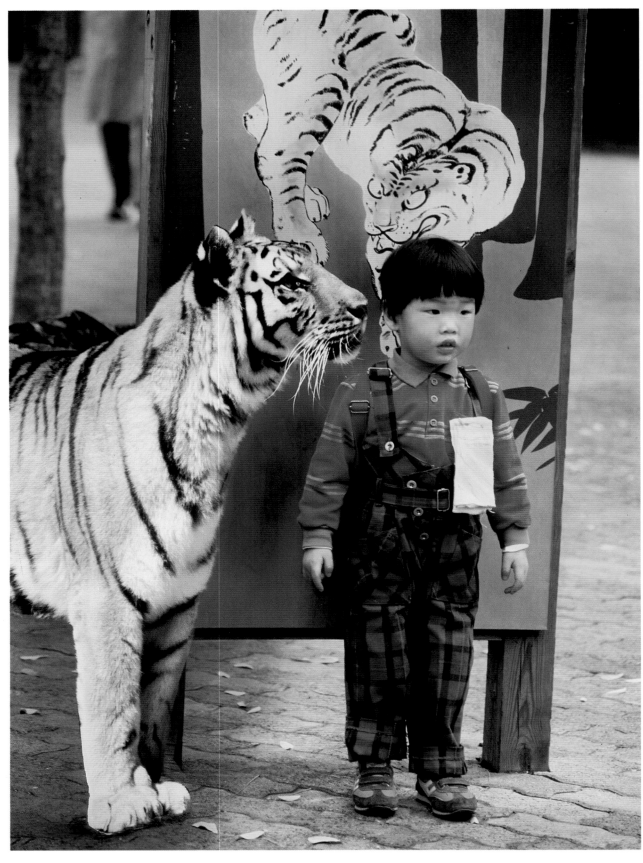

All art is but imitation of nature.
Lucius A. Seneca

Men are like wines,
age souring the bad
and improving the good.
Marcus T. Cicero

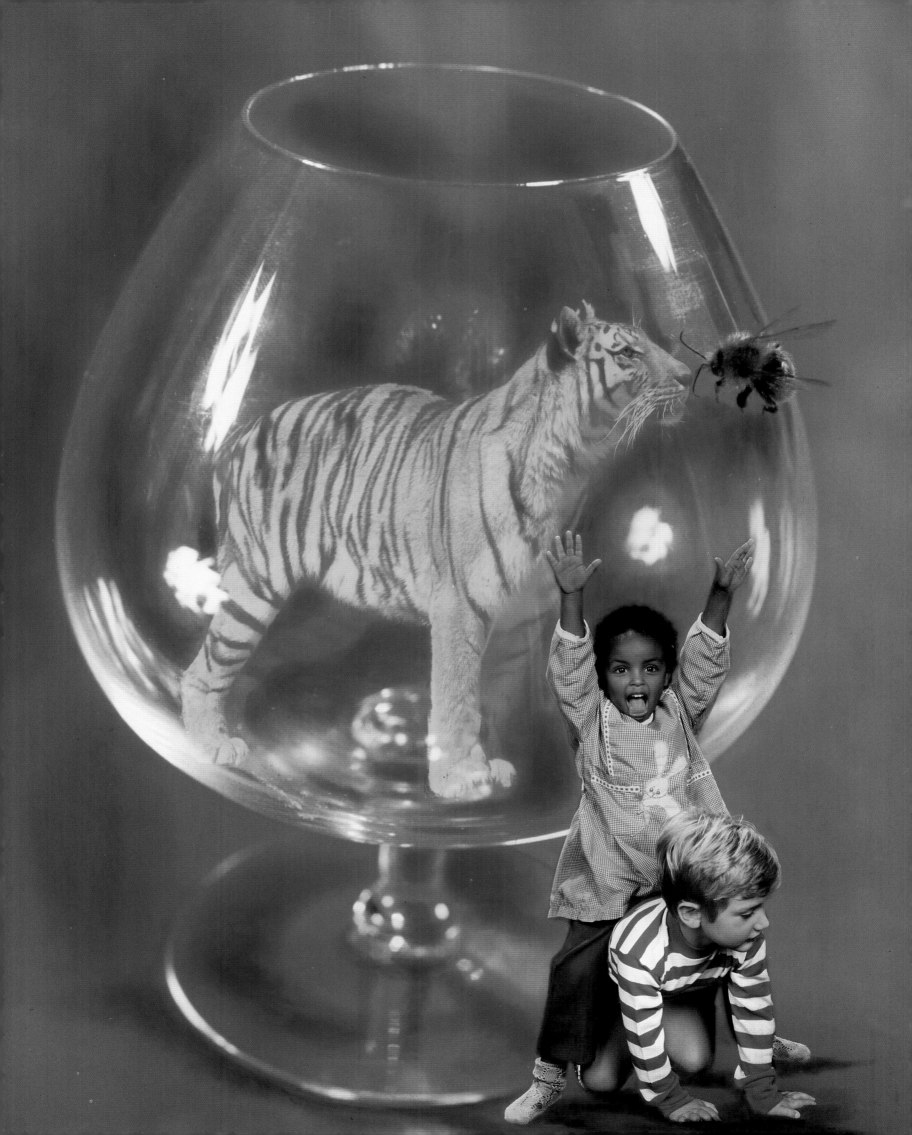

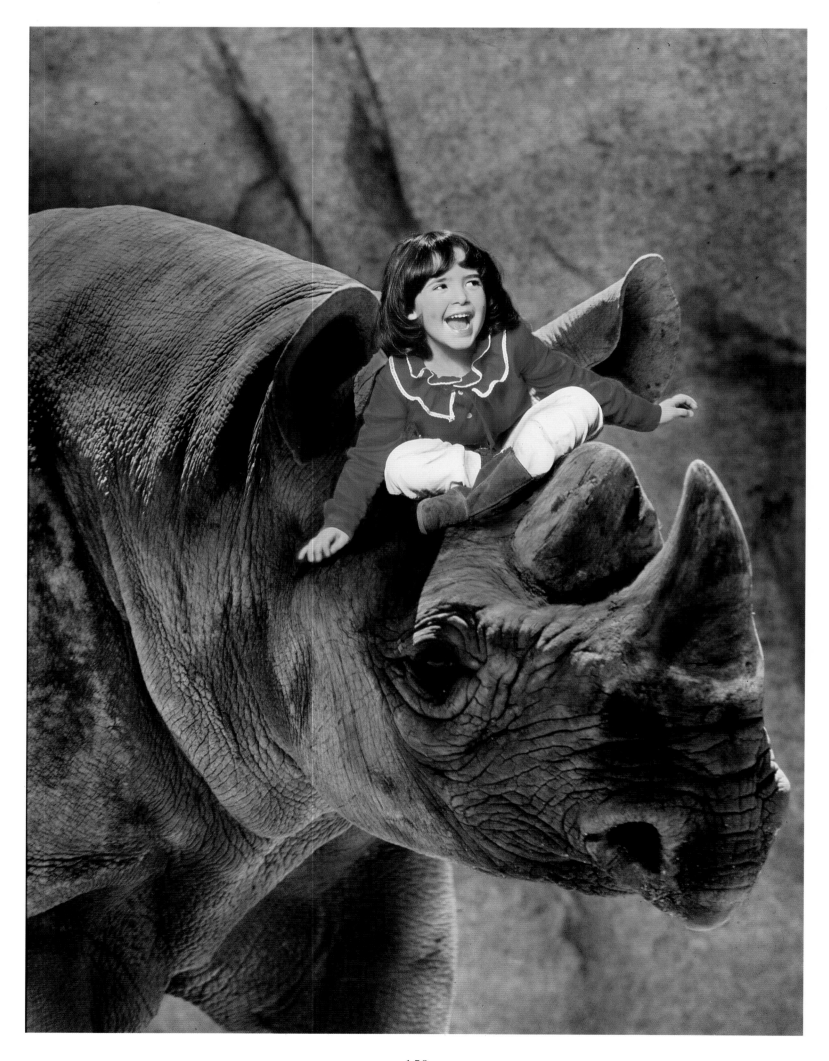

First Encounters

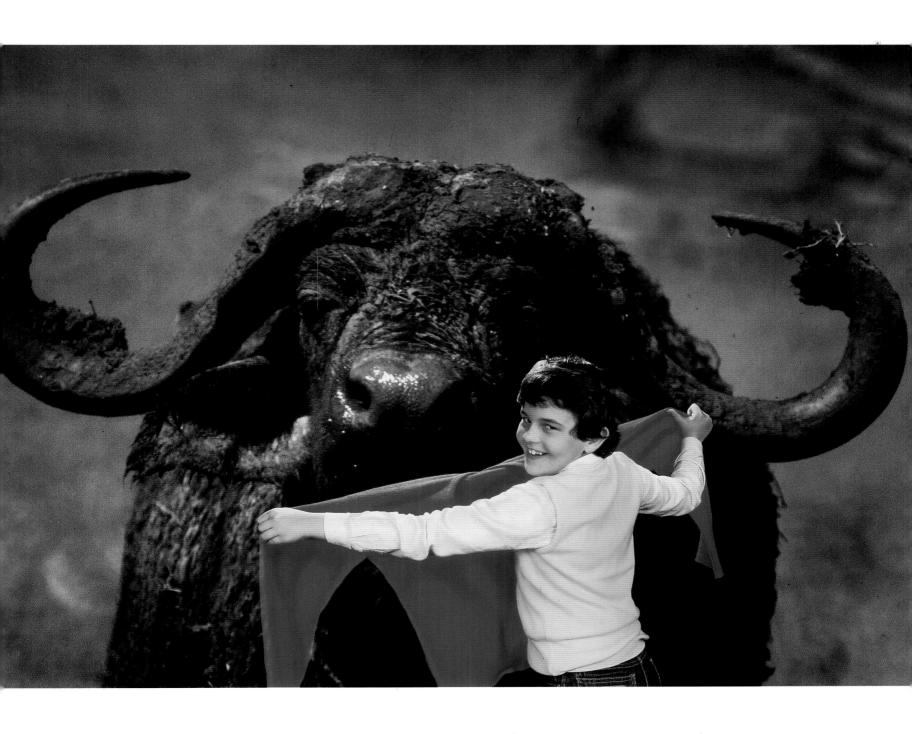

He who dares to laugh,
holds the world in his hands.
Giacomo Leopardi

Will often rules over man, more than reason does.
Filippo Pananti

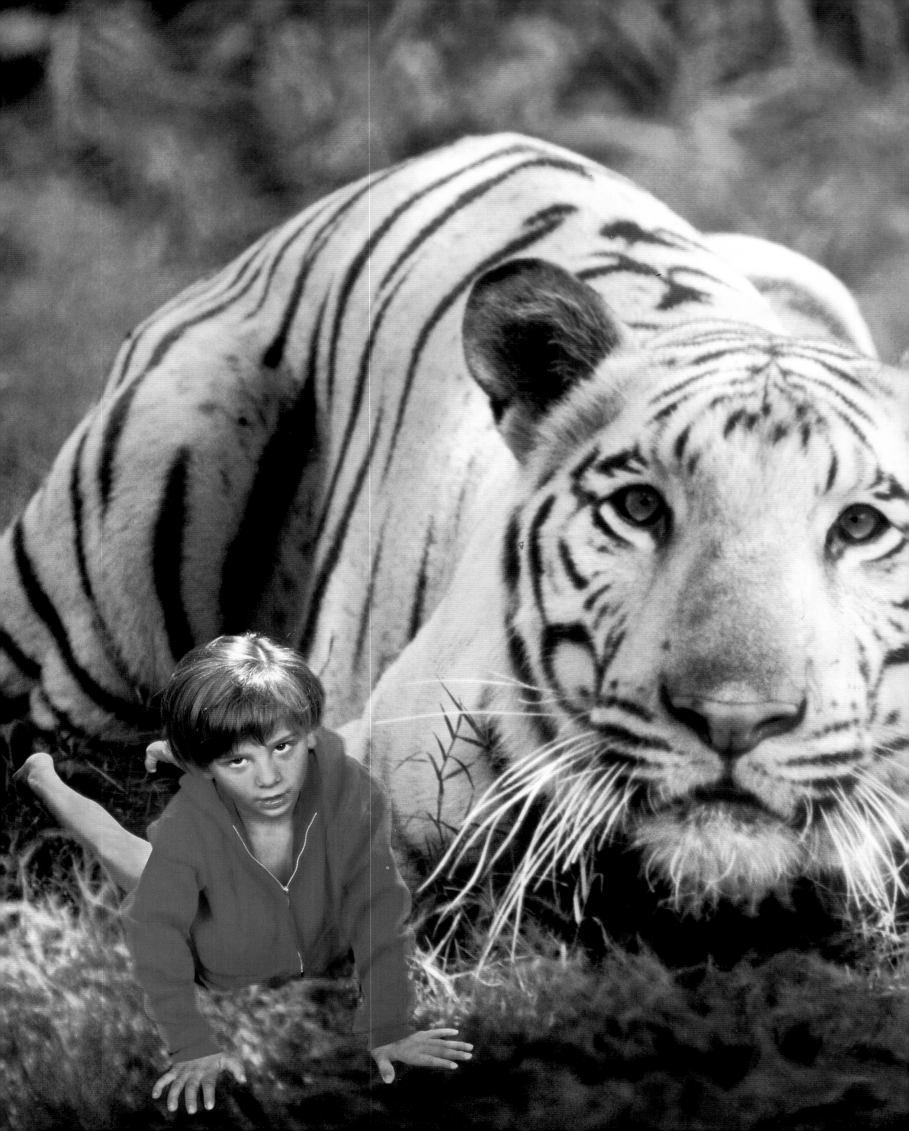

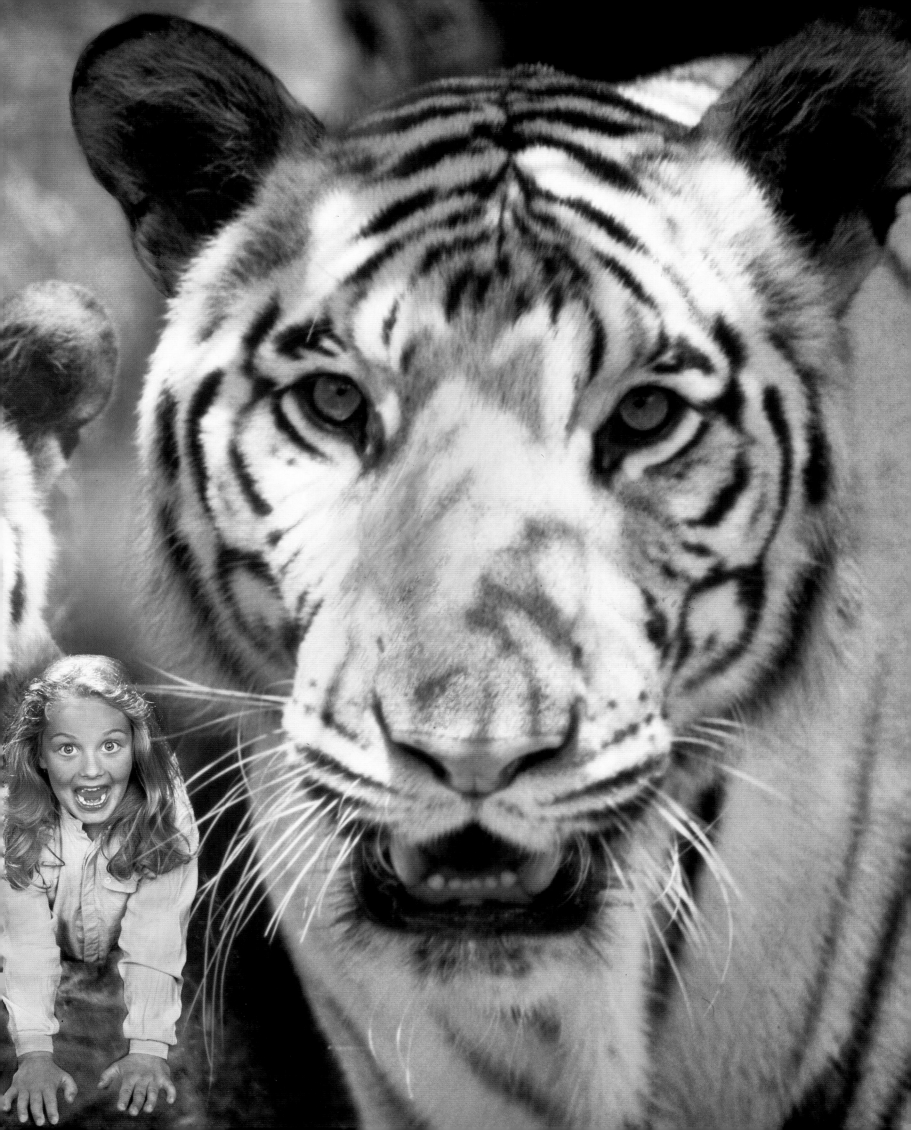

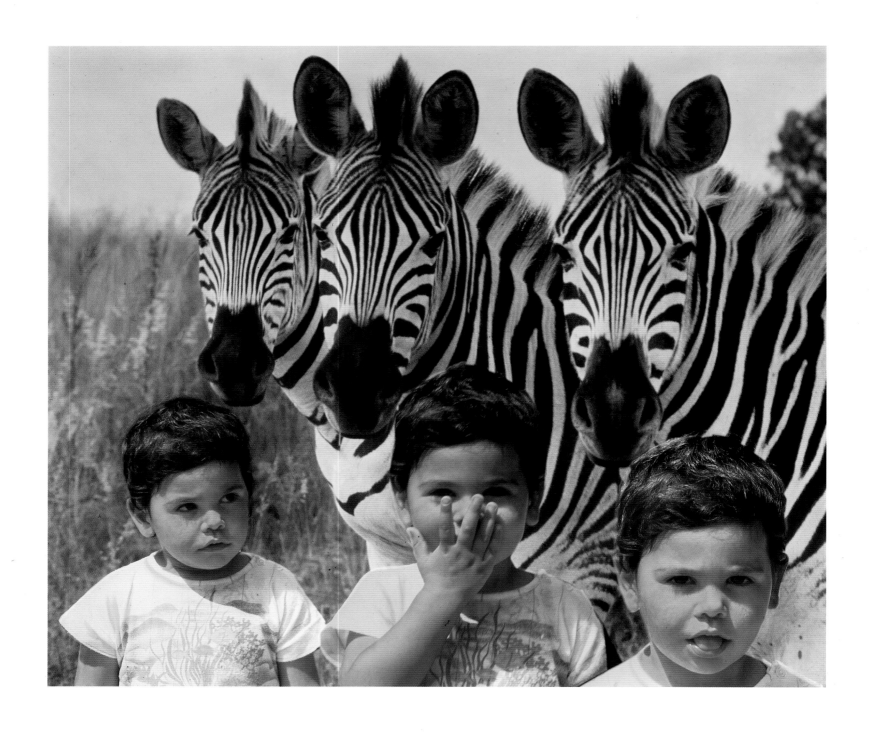

Beasts are not so beastly as we may think.
Molière

Instinct is the mind's nose.
Vaubano

◁ When a man wants to murder a tiger he calls it sport;
when a tiger wants to murder him he calls it ferocity.
George Bernard Shaw

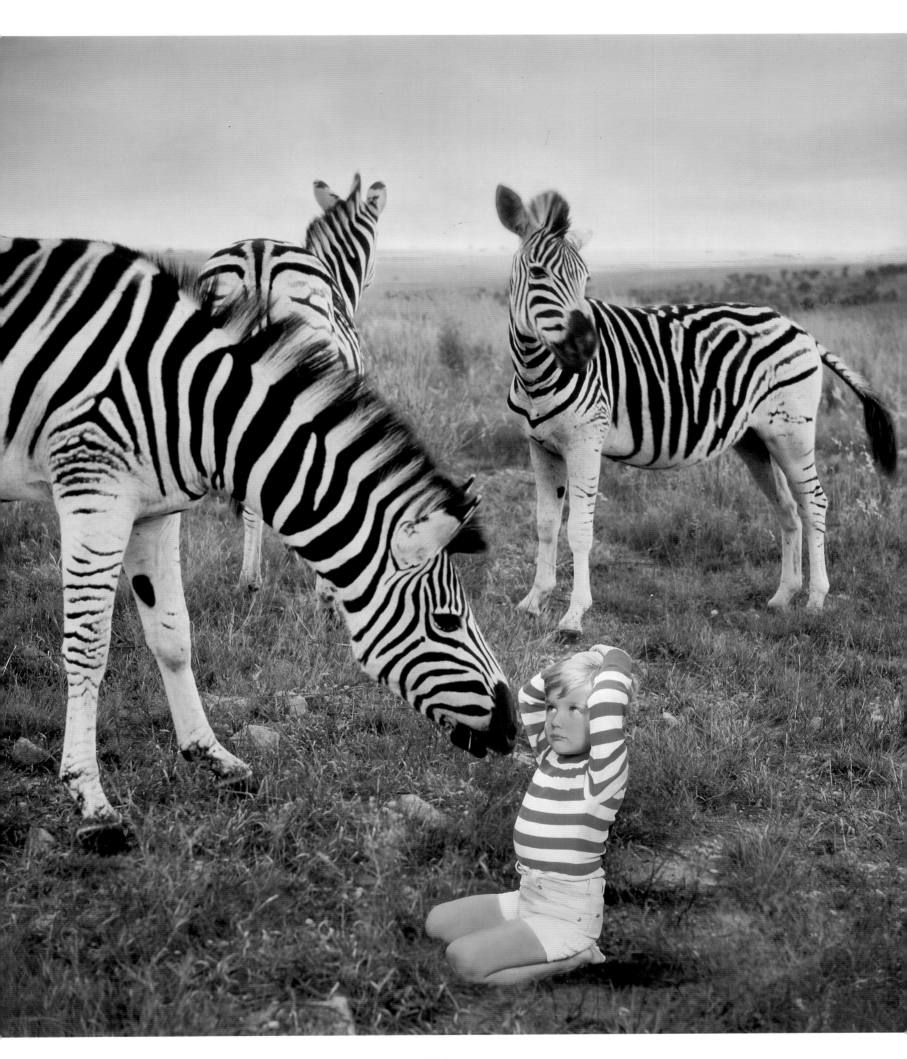

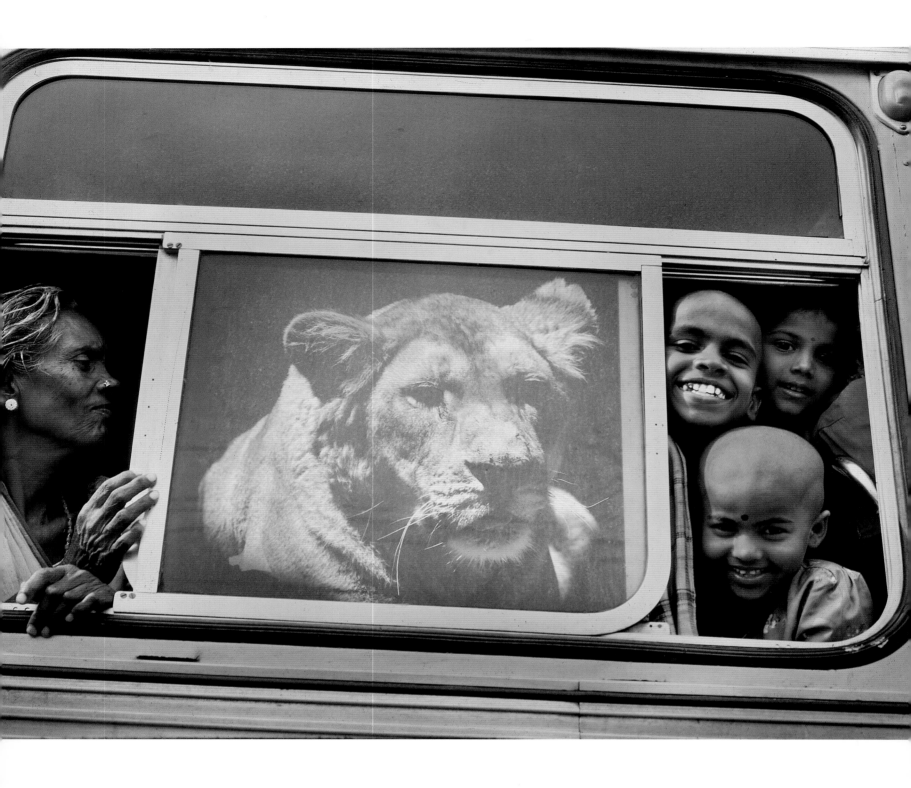

The world is a wheel and therefore takes all of us around.

Benjamin Disraeli

Respect is the tie of every friendship.

Renato Fucini

I would rather be right than President.

Henry Clay

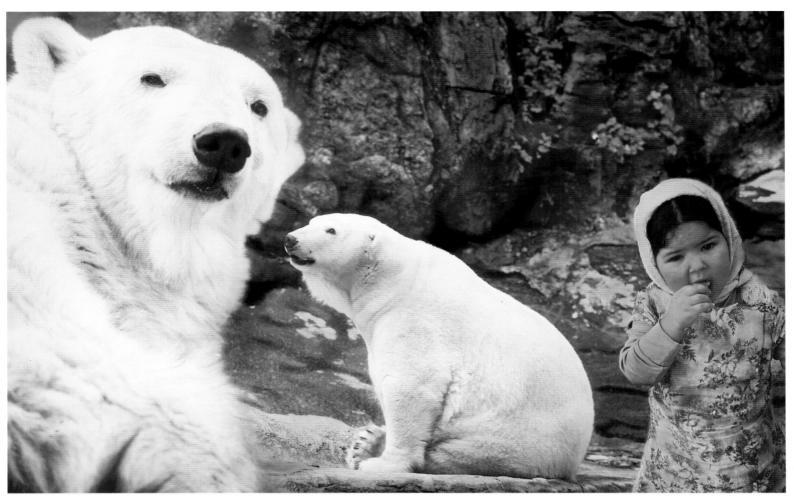

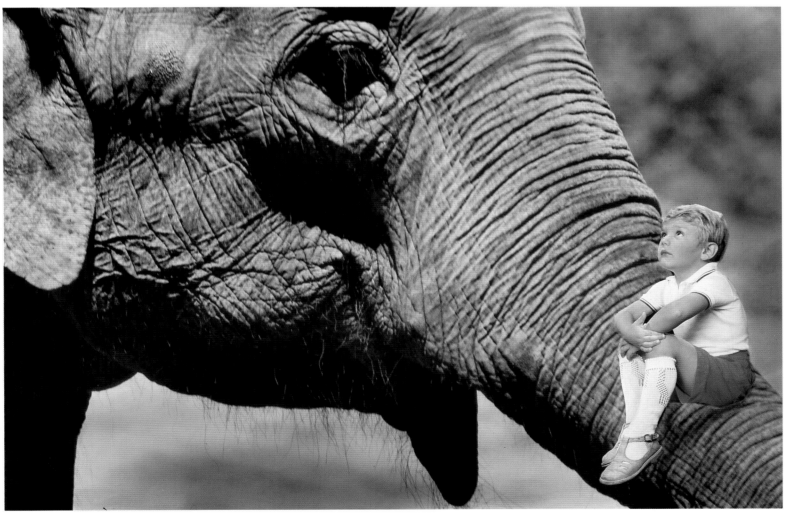

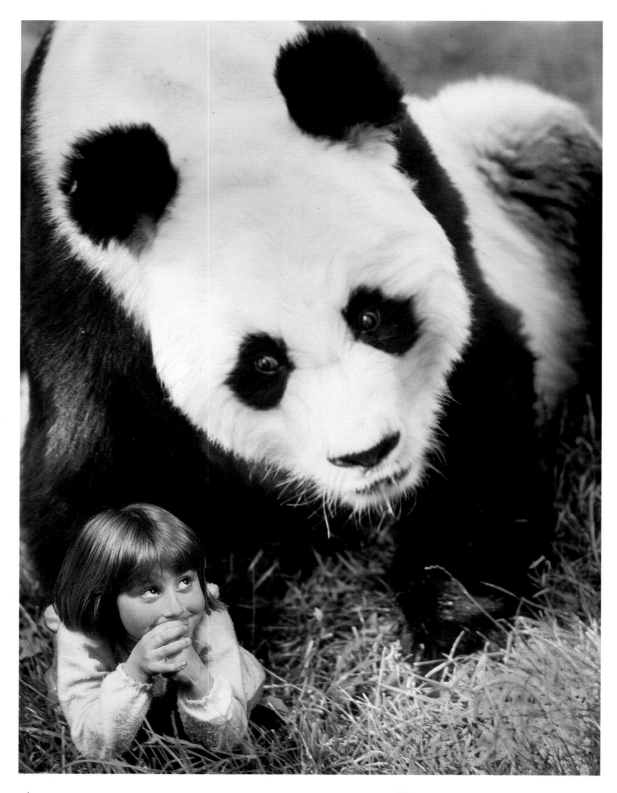

All ambitions are lawful
except those which climb upward
on the miseries or
credulities of mankind.

Joseph Conrad

I have nothing to declare
except my genius.

Oscar Wilde

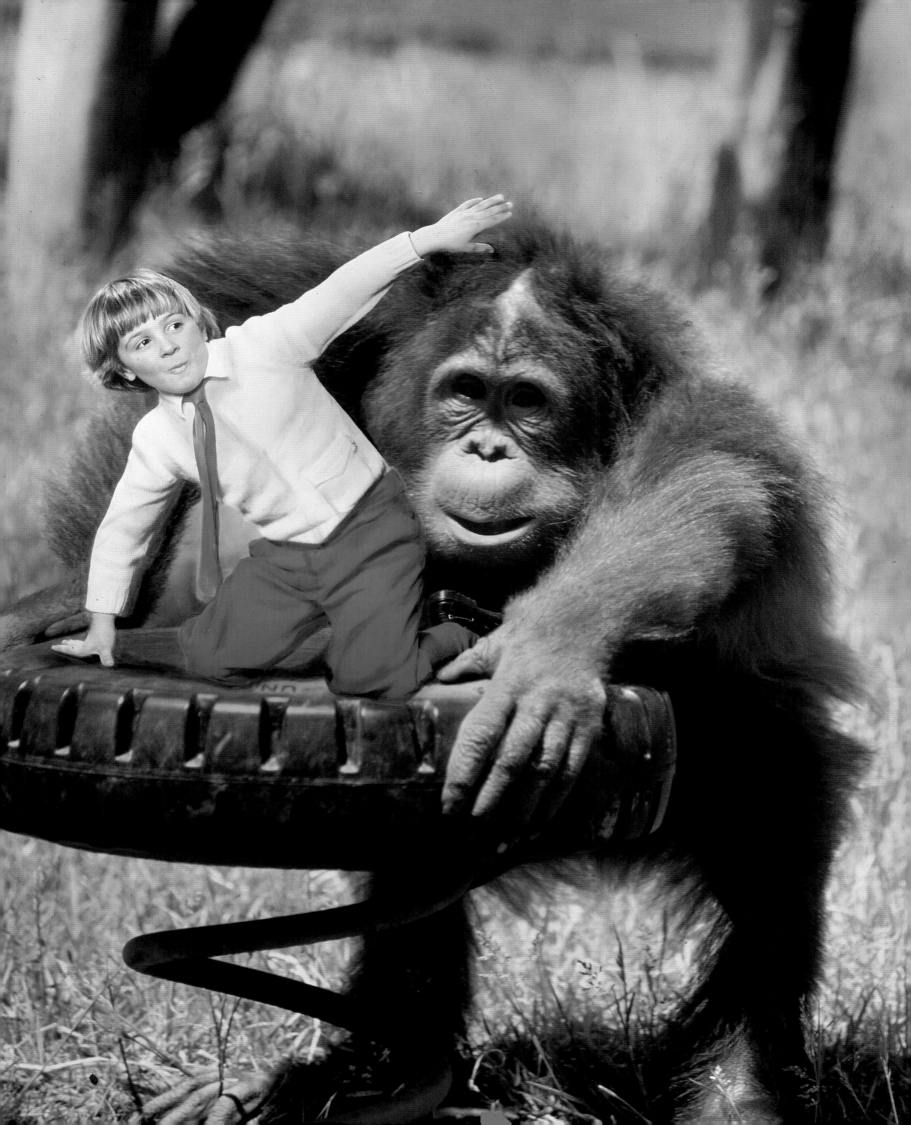

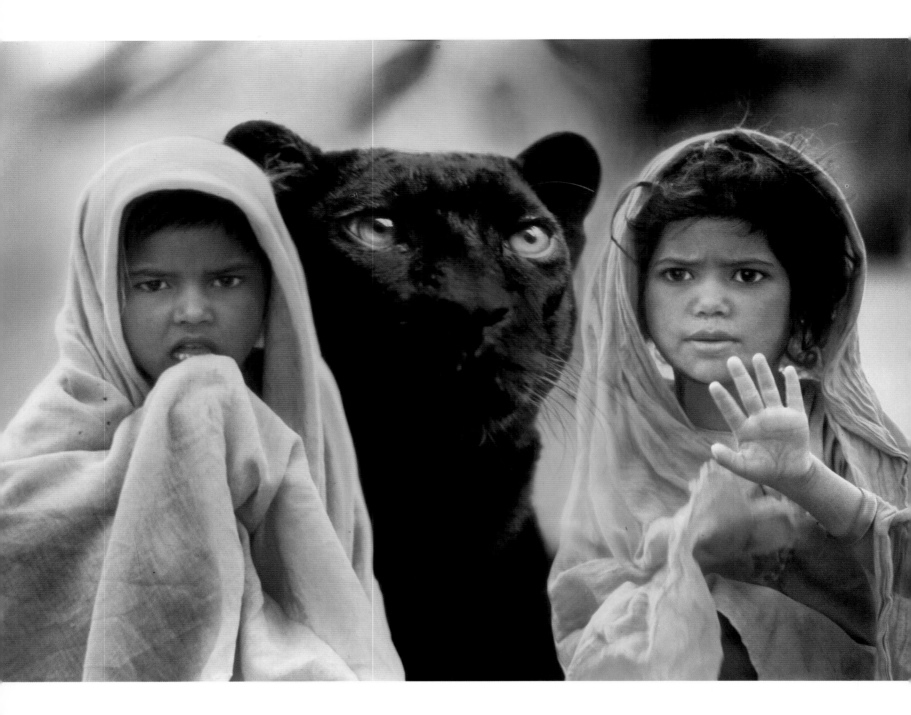

Man is superior to animals by word, but by silence he surpasses himself.

F. Masson

Prudence helps in avoiding misadventures and courage helps to sustain us through them.

Benjamin Delessent

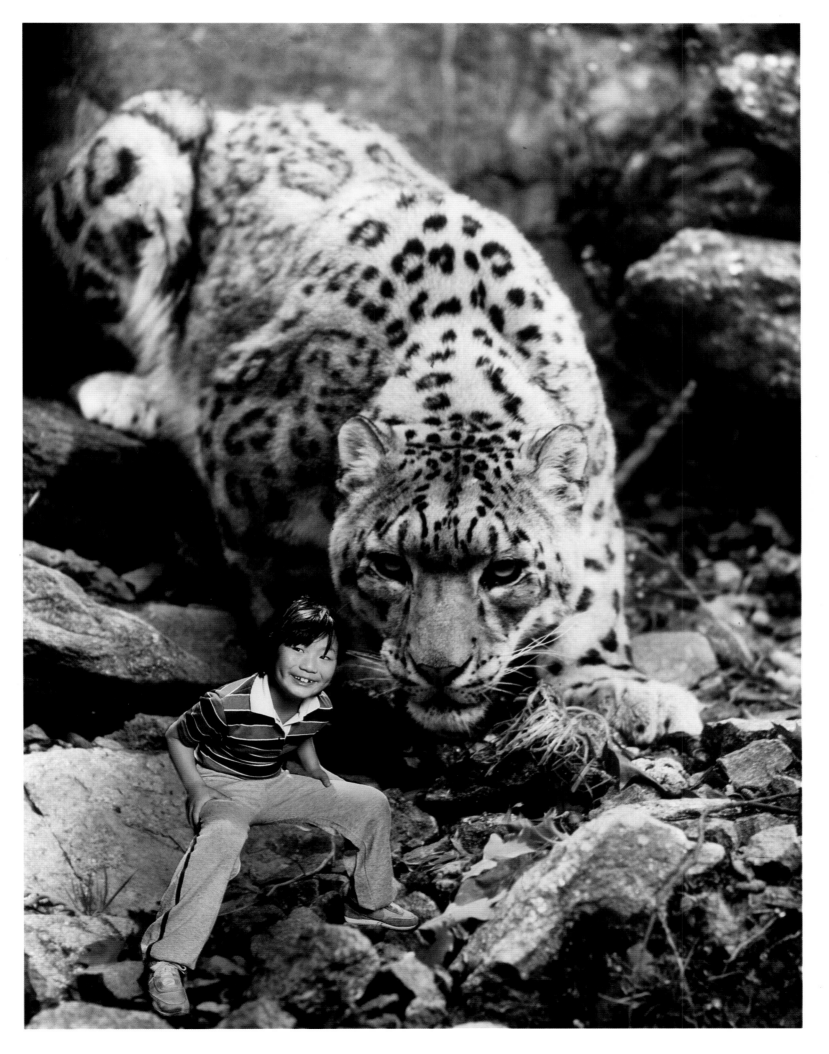

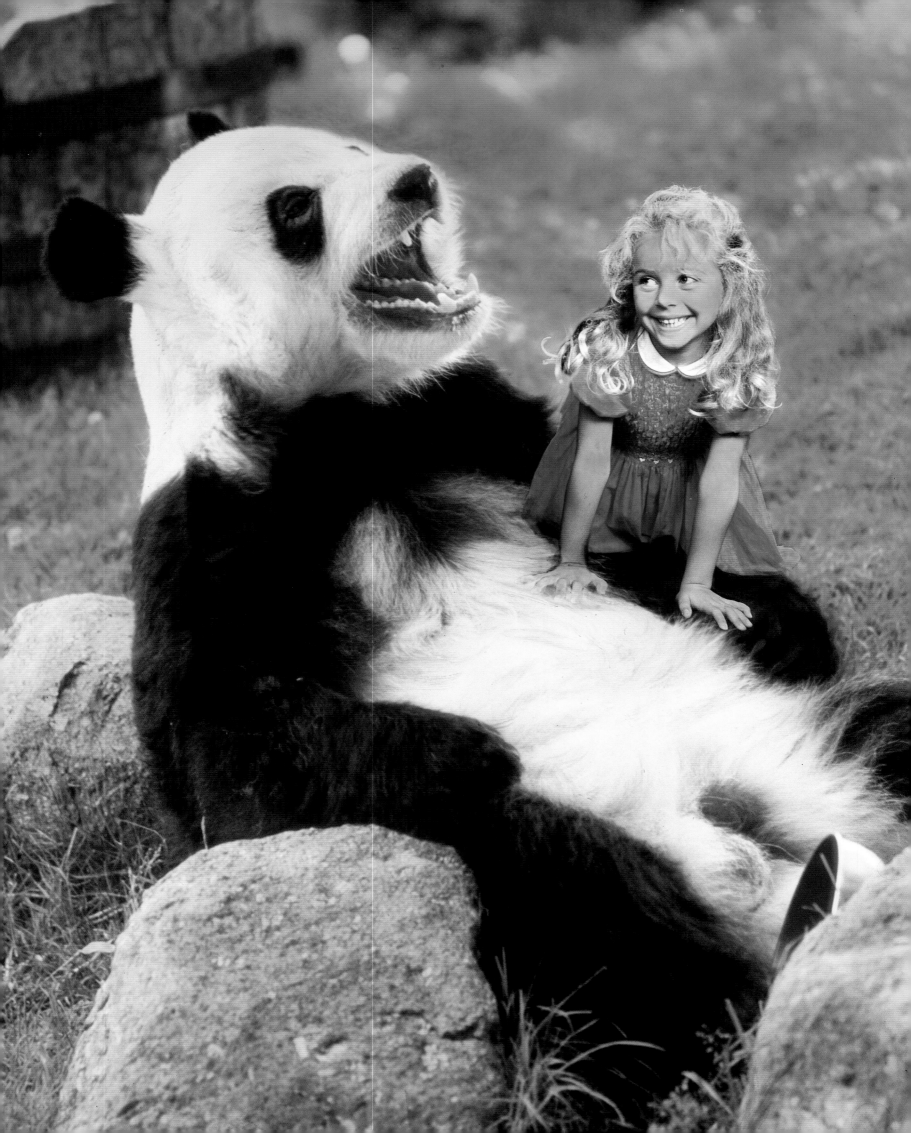

Friends of the Animals

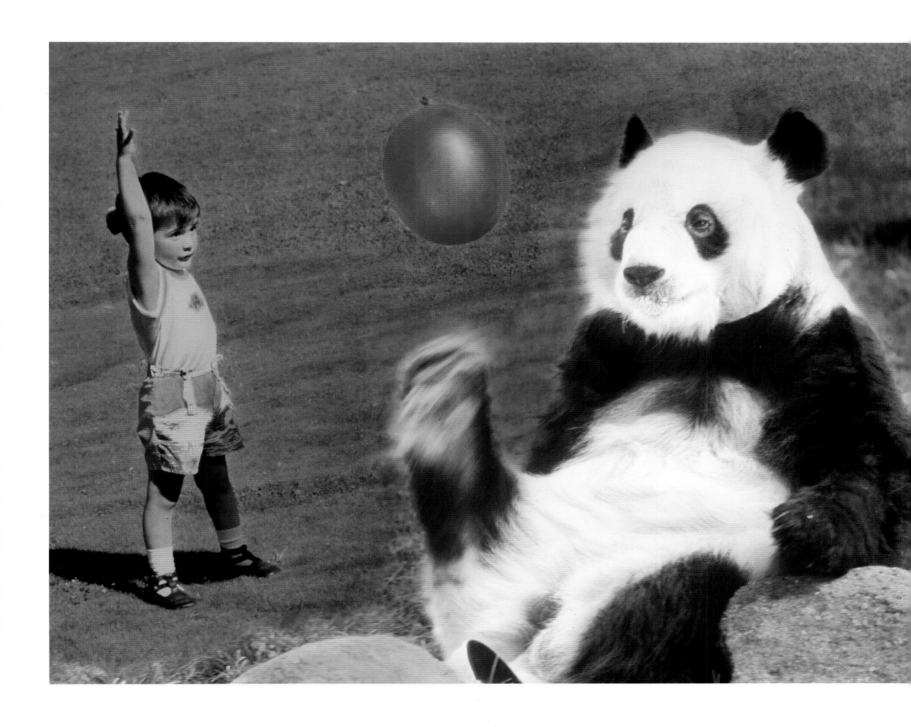

Happiness is the universal remedy for every trouble.
Aristotle

This minute, too, is part of eternity.
Duncan Stuart

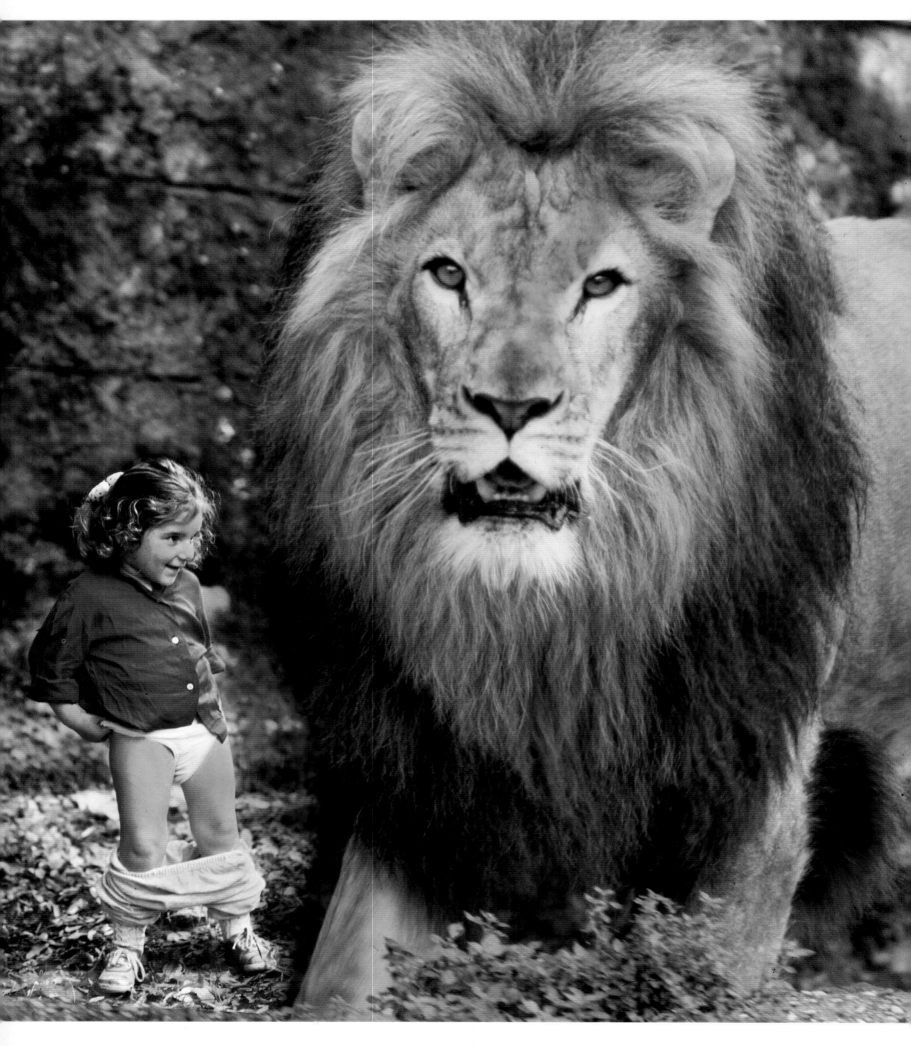

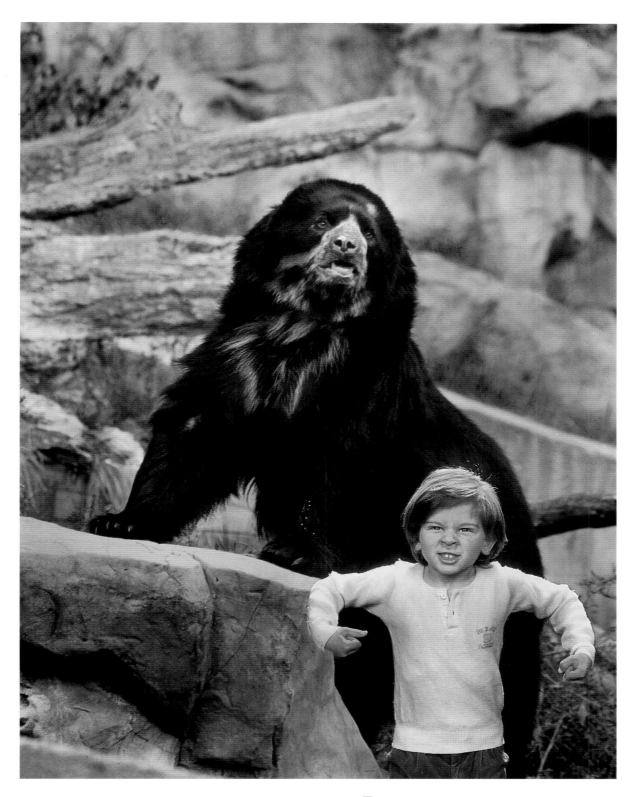

There is not much harm in a lion. Man is the only animal of which I am thoroughly and cravenly afraid.

George Bernard Shaw

I wish I lived when Napoleon lived, because at that time only one man believed himself to be Napoleon.

Tristan Bernard

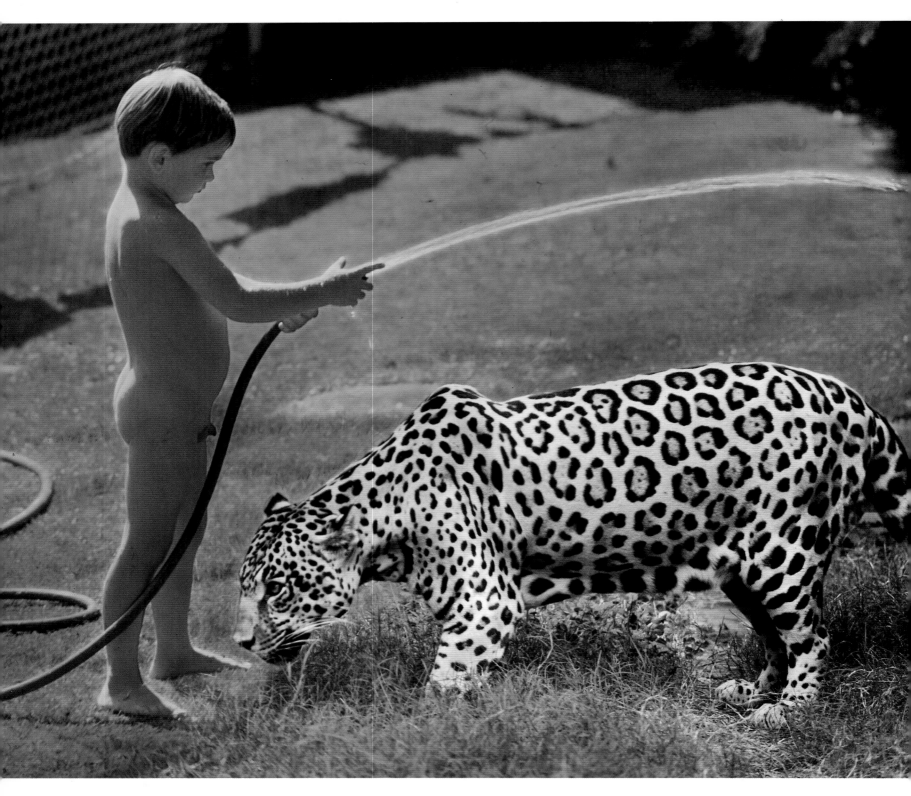

Nothing is more dangerous than power in the hands of someone who does not know how to use it.

Jean Jacques Rousseau

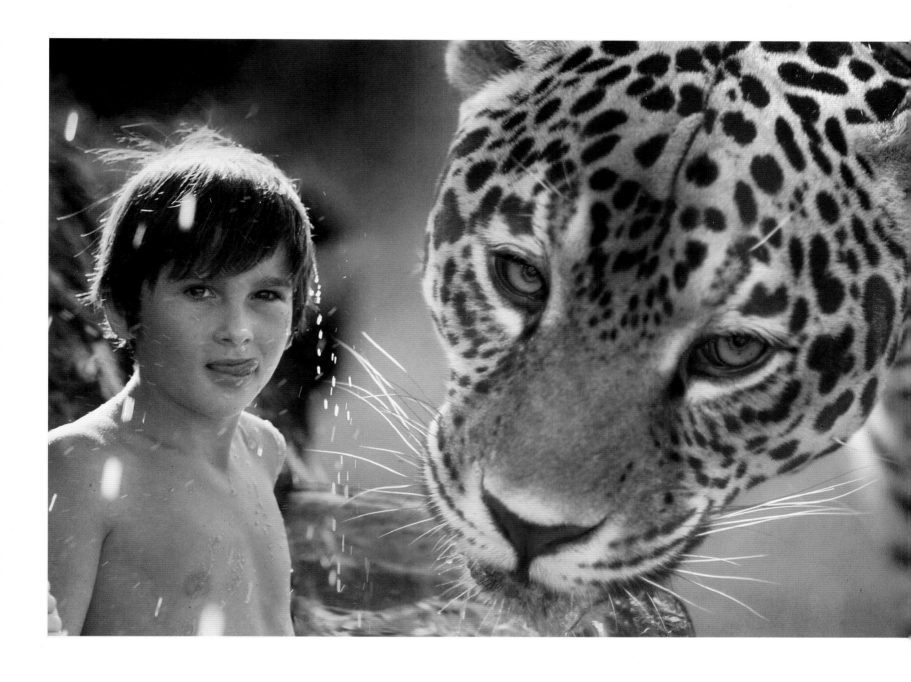

If it is true that youth is a defect,
we correct it in great haste.

Johann Goethe

To await pleasure is pleasure in itself. ▷

G. E. Lessing

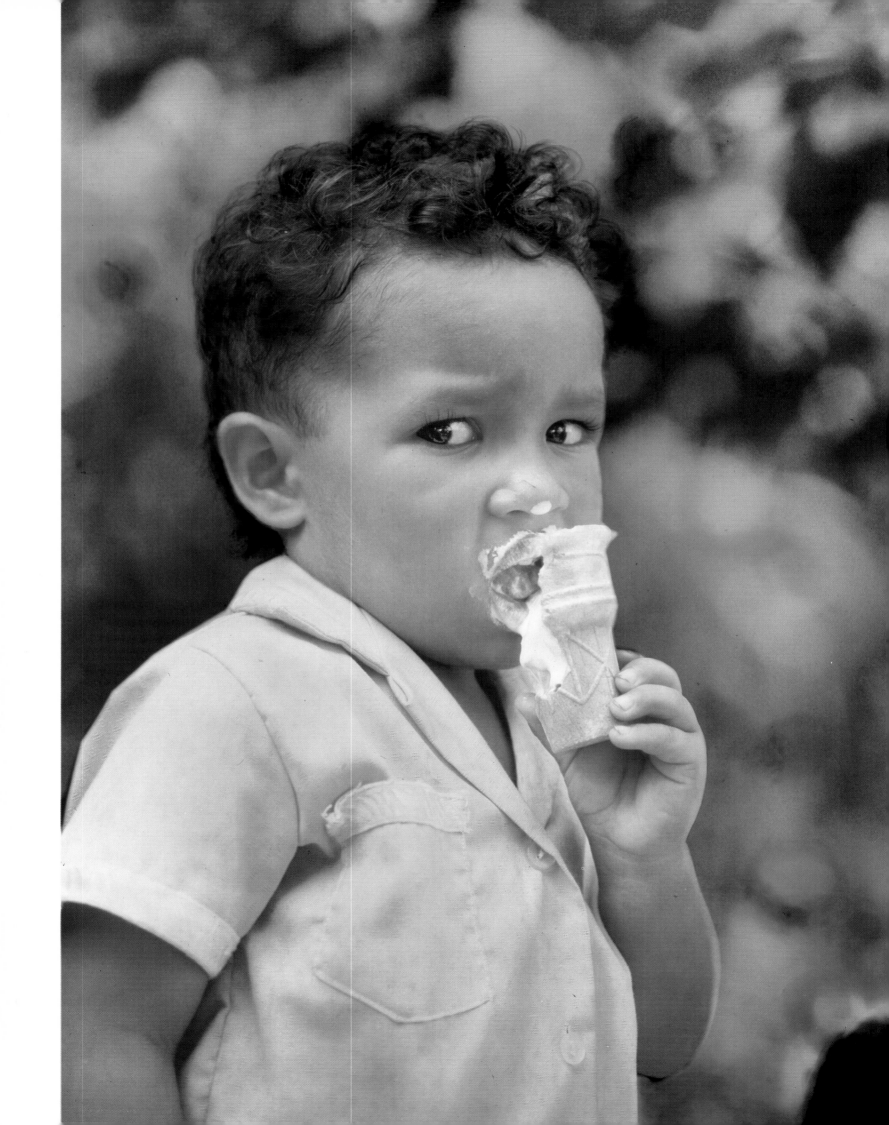

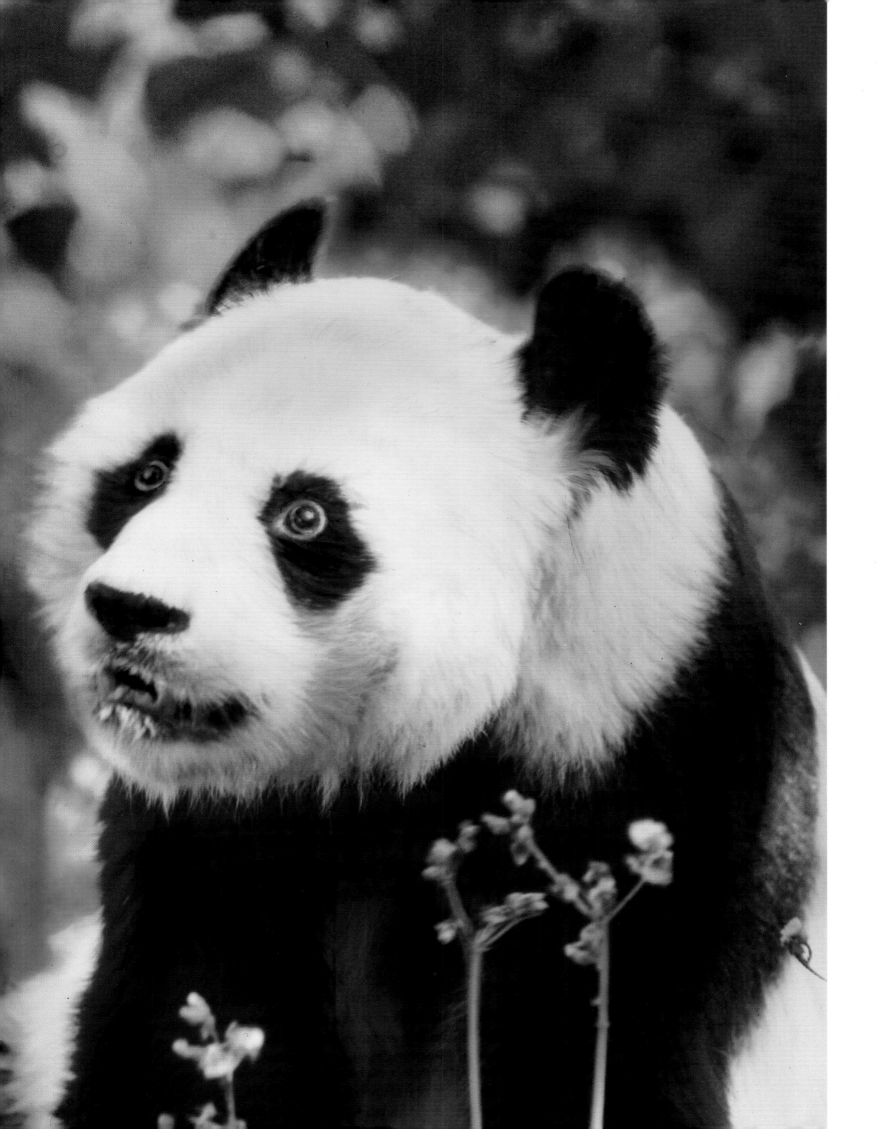

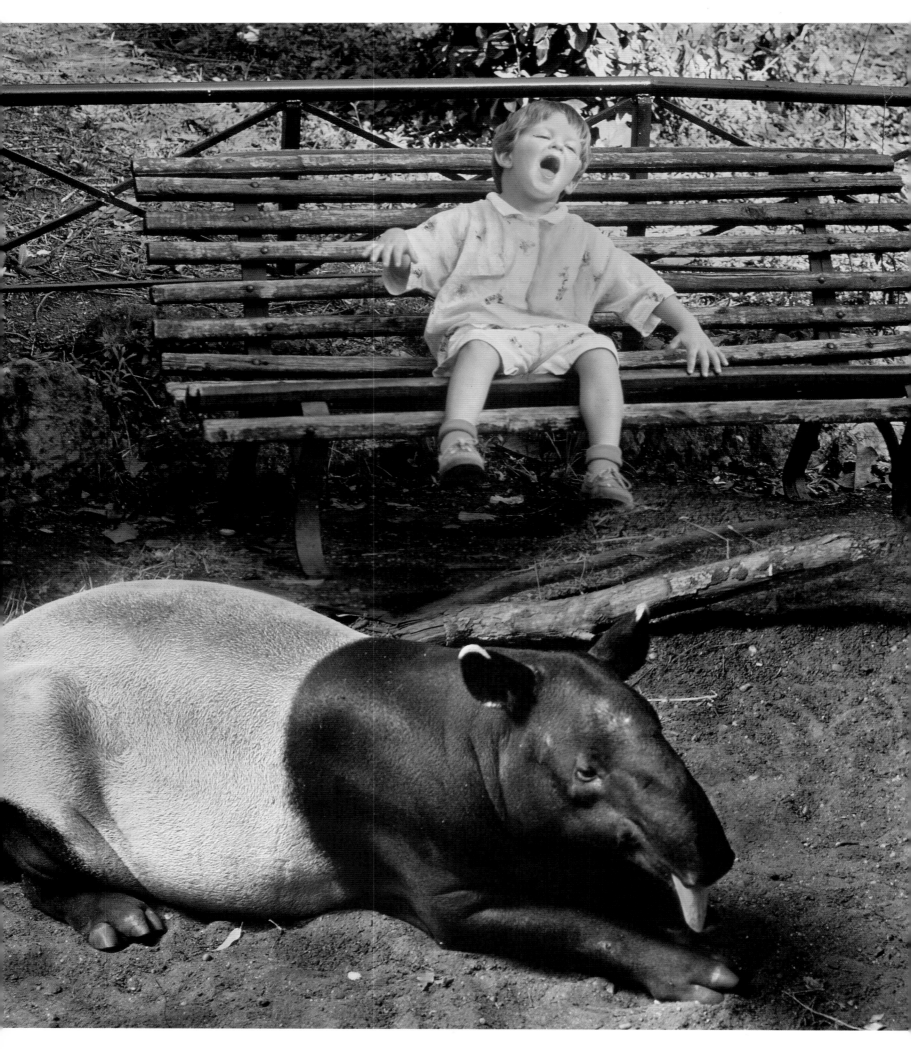

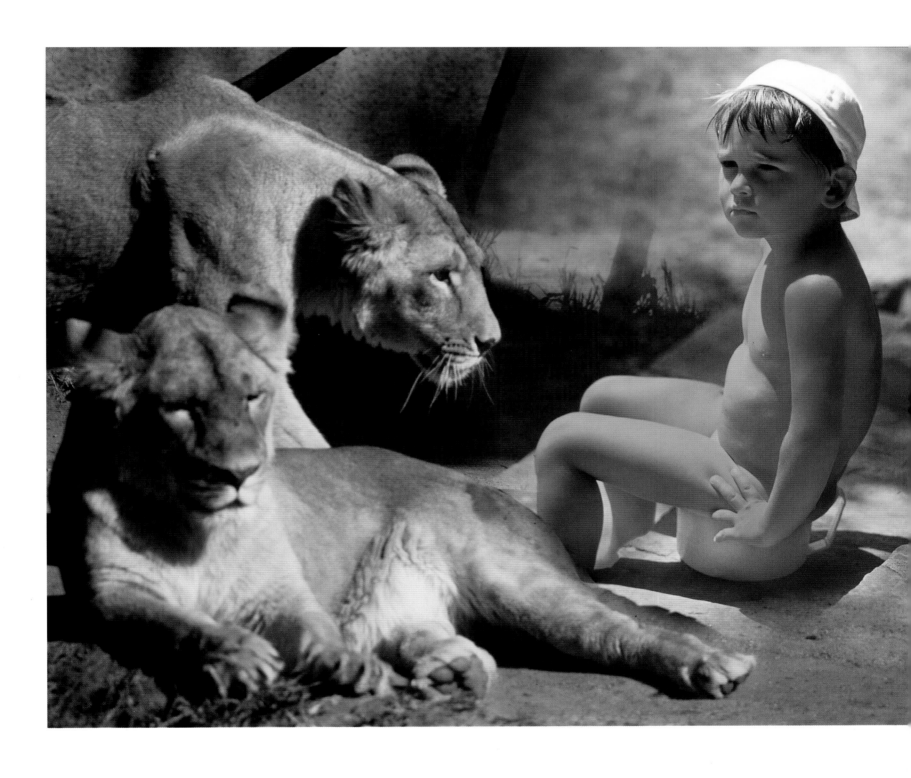

How beautiful it is to do nothing,
and then to rest afterward.

Spanish proverb

Animals are such agreeable friends.
They ask no questions, they pass no criticism.

George Eliot

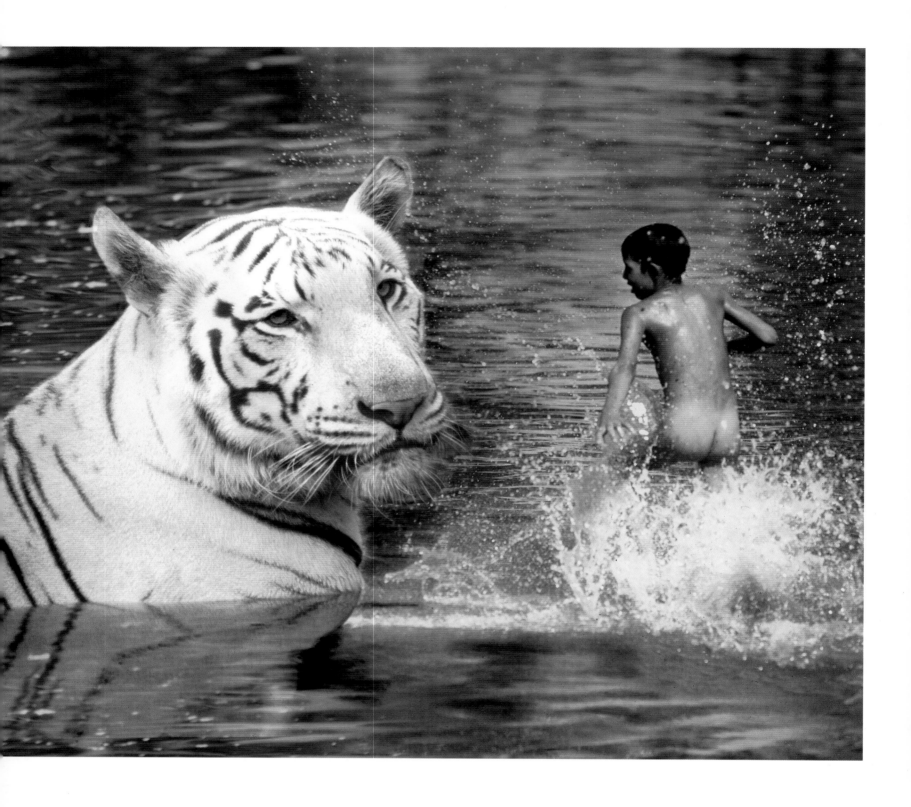

Throw an eager man in the water and he will come out with a fish in his mouth.

African proverb

Desiring little is like possessing an immense fortune.

Lucius A. Seneca

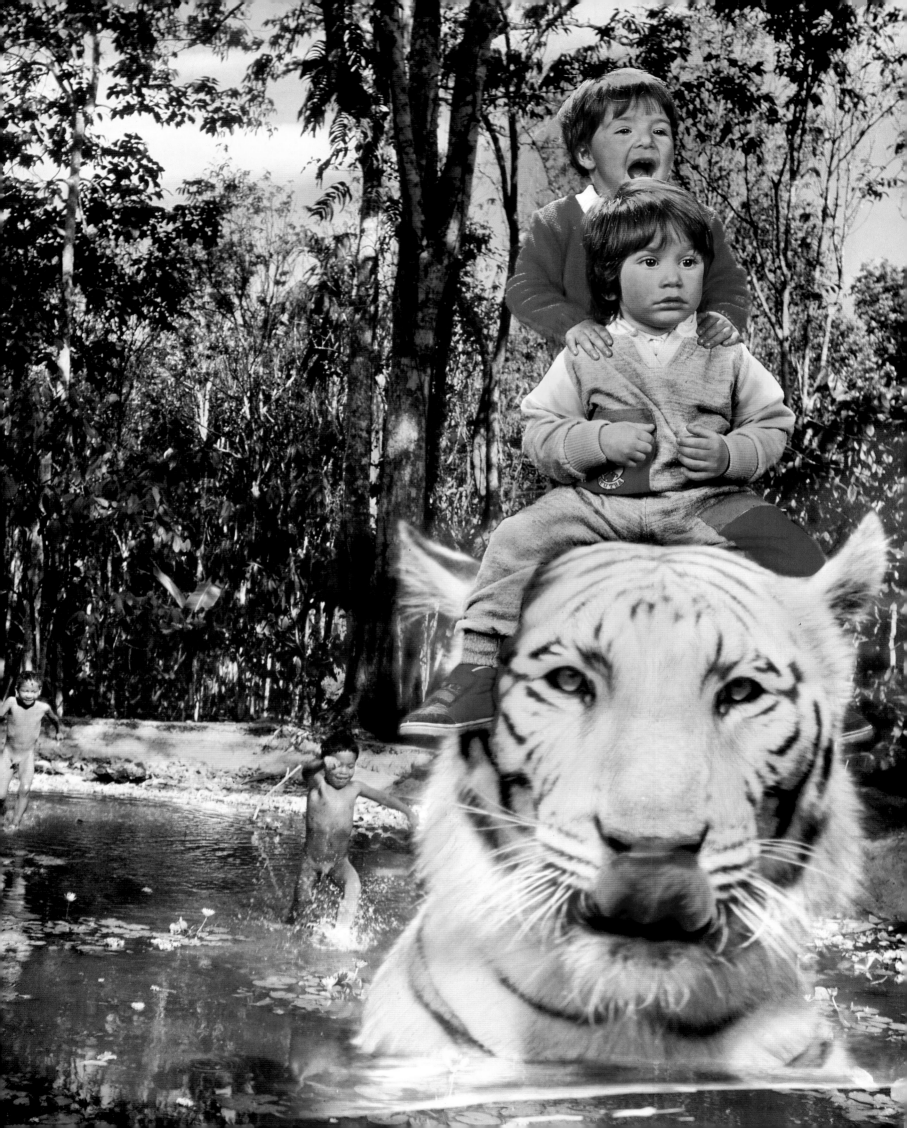

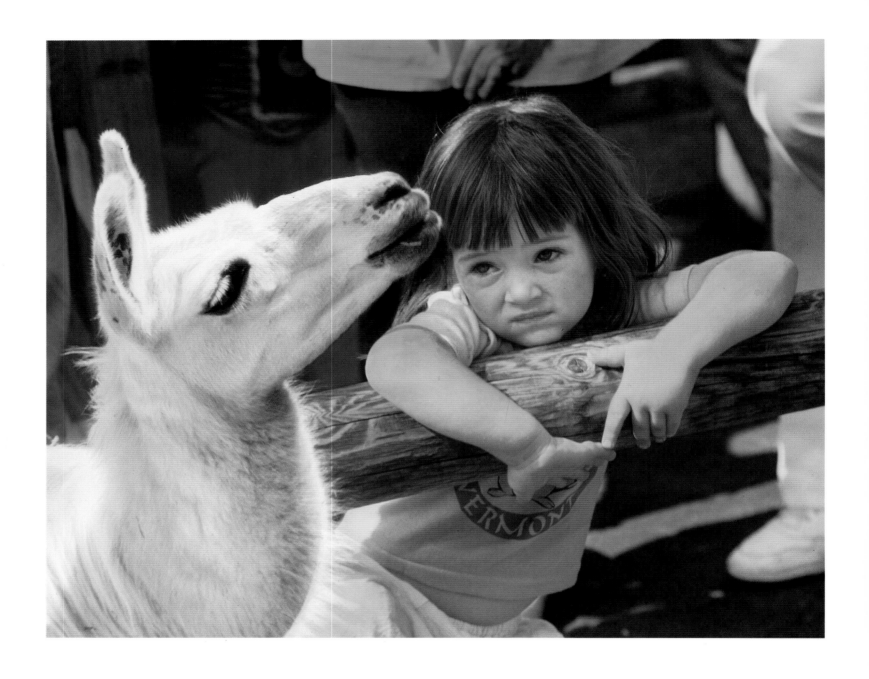

Real joy comes not from ease or riches
or from the praise of men, but from doing
something worthwhile.

Sir Wilfred Grenfell

Never argue with a woman when
she's tired — or rested.

H. C. Diefebach

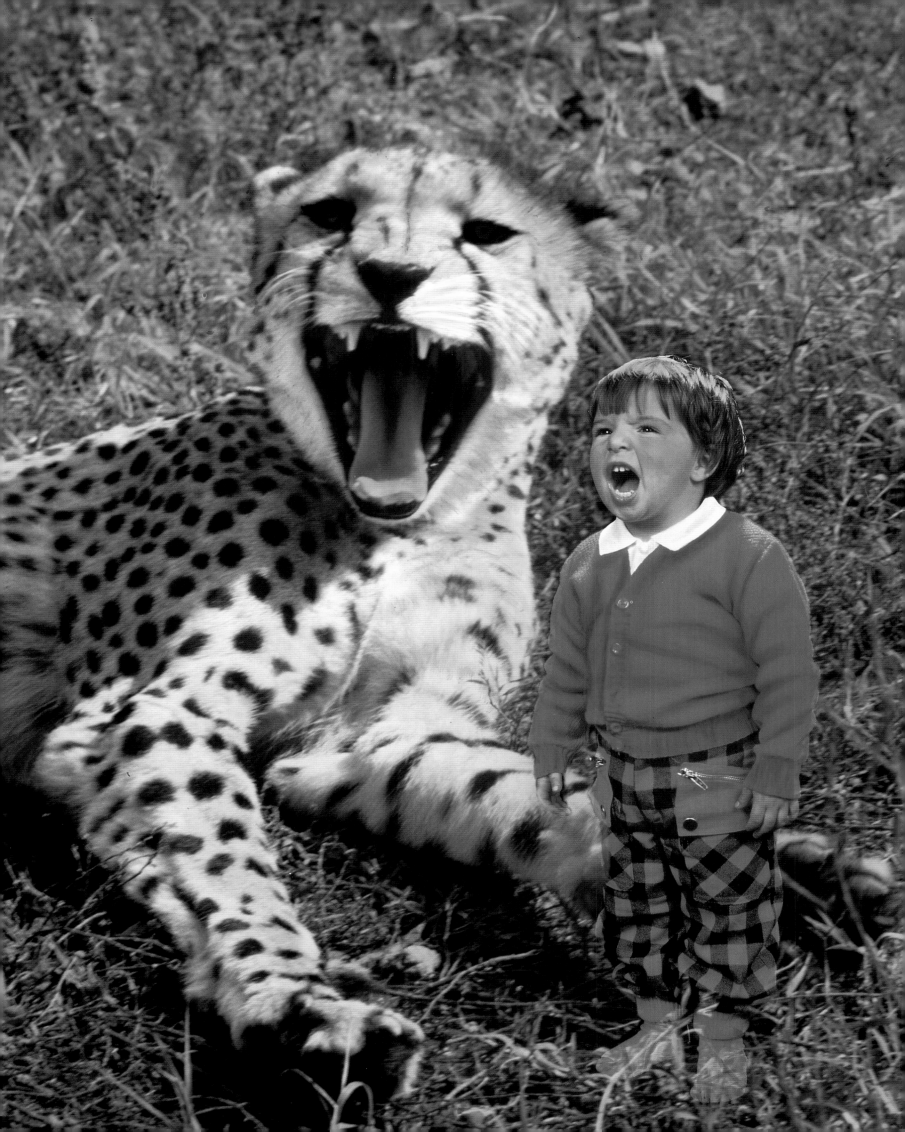

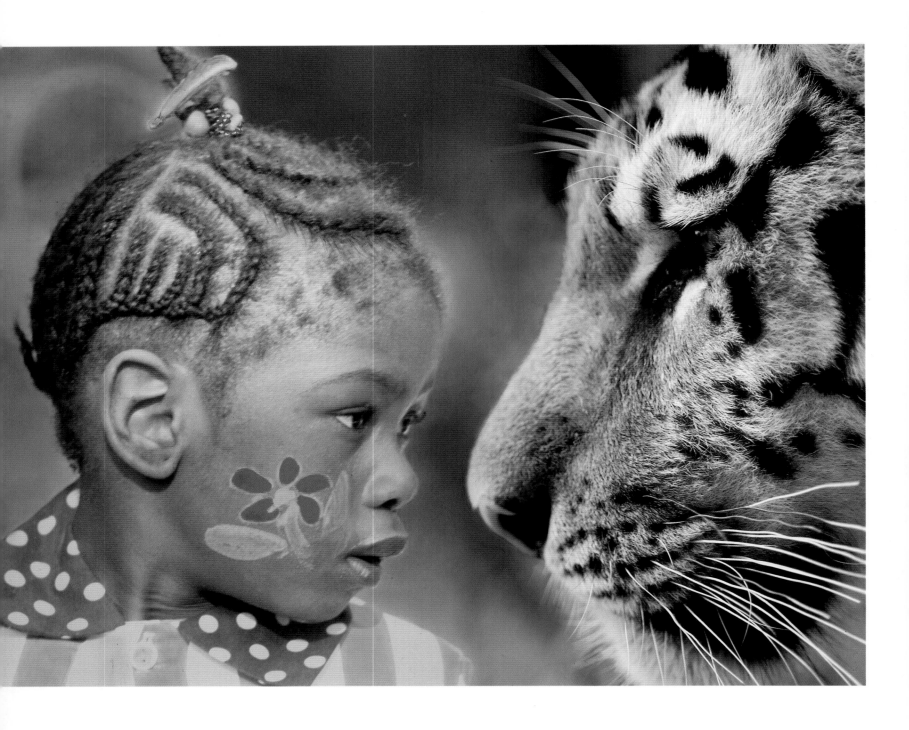

For ever it was and ever it shall befall that Love is he that all things may bind.

Geoffrey Chaucer

Desiring the same things and not desiring the same things that is, after all, real friendship.

Sallustio

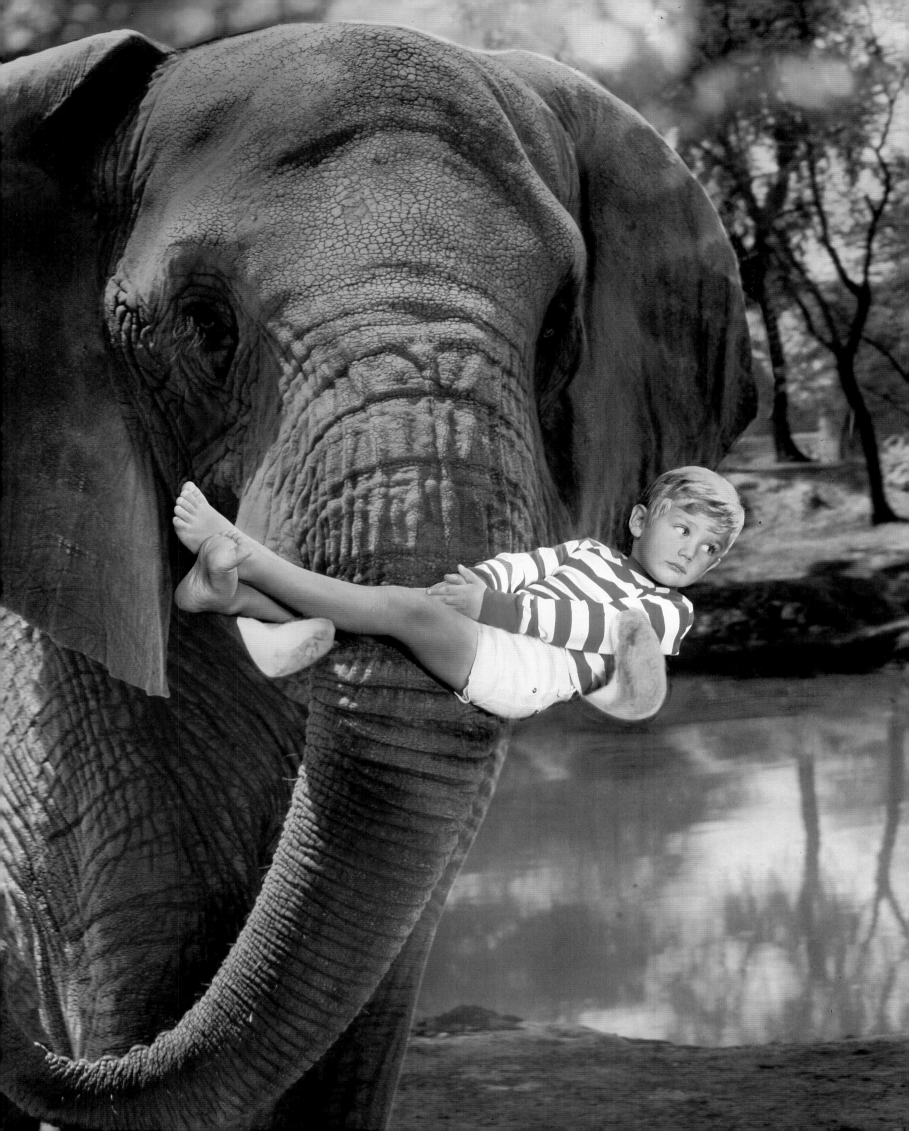

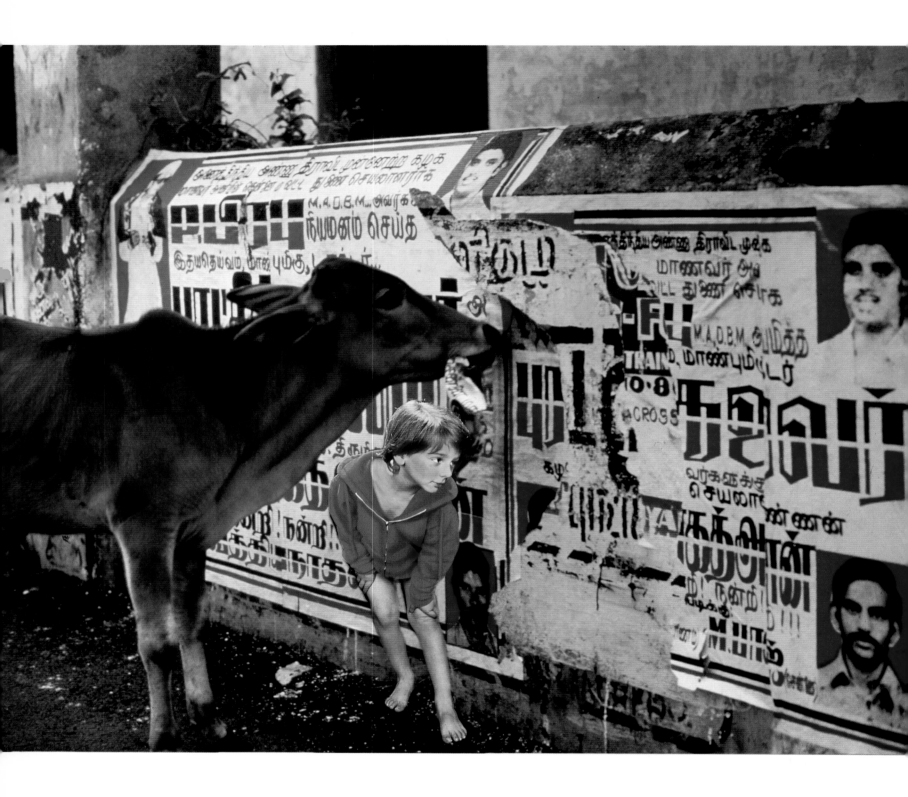

Some books are to be tasted, others to be swallowed, and some few to be chewed and digested.

Francis Bacon

The rich eat when they want, the poor when they can.

Diogenes

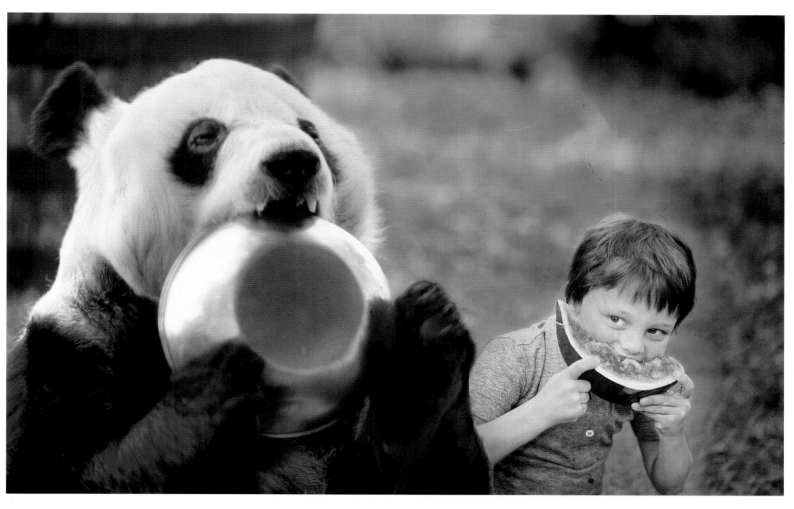

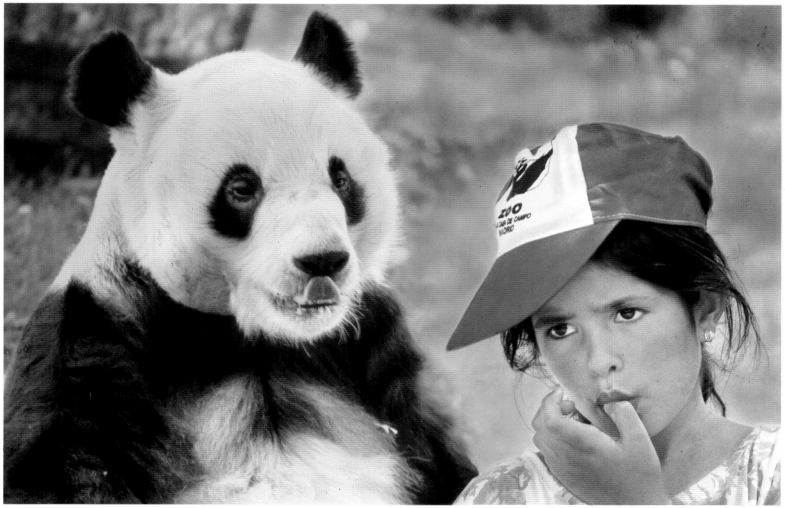

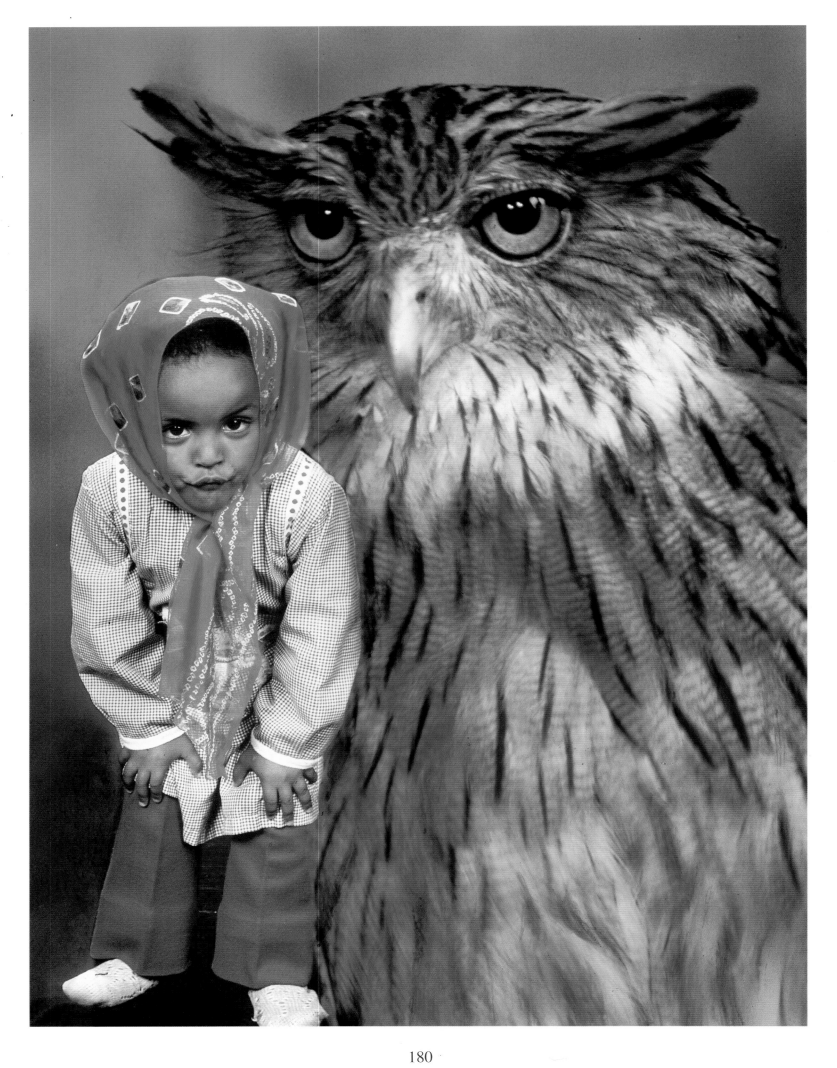

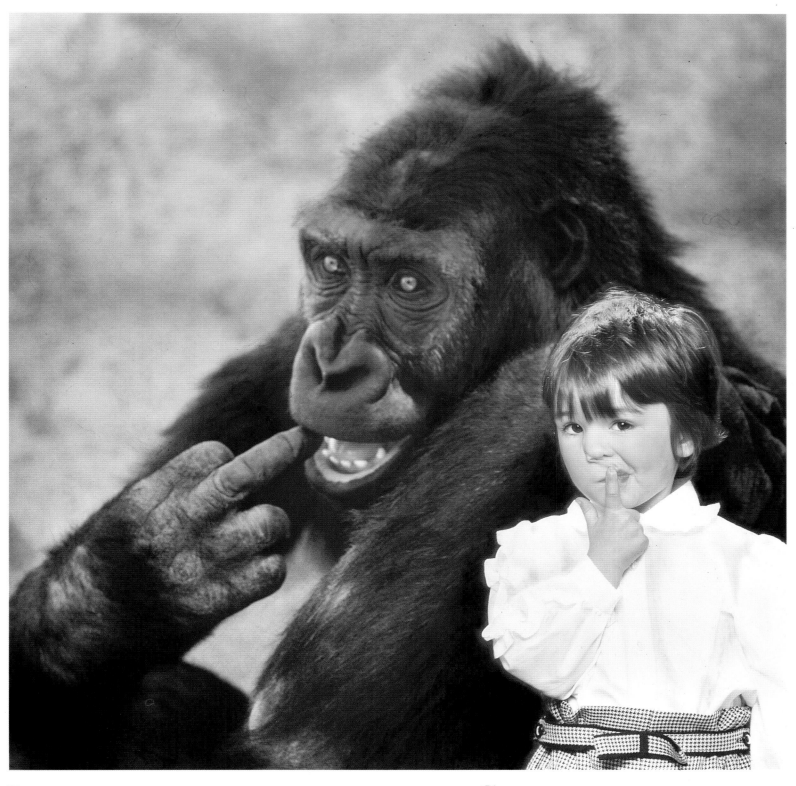

If you want to make people laugh, your face must remain serious.

Casanova

Getting old is a terrible waste of time.

Mary Pickford

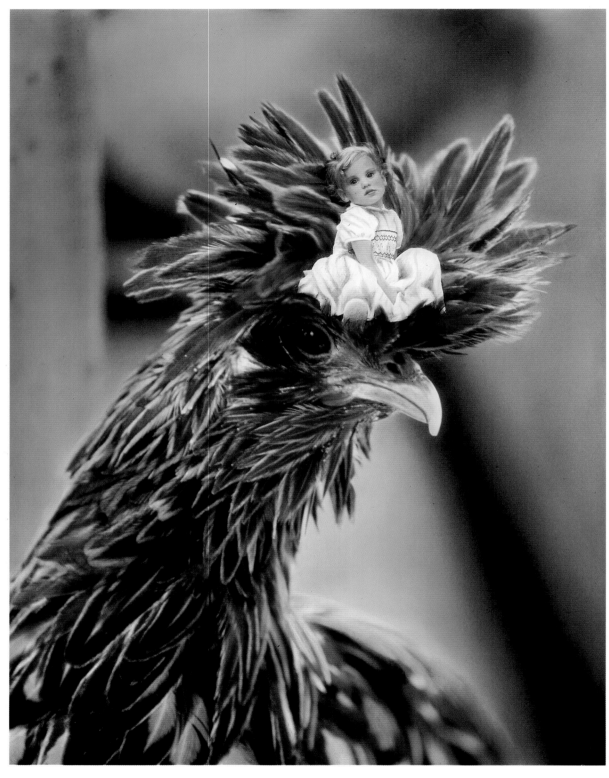

Anybody who still thinks the sky is the limit has no imagination.

Franklin P. Jones

So long as enthusiasm lasts, so long is youth still with us.

David Starr Jordan

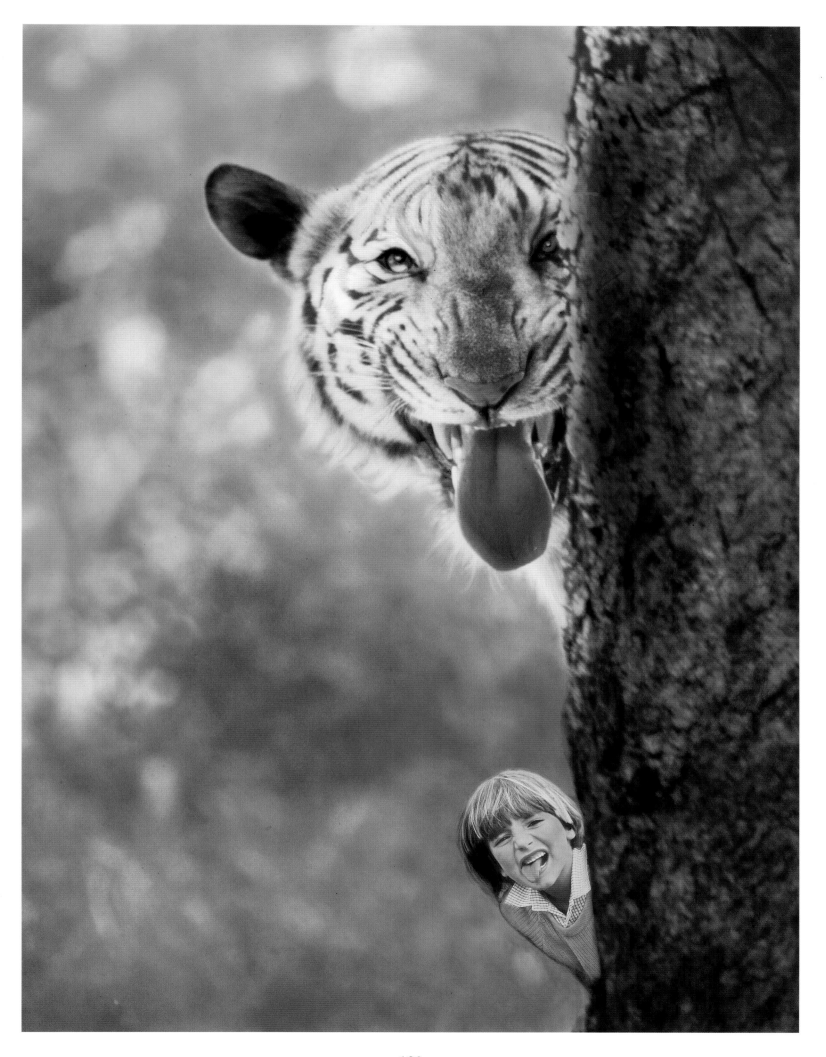

A World To Be Saved

The value of life lies not in the length of days, but in the use we make of them.

Michel E. Montaigne

page 186 ▷

Give me but one firm spot on which to stand, and I will move the earth.

Archimedes

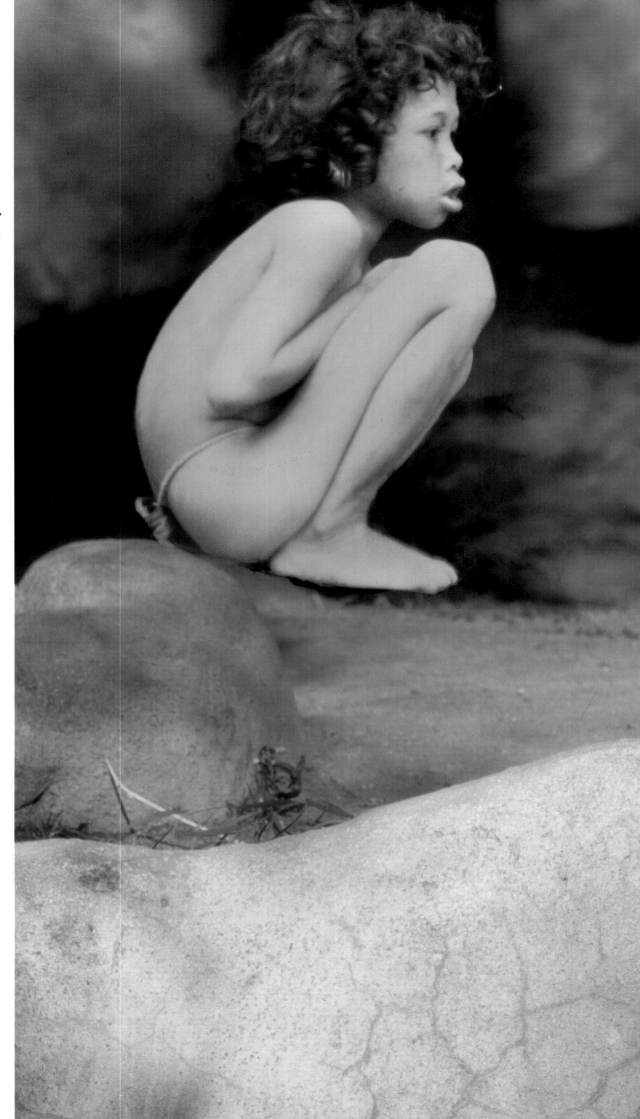

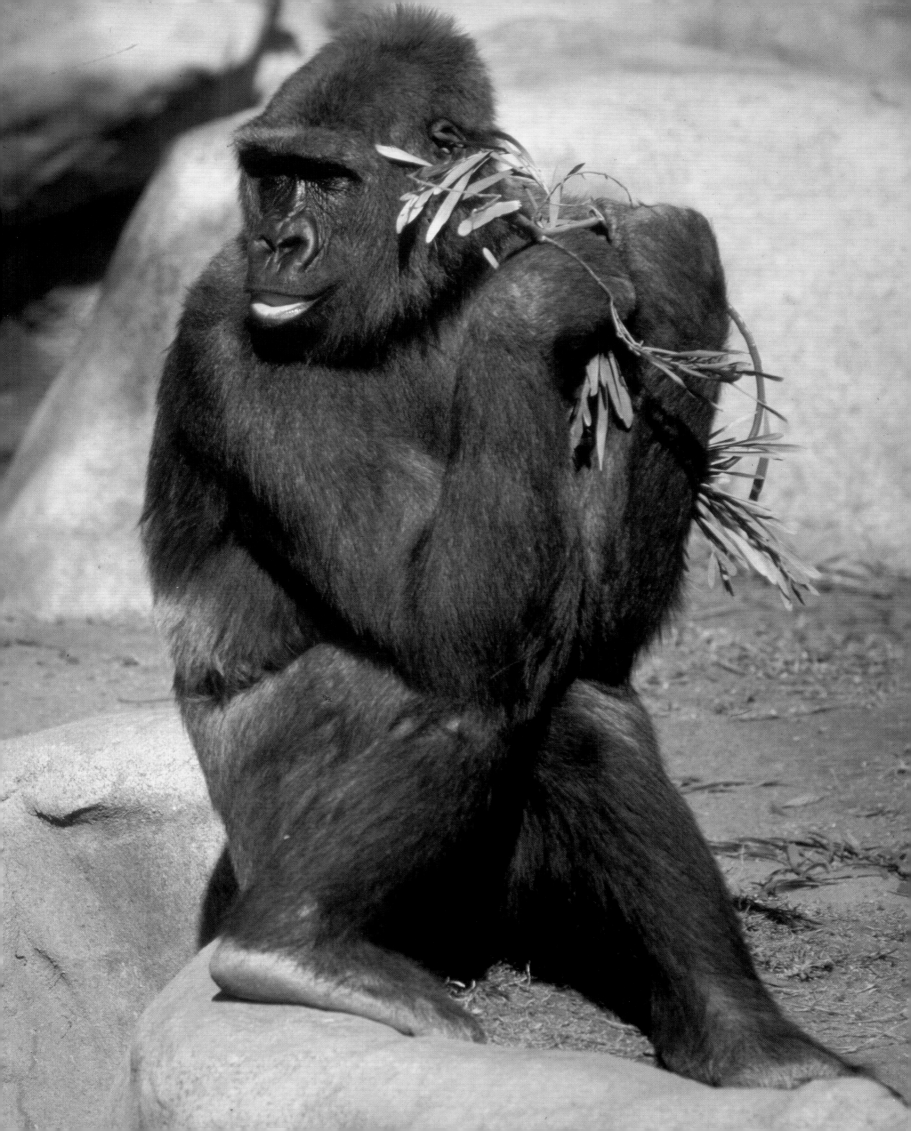

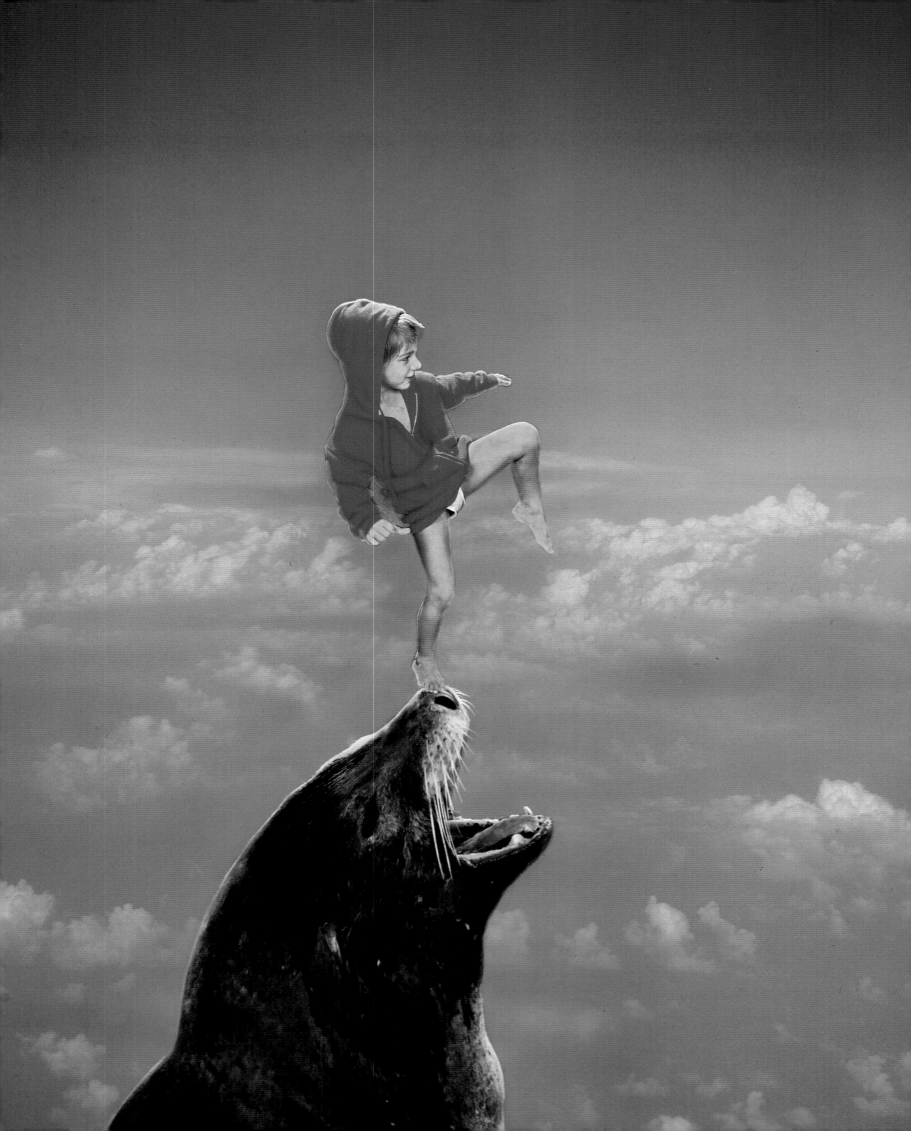

ILLUSTRATED INDEX

187

30 31 32 33

34 35 36 37

38 39 40 41

42 43 44 45

46 47 48 49

50 51 52 53

54 55 56 57

58 59 60 61

188

189

94 95 96 97

98 99 100 101

102 103 104 105

106 107 108 109

110 111 112 113

114 115 116 117

118 119 120 121

122 123 124 125

191

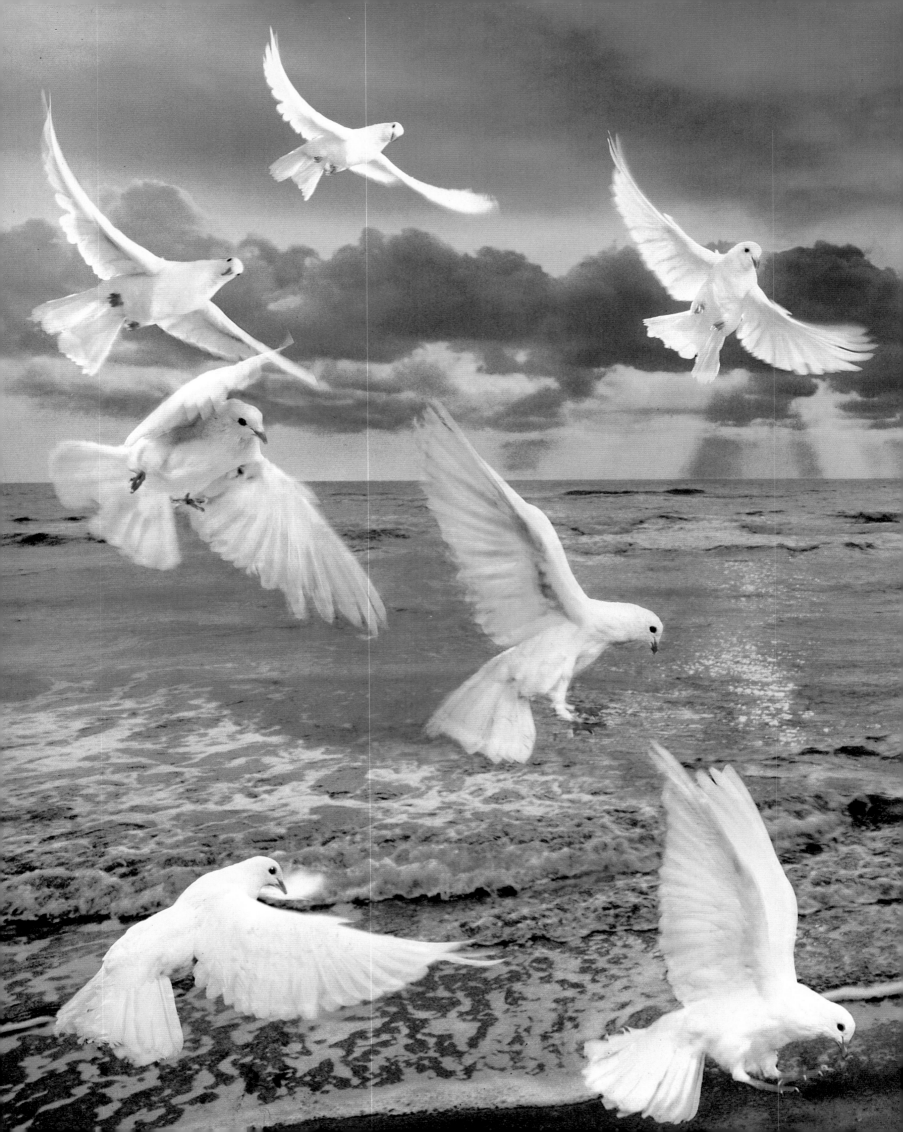